Crafted Lives

Crafted Lives

STORIES AND STUDIES OF
AFRICAN AMERICAN QUILTERS

Patricia A. Turner

Foreword by Kyra E. Hicks

UNIVERSITY PRESS OF MISSISSIPPI • JACKSON

www.upress.state.ms.us

The University Press of Mississippi is a member of the Association of American
University Presses.

Copyright © 2009 by Patricia A. Turner
Photographs © 2009 by Keith Stevenson
All rights reserved
Manufactured in the United States of America

First printing 2009

∞

Library of Congress Cataloging-in-Publication Data

Turner, Patricia A. (Patricia Ann), 1955–
Crafted lives : stories and studies of African American quilters / Patricia A. Turner ;
foreword by Kyra E. Hicks.
p. cm.
Includes bibliographical references and index.
ISBN 978-1-60473-131-6 (cloth : alk. paper) 1. Quilting—United States—History.
2. African American quiltmakers. 3. African American quilts. I. Title.
TT835.T797 2009
746.46089'96073—dc22 2008020368

British Library Cataloging-in-Publication Data available

To my sister/sistah quilter, Ruth Turner Carroll,
and everyone else who has ever admired what it takes to make a quilt.

Contents

CONTENTS

Foreword

I imagine if *Crafted Lives: Stories and Studies of African American Quilters* had been published in 1980 rather than today, it would have been difficult for anyone to claim there was a seven-point recipe for stitching an "Afro-American quilt." The range of African American quilters and quilts in *Crafted Lives* is too varied to permit such a simplistic seven-point assessment.

I first became acquainted with Patricia Turner four or five years ago through quilt research. She sent me an e-mail asking about some aspect of African American quilting. I couldn't place how I knew her name until I looked on my bookshelves and found two of her publications: *I Heard It Through the Grapevine: Rumor in African-American Culture* and *Ceramic Uncles and Celluloid Mammies: Black Images and Their Influence on Culture*. In the course of our e-mail correspondence, she mentioned that she was interviewing black quilters for a new book. I was excited! Finally a quilt artist, African American studies professor, and ethnographer all rolled into one was going to weigh in on the subject of African American quilting.

Patricia Turner's premise is that by asking African American quilters about their quilt making and finished pieces, she would allow the quilters to reveal vital insights about their "everyday lives and aesthetic values" and about their "artistic, social, educational, and economic circumstances." In short, quilts mirror much about the quilters.

Crafted Lives is unique because it's the first book to aggregate contemporary African American quilter stories with analysis of past and current issues affecting the African American quilting community. Roland Freeman's landmark *A Communion of the Spirits: African-American Quilters, Preservers, and Their*

Stories introduced us to black quilters from thirty-eight different states across the USA. *Crafted Lives* introduces us to in-depth life stories of nine young, old, male, female, rural, urban, traditional, and improvisational African American quilters. I felt a kinship to each of the quilters after reading their profiles and viewing the photographs of their quilts. I wanted to meet each one in person.

Patricia Turner gives us more than just quilter profiles. She explores five larger, thought-provoking topics in the African American quilting community from her cultural studies and quilt maker's perspective. For example, she deconstructs the issues surrounding Underground Railroad quilts and explains the phenomenon using folklorist tools. Whether you believe slave-created quilts mapping routes to freedom were actually stitched or not, you'll benefit from reading Patricia Turner's analysis. She also explores the issues of who and what determines whether a quilt is functional or art and who gets to decide a quilt's economic and artistic value. She does this by exploring the historical context and present-day controversies surrounding a select group of quilts, the ones popularly known as the Gee's Bend quilts.

Crafted Lives takes us into the twenty-first century by expanding the dialog about African American quilters and quilt making. Patricia Turner is artful in her stitching of *Crafted Lives*.

KYRA E. HICKS
Arlington, Virginia

Acknowledgments

During the twenty-plus years that I have been captivated by African American quilters, I have encountered numerous generous individuals who have shared their resources, time, and wisdom with me. As the introduction delineates, the quilters and quilt scholars who collaborated on the 1986 exhibit at the Festival of American Folklife were the first to welcome me into this fascinating world. The conversations with Gladys-Marie Fry and Phyllis May-Machunda, the demonstrations by Mrs. Mamie McKinstry and her neighbors, and the photographs of Roland Freeman enticed me.

After joining the faculty at the University of California–Davis, I met Sandra McPherson, a passionate quilt collector who introduced me to Eli Leon, whose personal collection of black quilts has to be one of the world's largest. Sandy and Eli always opened their homes to me, and I spent many a pleasant afternoon watching Eli photograph quilts outside of his Oakland, California, home. The Davis Humanities Institute, under the creative directorship of JoAnn Cannon, provided a much-needed fellowship when I launched this project in earnest.

Many individuals in several states were very helpful in my fieldwork, but two devoted dozens of hours to this project. Carol Hall, who guided me through Louisiana several times, and Keith Stevenson, whose photographs grace the book, were key partners in this effort.

Although this book elaborates on the work and quilts of nine quilters, several dozen quilters have allowed me to spend time with and interview them for this work as well as scholarly presentations on quilters. I wish I could have included stories from every quilter I have met. The members of the African

American Quilt Guild of Oakland (AAQGO) have been particularly generous sister-quilters for the past several years. I wish I lived closer to Kyra Hicks, Denise Campbell, and Carolyn Mazloomi, whose own works are indispensable to the study of black quilters and who have shared their wisdom with me when our schedules allow us to be in the same city at the same time.

Colleagues within the American Folklore Society have offered sound critiques as I worked my way through this material. Marsha MacDowell, Susan Roach, Laurel Horton, Teri Klassen, Diana Baird N'Diaye, Deborah Smith Pollard (D1) and Deborah Grayson (D2) kept me on my toes. D1 kept me abreast of all black quilt–related activities in Detroit, and D2 served as my point person on all things Atlanta.

When I finally began to convert the conference papers and conversations into chapters, various members of the UC–Davis staff community provided assistance. Arlene Jones, Marge Callahan, Lisa Borchard, Maddy Rehrman, and Christine Twiford all helped to keep me and this manuscript organized. Kathryn VanderMeer gave the whole first draft a very careful reading and editing. Mark Hoyer also served as an excellent reviewer. In the summer of 2006, Larry Vanderhoef, chancellor of the University of California–Davis, and Virginia Hinshaw, then executive vice chancellor, authorized a sabbatical for me, allowing me to finally finish the manuscript.

During that very first stay in Washington in 1986, my college roommate Peggy Canale hosted me in fine fashion. For the next couple of decades she was supportive, up to and including multiple walks along the beach in Sag Harbor, New York, in 2006 when I was pulling together the final draft and a splendid trip to Paris in 2007 when she helped me envision the paths of black quilters who were inspired by French landmarks. My New York support network also included Jean Smith, Carolyn Whitehurst, Marion Darden, Elizabeth Yennie, and Victoria Frisch. No matter what coast we were on, my son, Daniel Turner Smith, and husband, Kevin Smith, have cheerfully lived with quilts and conversations about them for many years. They are my most important inspirations.

Crafted Lives

INTRODUCTION

My First Quilt

My affection for African American quilts and quilters developed in the summer of 1986. At that time, I was a fledgling folklorist, in the nation's capital to do some research at the Library of Congress. And at the end of June, I did what any good folklorist then in Washington would do: I braved the stifling heat and humidity to revel in the exhibits and workshops at the annual Festival of American Folklife being conducted on the National Mall by the Smithsonian Institution's Office of Folklife Programs and the National Park Service. This meticulously researched, massive festival, devoted to the multitude of folk traditions practiced in the United States and outside its borders, has been mounted by the Smithsonian since the mid-1960s. I had attended in the past and was looking forward to seeing what the public sector folklorists, who regularly marry tenacious fieldwork and organizational acumen in order to mount this much-acclaimed event, had come up with for this year. In addition to observing the folk artists at work, I planned to sample the always tasty ethnic foods then available at the foodways demonstrations; I wanted to dance to the rhythm and blues music performed in the late afternoon concerts.

I did all of that and much more. The 1986 festival proved to be a personal landmark for me. By the time the festival's sponsors were taking down the signs and packing up the booths, I had been befriended by a remarkable group of individuals—quilters and quilt scholars—who profoundly influenced my thinking about the role art and craft can play in anchoring the stories that African Americans tell about themselves and their pasts. In the two decades since, I've come to realize that stories of individual and black collective experience can be narrated through quilts.

For the 1986 festival, renowned African American photo-essayist and quilt scholar Roland Freeman had documented in the festival catalogue the quilts and quilting traditions of several talented women from the Black Belt of Alabama. This guidebook contained fifteen remarkable black-and-white photographs that to this day can truly be "read," delivering a provocative and edifying story to the attuned reader. The setting for this story is rural Alabama. The main characters, of course, are the quilters; the supporting characters are their husbands, children, and grandchildren. Freeman's camera captured them all: in their homes, their yards, and their senior center.

And as a folklorist, I, too, was captured by Freeman—by the ever-expanding insights that such a small selection could reveal. These Alabama photos had many stories to tell. From them, for example, we can glean clues that not all of the quilters shared identical social status. The interior of one home suggests that it might be classified as a shotgun house—modest, traditional, black southern structures often built by the occupants or their ancestors with construction material that we might describe as "recycled," but that they themselves often labeled as "used." In another home, the ornately carved and polished wooden bedposts suggest that this quilter and her family enjoyed a more middle-class lifestyle. Clearly much-loved, conspicuously worn Bibles are frequent fixtures in the photographs, indicating that Christianity anchored the spiritual lives of these individuals.

The action in the stories emerges as we see the various ways in which women made, took care of, and used their quilts. Two photographs show several women working collectively around a quilting frame, constructing their handiwork. Another shows an older woman teaching a younger woman, using a loop on a quilt festooned around her lap. Yet another reveals a woman meticulously piecing a quilt, using only the surrounding chairs to hold her tools. The pictures show some quilters working in groups and others sewing solo. Some are named, others remain anonymous. Quilt upkeep is documented by photographs displaying quilts draped over fences or tethered to a clothesline by wooden clothespins. Quilt functionality is exemplified in scenes of the quilters resting under their handiwork with their husbands, or teaching their children and grandchildren how to transform scraps of fabric into durable and artistic household bedding.

A reader familiar with quilt motifs will note a broad range of familiar quilt designs in Freeman's photographs. In one, Mrs. Mary K. Smith is teaching her daughter and granddaughter to quilt by using the uncomplicated squares that

comprise nine-patch blocks—as I have since learned, the first simple patterns many quilters recall having learned to sew. At the other extreme, Mrs. Scarborough and her husband relax in bed under a full-sized double wedding ring quilt, one of the most difficult and time-consuming quilt designs to master. Such ornate quilts are usually only tackled by the experienced; I have since met many a quilter with a partially finished double wedding ring tucked away in a trunk or closet.

Without question, Freeman's passion for quilts and his love for quilters emerges from each photograph in this guidebook. This dedication and passion have since been further documented in the breathtaking sweep of his 1996 volume, *A Communion of the Spirits: African-American Quilters, Preservers, and Their Stories*, where he recalls his many years on the quilt trail. But it was this much more modest, carefully choreographed black-and-white photo essay from 1986 that first seduced me into the world of African American quilts and quilters. Although this aspect of his fieldwork was not publicly documented, he and his camera accompanied the Alabama quilters to Washington, where he chronicled their interactions with other professional folklorists, with other folk artists from different parts of the country, and with the curious public.

But there was more, as well. Festival organizers, including Phyllis May-Machunda, had arranged for some of the Alabama quilters documented by Freeman to participate in the festival by bringing their quilts from home and then, during the festival on the Washington mall, constructing a new quilt on a frame. Folklorist Gladys-Marie Fry facilitated the public workshops showcasing these quilters, joining to work with them during the days when the public was invited to wander through the open-air booth to witness the transformation of hundreds of fabric scraps into a quilt. Her task was to assist the quilters in explaining the process to the thousands of people who were attending the festival. The celebrated author of one of the most significant studies in American folklore, *Night Riders in Black Folk History*, Fry had turned her academic attention to nineteenth-century slave textiles. As was the case with Freeman, her interest was triggered, in part, by coming from a family of talented and dedicated quilters.

I attached myself to Fry and the Alabama quilters from the opening day. Since I was a still-inexperienced folklorist, it was a valuable opportunity for me to soak up knowledge from Fry, who at that juncture had been studying African American textiles traditions for several years, and delving into obscure records to identify nineteenth-century African American quilt practices. For

almost two weeks I hung out at the booth with Fry and the quilters. As the women worked on the quilting frame, we inundated them with questions about the role that quilt making played in their lives. I was struck by how freely they talked about their family histories. In my experience, many blacks are reluctant to share the kind of personal information that folklorists crave. Even my own family was nonplussed by my probing questions about the roots of our family traditions. Unaccustomed to and suspicious of scrutiny, African American informants often answer questions with a single word or with another question. This recalcitrance is easy to understand. Blacks have had good reason to keep their stories to themselves. Also, the notion that information on religious practices, foodways, quilt-making techniques, and other vernacular expressions is worthy of public documentation is still a new one in our culture. I don't know how many informants have responded to a question about a folk custom by saying something like, "People really care about this stuff?"

But with the quilt and quilting traditions as the focal points, the Alabama quilters were willing to converse about a whole range of historical, economic, social, and cultural issues. The Alabama quilters were also as taken with us as we were with them. All of us—Gladys-Marie Fry, Roland Freeman, Phyllis May-Machunda, and I—were African American success stories. We held our own within respected elite institutions such as universities and museums. We were all secure in our conviction that black academics and folk artists had much to contribute on the mall that connects the U.S. Capitol and the Lincoln Monument. Laughter permeated our booth. Mutual respect and trust were established and maintained throughout the festival.

By the end of the second week I came to the intriguing realization that by using questions about actual handmade artifacts, I would be able to document much about the everyday lives and aesthetic values of black Americans. Quilts that these women had sewn in Alabama and brought by train to Washington (they were reluctant to fly) adorned the booth. As Fry pointed out to the many observers who passed through the quilting booth, the quilts made by this small group alone represented many of the extremes in the African American quilting world. On the one hand she pointed to the quilt of Mrs. Mary Scarborough described above, a meticulously crafted full-sized quilt in the familiar double wedding ring pattern. On an off-white cotton background fabric, Scarborough had sewn precisely cut cotton pastel and calico pieces. To most observers, however, this quilt possessed no attributes linking it to an African American tradition, save the race of its maker.

On the other hand, Fry drew the audience's attention to a quilt brought to the festival by Mrs. Mamie McKinstry. Mrs. McKinstry was the most senior member of the group. Her quilt she called "Fishes of the Sea," and Fry enjoyed highlighting its many special elements. Comprised mostly of primary colors, the bright quilt contained three rows of four blocks. Within each block were eight fish whose heads met in the center and whose tails fanned out against an octagonal piece of fabric. The octagonal piece was superimposed on a larger square. The twelve squares in turn were separated by long sashing strips of fabric. Three vertical sashing strips ran from top to bottom between each row of three squares. Two were calico, and adjacent to each other; one was plaid, and placed at one end.

This positioning of the strips is one of several features that contributed to the quilt's asymmetry, a feature that Fry (and many scholars) pointed to as characteristic of African American quilts. By not alternating the plaid and nonplaid strips, Mrs. McKinstry was defying standard convention. In her discussion, Fry also focused on the fact that McKinstry's decision to use a fish, an animal, for the quilt is common to African American quilters. Although Mrs. McKinstry herself had not selected a top or a bottom of the quilt, what I consider the top had one square that began about an inch above the other three in this row. She hadn't framed this square with a one-inch scrap of fabric as she had the other three. This square was also different from the other eleven in the quilt in that the octagonal fabric did not contain a full piece of fabric for the octagonal shape. Little printed pieces of fabric separated the two ends of two of the fishes' tails. These surprises are what some mainstream quilters and quilt authorities might identify as "mistakes." But Fry, and others who have studied African American quilters, have observed and documented an alternate aesthetic. Many black quilters have told questioners that they like to "mix things up" and "fool the eye." They prefer their quilts to be unorthodox and unpredictable.

I was much taken by Mrs. McKinstry and her "Fishes of the Sea." Like the other Alabama quilters, she had hoped to sell some of her quilts at the festival. However, most attendees at the annual free festival didn't think of quilts as portable souvenirs, and at the end of the two weeks very few of the quilts had sold at the prices the women were requesting and well deserved. On the last day, they began to lower the prices so that they could realize some small profit and avoid lugging their cumbersome wares back to Alabama on the train.

Thus began the first of many ethical/fiscal quandaries regarding quilts that I have faced over the years. Mrs. McKinstry's asking price on the quilt had

been $750—a reasonable sum for a high-quality, unused, handmade quilt. As a young assistant professor eager to buy a house and start a family, I did not have $750 to spend on a quilt that I wouldn't even sleep under! But my interest in it continued unabated. So, at the end of the last day, I sheepishly asked Mrs. McKinstry if she would accept $100 for the quilt, and she immediately said yes. For me, the guilt was overwhelming. On the one hand, I couldn't personally rationalize offering a higher dollar amount, although I knew my lifestyle as an academic was a great deal more financially comfortable than that of this elderly woman. Having spent the last two weeks with her, I well knew that she was supporting herself on very little money. She consoled me, however, by emphasizing how pleased she was that her quilt would belong to someone who would use it for teaching. During the preceding two weeks I had been witness to McKinstry's generosity in her dealings with the folklorists, her sister quilters, and the scores of tourists who approached her. This final unselfish gesture with "Fishes of the Sea" was clearly in keeping with her overall approach to life.

And so I brought "Fishes of the Sea" home, and hung it on a wall. Ever since that summer of 1986, it has been given a position of prominence in all the homes I've lived in. Indeed, whenever we are pondering relocation, my husband knows to look for good quilt walls in any potential home. I take it down from time to time to take to a class. It has never occurred to me to sleep under it.

Its place in my life, though, extended far beyond its aesthetic and genre representation appeal, for I soon found personally meaningful layers beneath its colorful surface. Like many young faculty at most major universities, I was caught up at that time in the battle to publish or perish. I needed to write articles and books on African American folklore in order to secure tenure. Although I was loath to admit it, I was petrified. While I had no trouble imagining that I could start to write a book—anyone can start a book—I was extremely worried about my ability to actually *finish* one that a reputable publisher would want to issue. Ironically, my project concerned African American legends, the subject of Gladys-Marie Fry's first full-length book.

From my desk I often stared at "Fishes of the Sea" and thought of Mrs. McKinstry. Using the skills her mother and grandmother had taught her, she had finished that quilt. With small pieces of scrap fabric and her sewing tools, she had made blocks and joined the blocks together. When she had completed twelve, she sewed them together, superimposed them onto a filler, and then

quilted them to a sturdy back. And when she was done, she had created a beautiful and functional emblem. I took inspiration from Mrs. McKinstry's quilt: I could use the skills that I had developed in twenty-plus years as a student and from my many teachers and professors. Conducting the research and organizing my book would be like assembling the cloth, the thread, and all the tools. My chapters could be constructed like the squares on the quilt. Shape the sentences and paragraphs that comprise one, and move on to the next. If Mrs. McKinstry could finish that quilt, I could finish a book!

Several successfully completed manuscripts later, I now sit down to write a book about African American quilters. Since that summer in 1986 I have acquired several more quilts of my own, built a small collection for my university, interviewed dozens of quilters and their significant others, taught about quilts, attended and helped curate quilt exhibits, and read what other scholars have written about quilts. Although I remain more attached to the utilitarian quilts made for home use, I have also developed an affection for art quilts made to hang on walls. During the time between my first and my most recent publications, I often claimed that my research on quilters was my respite from my more controversial scholarship on African American legends and antiblack images in popular culture.

But I soon discovered that black quilt research has generated its own controversies. The extent to which black quilts reflect African aesthetic practices is a frequently debated point. Folklorists recognize this as the familiar twentieth-century debate on the scope and extent of African survival in new world African American culture. The relative value of "folk" versus "art" quilts is also an issue. As well, racial politics have intruded into black quilt scholarship, with whites claiming that their contributions are unfairly challenged by their black colleagues. And some African American quilt scholars bemoan the attention from white scholars, associating it with a new form of colonialism. Yet in spite of their disparate views, a clearly positive common denominator links all these scholars: their passion for the quilts they write about.

Although there may be exceptions to this rule, in my experience most everyday quilters themselves are uninterested in the debates that their work generates. To be sure, there is among them a wide range of understanding of these debates. Many of the quilters I have interviewed are unaware that anyone has ever hung a black quilt on a museum wall or that books have been written about these works. They are not particularly interested in whether or not a uniquely African aesthetic influences the look of their quilts. If they like to

talk about their quilts, they will do so to just about anyone, regardless of race or gender. To most quilters, the process of planning, making, and parting with a quilt stems from creative and generous impulses. The idea that academics would quarrel about their efforts defeats the whole point. Art quilters tend to be a bit more opinionated and concerned about the scholarly debates.

Just as scholars have identified African American quilts as objects worthy of study, art curators, collectors, and dealers have embraced these unique works of the hand and heart. Consequently, their value has its standard economic accompaniment. At times, the passion displayed is more for the monies that can be pocketed than for the quilts or quilters. Quilts originally created to be slept under now are being displayed and sold. How much money the Mary Scarboroughs and Mamie McKinstrys of the quilting world receive for their hand-crafted products depends on the integrity and the values of the dealers and academics with whom they come into contact.

As I learned more about historical and contemporary issues that pertain to black quilters and quilting practices, I recognized that quilts could be used as touchstones for analyses of the many artistic, social, educational, and economic circumstances faced by African Americans. For example, black quilters who have been deprived of economic and educational opportunities have limited access to materials for their quilts and have few options for marketing them. On the other hand, as more and more African American quilters enjoy the benefits of strong educations and solid occupational opportunities, the quilts they create and the venues that feature some of these quilts reflect the success and acumen of the quilt maker. In *Crafted Lives*, I use quilts to explore the breadth of African American culture. The first section—the stories—offers just that, the stories that demonstrate the ways in which quilting comes to be meaningful for these individuals. The second section—the studies—shows how African American quilts and quilters have figured in the academic and literary discourse about black culture.

Inspired by the ingenuity and creativity exemplified by the quilters in this study, I have organized this manuscript in a fashion comparable to their own creations. Because this research hasn't followed any rigid, predictable format, I believe that it makes sense for the book itself to unfold like a utilitarian quilt. It is my hope that the reader will emerge from this range of profiles and historical examinations with a sense of something larger than the individual "piecings" themselves—a fusion of impressions and documentation that fosters an intimate understanding of the particular experiences of black quilters and quilting.

The voices of African Americans against the thematic background of cultural struggle resonate in their handcrafting through the years, to be rediscovered and interpreted by each reader in his or her own manner.

From my viewpoint as author, my own discoveries in the process of crafting this book have been many. For two decades now, I have had the opportunity to learn from quilters about their lives, their communities, and their sense of their culture. And through all of these encounters, I've been able to learn much about myself. In the volume that follows, I will focus on the worldviews of the quilters I have met, for in listening to them talk about the quilts they make, about why and how they make them, I believe the breadth of the African American experience can be better understood.

Part One

STORIES OF AFRICAN AMERICAN QUILTERS

A Nine Patch Overview

At its 2007 Black History Month workshop at the West Grand branch of the Oakland, California, public library, members of the African American Quilt Guild of Oakland (AAQGO) spent several hours teaching visitors how to make nine patch quilts. At an earlier meeting we had all contributed three-inch squares of fabric culled from our stashes as well as twelve-inch backs. We'd assembled plastic bags with fabrics, battings, and instructions and also filled colorful bags with rudimentary sewing tools. Attendees took our gifts and sat at tables while our more experienced members taught approximately seventy-five visitors how to make miniquilts.

By using the nine patch as our sample, we were following a very old tradition. When asked, numerous quilters, including white ones, identify the nine patch as the first block they learned to quilt. Nine patches are reasonably easy to cut and stitch, but, because they are comprised of nine pieces of fabric, they lend themselves to enormous creativity. When constructed with imagination, a nine patch can demonstrate profound diversity. In tribute to the block that has launched thousands of quilters, I have selected nine of the dozens of individual quilters I've documented in the past few years to depict the scope and breadth of contemporary African American quilt makers. And I readily concede that within these nine profiles I have not captured the full range of types of black quilts and quilters. It is my hope that the stories of these eight women and one man tell the reader more than about the diversity of quilting practices. In these nine chapters I hope to show how current African Americans make their way in the world.

"EVERY DAY BEEN SUNDAY SINCE":
JEANETTE RIVERS

Jeanette Rivers counts. At any given moment she can tell you her age, the length of her marriage, the number of animals in her yard, the number of years she worked at any given job. She knows how many white shirts her husband owned on their wedding day (four). She knows how many pieces of fabric she used in her most intricately constructed quilt (4,231) and how many rows of butter beans she planted the prior year (three). She seemed to size my research assistant, Carol, and me up at the moment we stumbled from our rental car laden with notepads, cameras, and recording equipment. The short, slender, dark-skinned woman started talking before we could properly introduce ourselves or get the tape recorder set up. We were "ladies" from California interested in quilters and that was good enough for her.

She started talking about her husband with great pride: "Willie loves quilt-ers; his mother was a quilter. Oh, he loves quilts! He doesn't mind what I'm spending on quilts or quilt pieces and all." Willie Rivers's love for quilters, particularly for Jeanette, his wife of forty-four years, was as patently visible as a groom's when we first met the couple in their Zachary, Louisiana, home in 1997. It was about eight days before Christmas, and old-fashioned holiday preparations had overtaken their small, tidy household. Jeanette Rivers was making eighteen fruitcakes for friends and family, and Willie Rivers was finish-ing the cleanup necessitated by the butchering of a six-hundred-pound hog. In that first afternoon and in subsequent visits to the Riverses' home, Carol and I ate fruitcake, picked cotton, took pictures of dozens of quilts, and heard a series of anecdotes that add up to the story of a passionate, four-decades-long love affair.

Initially, the fruitcake scared us. But an enticing aroma glided through the festively decorated house, and clearly Mrs. Rivers's feelings would be hurt if we didn't accept the generous warm slices she placed before us. Our trepidation was eliminated by our very first tastes. Mrs. Rivers makes a superb fresh, moist, and succulent fruitcake unlike those that give the holiday mainstay such a bad reputation. The busy cook acknowledged that she, too, had been initially suspicious of this particular Yuletide tradition and paused to reflect on her own comeuppance:

> This [fruitcake] is something that people have quit making. And they don't know how to make a good one. Me and [my friend] know how. She came over from Germany during the time of Hitler. She was a very sweet person. We worked at the library together. She was a typist, and I was mostly doing janitorial work. She asked me about the fruitcake and I said, "I don't want *none* [emphasis added] of that fruitcake, I'm nutty enough as it is. I see you a have a sign there for two of them for $7, I know I don't want none of them." She laughed. She told me like this, she said, "Jeanette, cut you a slice of that fruitcake and if you don't like it, I won't charge you for it when I get back." Said to myself, to taste it, she wants you to taste it so bad. I tastes the lady's fruitcake. When she came back, I got $3.50 out of my purse and put it there because I had ate half of her fruitcake up! I told her, "I ain't never tastes no fruitcake tastes like this." She said to have a good fruitcake you have to have good things.

Mrs. Rivers's "how I started making fruitcakes" tale reveals several aspects of her persona. Her self-effacing humor comes through as she recalls how quickly she reversed her initial prejudice against fruitcake. In this and in all but one of the commentaries that will be quoted in this profile, laughter permeated Mrs. Rivers's telling of her story. In spite of her own upbringing in a community marked by what she describes as "hard-core segregation," she betrays no ethnic prejudices against her immigrant co-worker. The northern California library where they both worked was located in what had evolved into a largely black working-class community. Clearly Mrs. Rivers had no reservations about adopting a recipe proffered by a white woman whom she twice refers to as a friend. She robustly tells a story crediting her white friend's talent and tenacity and highlighting her own original reluctance. Her remarkable memory and unswerving attention to numerical detail are documented in her recitation of how many pieces of fruitcake she ate and how much she paid.

The saga of the slaughter of the six-hundred-pound hog further reinforces these dimensions of her personality and brings out other nuances of her world-view. Describing that annual ritual she nonchalantly notes:

> They [Willie and several friends and relatives] shot him, and they brought him right out the pen. They put him on this slab of concrete back there; there's about twelve men out there. They heated the water out there. I had my wash-pot out there. I fried out cracklins [a deep-fried treat made from pork fat] after they got through; I had seventy-five pounds of cracklins and lard and every-thing. And most people say, well, you eat all *that?* How in the world do you live? Look, I've been eating *that* from my early childhood days. I'm seventy-five years old, I don't take no kind of medicine. No kind of medicine . . . you see, my husband and I, that's all we love to do. We farm.

Here she gives credit to Willie and his friends for tackling the more laborious tasks related to killing and butchering hogs. As she had already done in telling us how she makes fruitcakes and would soon do in telling us how she makes quilts, she methodically reviews the steps in the process. She understands that many outsiders are likely to be perplexed by the Riverses' desire to grow and prepare as much of their food as possible. Her eyes dance and she chuckles warmly as she boasts about her good health. She knows that she, Willie, and the pleasure they take in each other and the life they lead is the best evidence of all.

BACKGROUND

On March 10, 1953, Willie Rivers married Jeanette Barrow in Reno, Nevada. Both were born and raised a half continent away in the area surrounding Zachary, Louisiana, a tiny African American enclave about twenty miles from Baton Rouge. From the extreme deprivation that accompanied rural southern sharecropping to the tantalizing opportunities possible in military service and the subsequent benefits that could be extracted from veteran status, the Riverses faced obstacles and challenges familiar to numerous African Americans in the second half of the twentieth century. With hard work, faith, humor, and an ability to reap satisfaction from working with their hands, Willie and Jeanette Rivers made extraordinary lives for themselves.

Willie's stints in the army during both World War II and the Korean War had taken him far from the South. And even though the U.S. military was not completely desegregated when Willie enlisted, he still found it less stifling than the more extreme segregationist mores still ubiquitous in Louisiana. To the decorated drill sergeant, the Oakland, California, of the early 1950s seemed to offer more choices for a black man than Louisiana did with its white supremacist regime. During a visit home he began to court an old friend, Jeanette. On the Sunday night before Thanksgiving, six weeks after their first date, he made it clear that it was his intention to follow career opportunities in northern California. Accepting his proposal meant Jeanette would have to leave the South for the first time and plan a life away from her family.

Jeanette had already been married at age sixteen. She and her first husband fought frequently and divorced after having a son and a daughter. Her son was thirteen and her daughter ten when the relationship between Willie and Jeanette flourished. With some childcare help from her own mother, she had been working as a maid to support herself and her children. Willie expected Jeanette to bring her children with her to California, but her first husband forbade it. He insisted that they stay with him, and he planned to finish raising them. Jeanette nevertheless decided to go to Willie in California.

Willie sent her a one-way ticket, but he promised her that if she was disappointed with California or missed her family too much, he'd release her from her obligation and pay her fare home. With characteristic independence and self-assurance, Jeanette sequestered enough of her own savings for a ticket so that she could return home on her own steam if Willie's promises of a better life didn't come to fruition. With a mixture of anticipation and apprehension she boarded the train and embarked for California.

Even more of Jeanette Rivers's indefatigable good humor is evident as she tells the story of train travel during the days of segregation. When she boarded in Baton Rouge, black passengers and white passengers were assigned seats in separate compartments. But before the train reached California, the rules changed and new passengers were seated on a space available basis. She laughs robustly as she recalls, "And when we got to El Paso they mixed it in with the white people, everybody mixed in together. And my seat was in between two white sailors—between two white sailors!"

Willie had arranged for her to board with his sister in Oakland until he could get enough time off to take her to Reno to get married:

And so I stayed there and when the ten days was up he wrote me a letter and said you be ready cause we gonna be married. And I said well that's okay. We went to Reno, Nevada. We took the bus up there, and I was glad we did. I had never been up there before. Then we decided after we got married that we'd come home [to Louisiana] one year and then the next year we'd go up to Reno. And every time we'd go up there we'd see the show, we'd see Dean Martin and Sammy Davis—all of them and Frank Sinatra. And so we did and that was the tenth of March and I had left [Louisiana] on the fourteenth of February. After that we just had no more problems. Every day been Sunday since with us since then.

The combination of married life and a setting less dominated by racial inequality agreed with the Riverses. Louisiana's substandard black schools were one of the reasons why Willie and Jeanette had been willing to leave their homes in the first place. In the 1930s and 1940s nonhumid days in Louisiana were more common than educational access for blacks. There was no high school nearby for blacks to attend, so both Willie and Jeanette had to make do with sixth-grade educations. In the culture of their youth, blacks were expected to go to work in the fields or in domestic service. Marriage in mid-to-late teen years wasn't uncommon. Willie eventually enrolled in a night school that brought him up to an eighth-grade level. Jeanette had performed domestic work in Zachary, and she found similar but at least better-paying jobs in Oakland and Richmond. She sent much of her earnings home to contribute to the support of her children, who had moved in with her own parents.

Following an occupational track familiar to many poorly educated African American men of his generation, Willie Rivers exchanged his military uniform for one of the United States Postal Service. Despite his inauspicious academic beginnings, he rose through the ranks and retired at a high salary. He had a superb memory and never had any problems with the standardized tests necessary for promotion at the postal service. Mrs. Rivers recalls with pride, "My husband was a supervisor then and he had about forty-seven people working under him then and about thirty of them were ladies."

But in spite of their success in California and their dissatisfaction with the South's racism, Willie and Jeanette preferred rural living and really did want to be near their families. Their biannual trips to Reno for stage shows notwithstanding, they were never meant to be city people. Self-sufficiency was a

high priority for the Riverses. Growing up where sharecropping was the norm, they'd seen their families and neighbors fall into deeper debt with each passing year. Willie's family had a bit more financial stability than Jeanette's, but money had been a persistent worry for them. To Willie and Jeanette Rivers, success equaled a debt-free existence. Within four years of marrying, the Riverses put a down payment on a GI house in Richmond, California. At the end of a single decade, the postal employee and his janitor wife paid off the mortgage in full. Although owning a home was a priority, more mundane material things held no appeal for either of them. Jeanette Rivers continued to make her own clothes and to launder their clothes by hand in the bathtub and hang them outside on a clothesline. Their modest Richmond yard had room for a small garden where they could grow some fresh produce to eat and then can the surplus for the winter months.

The sixties proved to be a topsy-turvy time for them and for many other black Americans who had escaped the South to carve out better lives. The once-welcoming cities of the North became frightening as drug use and criminal activity proliferated. The South's white supremacists lost some of their grip, and home ownership, educational access, and viable occupational opportunities were now at least possible for hard-working blacks. Willie and Jeanette made up their minds to return to Zachary, the town they had abandoned in the early 1950s. In the late 1960s they bought three acres of uncleared land. Since they had always lived well within their means, their savings allowed them to retire in Zachary with enough money to clear their land and build a house. In fact, Mrs. Rivers states with obvious pride that their brand-new Zachary home was all paid for "three months before we moved in." Of course, she remembers that they moved in on "the twelfth of January in 19 and 73."

Growing cotton and butchering hogs was out of the question during the seventeen years they lived in California. But Mrs. Rivers did continue to garden and sew and quilt. Jeanette Barrow had been twelve years old when she pieced her first quilt using scrap fabric from three sources. She recalls:

> First quilt I pieced up, I never will forget that unless I die or go crazy. I was twelve years old. Miss Lou Green and Annie Adel Corn, they called me Teepee because I had that Indian [thick, straight] hair. Annie said, "Take Teepee these little quilt pieces, she's always fooling around with quilt pieces but Sally [Jeanette's mother] don't have enough to give her. Take these little scraps of

quilt pieces and see what she'll do with them." So Lou brought them and said, "I'm going to show you how to do it, because I know Sally ain't going to show you." My momma said, "That's all right with me, I wish all of them learn how to quilt." My momma quilted too but she didn't quilt fancy like I do. She couldn't do that quilt. I took this quilt. I was twelve years old. I went to work on it. Then cousin Nanny come and she said, "Teepee, you working on a quilt, you want some more quilt pieces?"

Mrs. Rivers goes on to say that her "mamma and daddy never owned no land" and had "fourteen head of children. Seven girls and seven boys and she raised them." For sharecroppers, material resources were so meager that even scrap fabric was valuable. The relentless rigors of sharecropping meant that her mother had neither the time to teach her nor even enough fabric left over for initial efforts. Even the tiniest pieces of fabric could not be spared for her daughters' experimentation. When young Jeanette tried to sneak a tiny piece of fabric, "She [mother] see'd that and whip[ped] my behind! I was making a quilt for my doll. They were cob dolls [made from corn cobs], we didn't have nothing else back then."

With guidance from Miss Lou Green and Annie Adel Corn, Jeanette Rivers learned how to quilt. Store-bought clothes were a luxury that the Barrows could not afford and one that Jeanette, who has worn clothes of her own making in all of my interviews with her, never coveted. Her quilts are usually made out of fabric scraps from her other sewing. She favors very bright colors and liberally mixes cottons, polyesters, silks, and corduroy. Her quilts are often comprised of rectangular or square blocks of fabric. Variations on nine patch patterns, such as the fence rail and tumbling blocks, appeal to her. She experimented with more organic shapes using half circles and triangles to form images of ice cream cones. She calls that design "Baskin-Robbins," and it's one of the quilts she most frequently makes to give as gifts or to sell.

WILLIE'S QUILT / JEANETTE'S MONTE CARLO

In the early 1980s, Willie was skimming a quilt history book that a friend had brought over to their home. He came across a boldly colored "Lone Star" quilt. Two aspects of the quilt appealed to him. The quilt in the book was a replica

of one that had been found on the dead body of a Civil War soldier. Himself an active veteran, Willie felt a kinship to the quilt and the soldier. He was also struck by the look of the quilt—especially by its bright colors. He asked Jeanette if she could make a replica.

I like to think that even if I had encountered a collection of Jeanette Rivers's quilts without her or anyone else to contextualize them, I'd have known there was a special story behind the making of this particular quilt. The center star is comprised of fourteen rows of fabric. From a design and execution perspective, the "Lone Star" quilt posed the most technically demanding challenges of any quilt she'd ever attempted. With eight radiating arms that must touch the border at equal distance from the center, the quilt is flawed if each piece of fabric isn't the right color and the correct size. Smaller replicas of the primary star are nestled in each of the four corners.

Before cutting any fabric or threading any needles, Jeanette Rivers knew that her husband had taken a liking to a quilt that stretched her abilities. And Willie himself must have known that this was more challenging for her. She starts the story by saying,

> He liked the quilt. He said, "I'll go. I'll buy everything you need." I said, "I don't want to do that, look at all of the little pieces! I don't want to do it." He looked at me and said, "You do a lot for me you don't want to do, won't you make that quilt for me?" I said, "I guess I'll try." I told him, "Yeah, but you got to buy the colors cause I don't have all of them colors." And we went to Wal-Mart out there and bought it. And it took me about three months cause see I was here [in Louisiana] then. When I started, when I got this [one of eight arms of the] star here about halfway done, it stretched from the bathroom to the bed. I had to take every speck of it loose and cut it down. It took me three days to practice. He said, "Don't give up. I like it. I'll help you." I said, "You can't help me do a thing but give me more work to do. Shut up."

She couldn't say "shut up" with a straight face to us, and I doubt that her face was serious when she said it to Willie. Twenty-plus years after the quilt's completion, she cherishes it still. She wants us to know how much it means to her that she stretched her quilt-making abilities and she did it for Willie.

To Mrs. Rivers the right way to show us a quilt is by making a bed with it. As she takes a newer one off her bed and places Willie's quilt on it, her comments on the quilt and on Willie are woven together:

Now this is the quilt. I want you to follow it and see how near I made it. This is what I really want you to see, how I made it. You can see how much it looks like the one in the book. You talk about a blessed man. I had a good husband. If he got mad about anything, he'd say a few things and then he'd shut up about it and not say any more. He'd be silent for a while. And then I'd say, "What are you so silent about?" He'd say, "We need to talk." And then he would talk sense then. What he was doing was he was conning me. I agreed with everything he did. I didn't have sense enough to disagree. I just could never get a squawk with him, no kind of way. If I asked for the sky he'd try to get it for me. "You don't ask for nothing you don't want," that's what he'd tell me.

With the photo from the book containing the model for her "Lone Star" quilt as a reference point and the quilt itself on the bed she shared with Willie, she walks us through a description of the quilt:

Now you look at the book and look at that. See here [the center of the star] starts with the red. Then comes the yellow. Then comes this powder blue, I call it. Then comes the red. Then the white. Then the black. When I got here, he thought it was beige, and I thought it was peach. And I went and found this in-between material [a light tan] and we settled with that. If you look at it, it looks right. And if you look here, I made these four little stars that are set on each corner. I made these just like the others. And that's his pride and joy, he loves that; I made it for him, and he loves that.

Soon after completing the quilt, Mrs. Rivers tested Willie's affection for it. A bit tired of their old truck, she decided it was time for a new car. At the local Chevrolet dealer, "all I saw was that Monte Carlo." When Willie blanched at the cost of an upscale coupe, she nonchalantly told him not to worry if he didn't want to spend the money—given the number of compliments she'd earned from making the "Lone Star" quilt, she was sure she could sell it and earn enough money for a down payment on the twelve-thousand-dollar car. The good-natured threat prompted him to go down to the car dealer with his checkbook at the ready. Still averse to accumulating any unnecessary debt, he signed the note on the brand-new car and paid it off in three installments within three months. As of this writing, the 1981 Monte Carlo is in good shape and is still Mrs. Rivers's primary mode of transportation.

I asked Mrs. Rivers if she really would have sold the quilt that meant so much to her husband. She laughed and said she knew that she'd never really have to do that. Willie had always given her everything she wanted because her wants were generally quite simple and easy to satisfy. Sitting and smiling to himself while she recounted the story, Willie confirmed his belief that her threat was an idle one, saying, "We play all the time. You two ladies don't ever get old. When you get old, you get cranky. You stay young!"

Before we departed from our first interview, Mrs. Rivers reviewed the course of an average day and in doing so further attested to the strength of their relationship:

> After I get through with everything I sit down and I read my verse of the Bible. I told my husband, he goes to bed at 10:30, I told him I was going to sit here and read my verse of the Bible. I was going to read two but on my way to reading this one I kept going to sleep. We get up at 5:30 in the morning; he gets up at 5:30 and I get up at 5:30. At a quarter of 6:00 or ten minutes to 6:00 he sits right there and he been doing that for the twenty-five years he been home and eats his breakfast. He's been doing that for the twenty-five years he been home. For 12:00 or a quarter of 12:00, he's coming in to eat his dinner. At night at 6:00 he comes back and he'll eat some supper. Now, he doesn't eat any sandwiches or nothing like that. He eats a balanced meal. We kind of health freaks. I see that he have balanced meals every day of his life. He eats the right stuff. He keeps pretty well, he has high blood pressure and is a diabetic, but you don't know it. A diabetic is something like an allergy if you works. But mine [Willie] is busy doing something all day long, he's going from one thing to another. Two people like me and him. We've always worked together. He might say, "Jeanette, I'm not going to do that." I say, "Then what you going to do then?" We'll meet one another halfway. When we leave off, we're laughing. You can hear me and him laughing all the way over to the cellar. He makes everything a joke. We been married forty-five years and every day been Sunday with us since the day we married. Every day been Sunday since.

Jeanette Rivers tackled the "Lone Star" quilt the same way she tackled other aspects of her life. After only six weeks of dating Willie Rivers, she sensed that they shared similar values and that he would make good on his promise to give her a better life. Leaving her whole family behind to relocate to California had intimidated her at first, but she gamely boarded the segregated train and made

her way west. She was right about Willie. He followed through on his commitments and together they learned how to achieve a good life in an urban environment. When Willie took a fancy to the pictured quilt found with the dead soldier, she decided to try to give Willie what he wanted. His own military service had served as their portal to personal prosperity. But she was apprehensive about making the "Lone Star." The geometry of constructing a star out of fabric made her nervous, but she kept at it until she got it right. She'd learned a long time ago that much was to be gained by trying, and that Willie would stand by her as she stretched herself. Jeanette Rivers is very proud of the quilt she made for Willie and very proud of the life she made with him.

CONCLUSION

When I called Mrs. Rivers to arrange another visit in late 2003, she told me that Willie had passed, that he'd had a "cardiac unrest." I had a hard time picturing their home and small farm without him and couldn't imagine how she filled her days and nights alone. It hasn't been easy for her. She is the last survivor of Frank and Sally Barrow's fourteen children. Although her own son and daughter from her first marriage usually say that they preferred life in Louisiana with their friends and cousins and wouldn't have wanted to grow up in California, some tension does surface in their relationships. In Mrs. Rivers's church it is customary to take pictures of family members with the deceased in an open casket. Although she attended her stepfather's funeral, Mrs. Rivers's daughter refused to stand next to her mother and her own children in the picture.

Yet Mrs. Rivers still punctuates nearly every conversation with a funny story or a joke. She still follows an ambitious schedule, and starts her day doing the military calisthenics she and Willie used to do together. In the spring after he died she planted tomatoes, string beans, mustard greens, butter beans, and okra. Her cabinets are filled with canned vegetables, and her freezer is stocked with butchered meat. The Christmas after Willie died, she made thirty-four large fruitcakes and seventeen smaller ones. Commenting on how she copes with the loneliness she says, "I don't know what I would have done without quilting when my husband died. I made eight quilts since he passed."

Before he died Willie began to worry about the aging members of the local American Legion. They didn't have their own lodge, and he couldn't see how they'd ever get the resources to secure one. He told Jeanette that he

wanted to do something for them. After weighing the options, Willie agreed with Jeanette's advice to lease them a portion of their three acres of land for a post—ninety-nine years for one dollar per year. Together, they went to a lawyer and had their wills drawn up to reflect that legacy. Expecting that he would die before her, Willie asked her to see to it that the legion got a post, and that dream has become her life's work. The land had to be fully cleared and graded. She found a used portable building, negotiated a good price for it, and had it moved to the property. A fence had to be put up and driveways made. With other women connected to the veterans, she's made a red, white, and blue quilt to hang on one of the building's walls. The members of the post paid her the ninety-nine dollars in one payment. She took it to the store and bought ninety-nine silk flowers.

The day Willie died started out the same as all of their others. They were out in the backyard and his leg gave out on him:

I went over to him and said, "What's the matter?" He said, "I can't seem to put any weight on my leg. I can't walk." "You can walk," I said. "I'll help you." I got him up and he made it to the kitchen. Then he fell down again. I got him up and propped him against me and we made it into the living room and he fell in front of the fireplace. I said to him to stay there, I was going to just go to the phone to call the paramedics. He said. "I won't leave here." I went to the other room to call the paramedics. That was it. He was gone. Just like that. He really didn't suffer none. And I am so thankful for that.

People ask me from the legion and all how come I didn't cry. We gave him a real nice funeral and all. I just say I can't cry because he didn't suffer. He wouldn't want me to cry. We made a pact early on that whichever one of us was left would continue marching forward like a soldier without weeping nor looking back because when God calls you home you must go. I did not shed one tear for him.

Chapter Two

FAR FROM HOME ECONOMICS: DAISY ANDERSON MOORE

No delicate hand-painted flowered teacups and matching saucers are nestled in Daisy Anderson Moore's china cabinet. The impressive piece of oak furniture hugs a wall close to the front door of her spacious Louisiana home. Instead of showing off fine heirloom candlesticks, ornate gravy boats, or imported crystal goblets, the china cabinet is used by this tall, trim, toffee-complected octogenarian to display and protect precious paper artifacts close to her heart and mind. Dozens of recently published books and numerous framed family photographs crowd the open shelves at the top. Dust doesn't accumulate because Mrs. Moore routinely replaces her older Toni Morrison or Maya Angelou titles with the writers' most recent publications and updates photographs of her grandchildren with more recently taken snapshots. The doors of the lower portion of the cabinet protect older photo albums, scrapbooks, and similar family ephemera.

Although she doesn't collect flowered china, there are flowers in Mrs. Moore's environs, in her meticulously tended garden and on her exquisitely crafted quilts and pillows. But the twenty-plus story quilts that Mrs. Moore has made since the early 1980s don't fit in this cabinet; they are preserved elsewhere. She's given several to her children, grandchildren, and church. Her personal collection of quilts is folded neatly and stored in the back bedrooms—except one that hangs prominently on a living room wall. Mrs. Moore's home includes several conversation areas where comfortable sofas and chairs, bookcases, and a cherished piano hold treasures similar to those in the china cabinet. The books, the pictures, the quilts, and the piano tell the story of Mrs. Moore, her siblings, her children, her grandchildren, and the ancestors whose rich history means so much to them all.

BACKGROUND

Young Daisy Anderson inherited her mother's affinity for math and physics. She learned to quilt on her own. Married in 1909, her parents, Lucinda and Charlie Anderson, were determined that their eight children would have access to the best possible educational opportunities allowed in the Jim Crow South. As children of slaves in rural Texas, Lucinda and Charlie methodically confronted the social, economic, and educational hurdles imposed by the southern power structure. Lucinda Barnett Anderson did make quilts occasionally, but her personal sewing time was consumed by outfitting Daisy and her five sisters and two brothers for church and school. Her reputation as a seamstress allowed her to work in her home, taking in sewing for clients. Charlie first considered a career as a teacher, but eventually pursued a more secure and lucrative position as a railway mail clerk. Music permeated their home as Lucinda taught music fundamentals to all of her children.

Daisy and her siblings were as ambitious as their hard-working parents. Daisy's fondness and aptitude for the sciences led her to contemplate a career as a medical doctor. She enrolled in college and enjoyed a demanding science curriculum. But the tuition and ancillary costs of medical school were beyond her father's financial reach. So instead of pursuing medicine, she completed an undergraduate degree at Wiley College, a traditional black institution nicely documented in the 2007 film *The Great Debaters*, and became a high school science teacher. Her mother and father clearly instilled in her an abiding reverence for formal education, and she raised her own children in an academic environment enriched by books and music.

Even when Daisy was a child, her interest in science and math was balanced by a talent for and interest in the kind of domestic pursuits more typical of young southern girls. Daisy, like so many others who eventually take to quilting, loved to design and sew fashions for her beloved homemade dolls. While she didn't actually learn to quilt as a child, she fulfilled a rigorous curricular regimen that included the fundamental skills required for quilt making:

> When I came along in high school I took sewing and cooking and homemaking. Not "family living," as it is now. I never will forget we had a notebook and we had to make every kind of stitch you could make. When I came along in homemaking, I had the basics. Quilting is really just making straight stitches going through three layers as small as you can make them. Years ago the women

took pride in so many stitches you could get in an inch. If you sewed an inch, you try to make fifteen to twenty stitches in an inch. I have never been able to perfect that much but you strive for that. You strive to make your stitches as small as you can make them. You strive to make your work neat. And then you have to measure.

Twice widowed, Mrs. Moore has had forays into quilting that coincide with significant milestones in her professional and family life. The first time she took up quilting she was a young wife and mother. Her husband was stationed overseas, fighting in World War II. With him in combat and in constant danger, she was desperate to find activities to occupy her hands and thoughts during evenings and on weekends. Fortunately, a girlfriend's mother recognized her need for distractions and gently prodded her into taking up quilting. Mrs. Moore recalls:

She encouraged me to make my first top of a quilt and I haven't quilted that quilt yet! She said, "Why are you sitting around here? You need to make a quilt." So, I would go up to her house. I was lonesome. I did make this top and I *cherish* that top because I used the scraps from my mother's scrap bag, and I can reflect on the scraps being from dresses that she made us when we were girls. Why I kept that so long, they were her scraps from sewing. I did make that quilt top. I don't know, I better hurry up and finish it [make a completed quilt]. I'm not getting any younger.

When her husband returned safely from the war, she put quilt making aside for a while and turned her attention to her growing family and her work as a teacher. But when, within a couple of years, he died in a tragic accident, Mrs. Moore grappled with the loss in a number of healthy ways, including taking an advanced summer science curriculum for teachers at UC–Berkeley. She then married her second husband, who shared her values and soon acquired his Ph.D. in philosophy from Ohio State. They had more children and moved around throughout the South until he found a suitable long-term academic position. As the children left to attend college and to marry, leaving her and her second husband as empty nesters, she resumed her quilting.

Since she was an adept seamstress, it wasn't difficult for her to hone her quilting skills. An inveterate bibliophile, she sought guidance from the relevant literature. In her words: "I'm a person who loves books. Look like, anything

I am going to get into, I really go wild with the books. I need to cull some of them out. I bought a book *How to Quilt* and *A Quilting Primer* and I taught myself. I follow instructions pretty well."

THE QUILTS: CELEBRATIONS OF FAMILY

Once she started to quilt seriously, she embraced the rediscovered pastime with determination and vigor. Mrs. Moore wants each of her quilts to be *about* something, to tell a story. Fully capable of making strip or block quilts, she rarely composes a quilt solely in this fashion. Appliqué—a technique allowing her to cut her fabric into unique shapes—lends itself to her story-telling impulses. Most of her quilts reflect her penchant for appliqué.

Exploring Mrs. Moore's quilts with her is akin to reading a family history book containing a well-illustrated story about her and her family's remarkable educational accomplishments. Only her book is a three-dimensional one composed of fabric. Commenting on her preferred topics for quilts she says, "Most of my quilts that I make, they usually depict something that I want to leave as something about my life." One of the first quilts she will show a visitor depicts her family tree. The quilt is anchored by a large brown tree and contains red apples and green leaves all etched with names of family members. The value she places on this quilt is evident when she acknowledges that she purchased fabric for it rather than rely on the considerable box of leftover scraps from dresses she made for her daughters.

Family and education are recurring themes in her quilts. Several decades after she graduated from college she purchased yards of salmon pink and apple green fabrics, the trademark colors of her Alpha Kappa Alpha (AKA) sorority. She notes: "I have four sisters that are AKA and fourteen nieces that are AKA. I put the emblem in the center. Then I put little ivy leaves all around the edge. And then I put the names of all of the members of the family that were AKAs in the leaves."

Strong bonds link the members of this venerable African American sorority, founded at Howard University in 1908 and incorporated in 1913. For young African American college women, the sorority offered a resilient social safety net for students with similar social, educational, and cultural aspirations. Charlie Anderson prioritized sending his children to college above his own desires and needs. He had carefully provided the money needed for tuition,

room, and board. Lucinda had sewn enviable college wardrobes for each of their daughters. But Mary and Charlie Maxine, Mrs. Moore's two older sisters, wanted to pledge the AKA sorority; they wanted to belong to an organization devoted to smart, young black women. In order to pay the obligatory dues, they wrote home for money. Charlie Moore was puzzled by the unanticipated request and asked his wife what was the advantage to his daughters' future of joining a sorority. Lucinda Anderson's mother wit told her that it would be to their daughters' well-being to pledge. Since Charlie belonged to fraternal organizations dedicated to fostering beneficial relationships among upwardly mobile African American men, he was not unsympathetic to their pleas. Having made sure that they had tidy clothes to wear and the required books to study, Lucinda and Charlie decided to nurture their daughters' social inclinations as well. Having exhausted his resources on tuition, Charlie went to the bank and took out a loan to send his daughters money for the sorority dues. Eventually the daughters learned that their father had gone into debt so that they could participate in a sorority.

When Daisy was ready for college, her oldest sister, Mary, was already working and told her that if she joined AKA, she was not to ask their father for the money for dues. Mary would send the dues to support Daisy's initiation into the sisterhood. The Anderson sisters were well aware of the sacrifices their parents were making. The Anderson family subscribed to the tenet adhered to by so many black Americans in the early decades of the twentieth century: they were "lifting as they climbed." Charlie Anderson suppressed his own dreams. His children knew that he really wanted to buy a car. But their education, including nonnecessities such as sorority membership, always came first.

Just as her older sister extended herself, Daisy Anderson Moore has continued to support the dreams of those young women who have followed her. Mrs. Moore never directly boasts of the fact that so many of her female family members were able to get college educations in the Jim Crow South. She lets the AKA quilt stand as a testimony to her pride in their achievements.

For her family tree quilt, Mrs. Moore relied upon traditional appliqué techniques to design a prolific apple tree to represent her genealogical research and ivy leaves to chronicle the AKA sorors in her extended family. But by the late 1980s, she was ready to move beyond stitching a family member's name on an apple or an ivy leaf. She wanted her quilts to contain the actual reflections of her loved ones. Her desire for verisimilar images and her comfort with science and innovation led her to be an early adapter of new technologies in quilt

making, even though her first experiments had mixed success. Discussing her first attempt, she recalls,

And then I made another quilt that I call my memory quilt. And I have blocks in there that depict something that I enjoy, the subjects that were impressive to me from my childhood. . . . Well, I read where you can transfer your pictures to the cloth. I have a lot of my pictures on that plain white paper now. I have bought that transfer photocopy paper. After the photocopy company puts your image on the paper, you take your iron and you iron it on your material. I sent these pictures to a company I saw in one of my books in New York. It was my mother's picture, my father's picture, my grandmother's picture, and then a picture of my sisters and brothers. Well, those pictures are fading now. Well, I've been thinking, somehow I'm going to take those blocks out of there. They told me they wouldn't fade. They charged me nine dollars for each picture. I made that quilt ten years ago [circa 1987]. That quilt has never been in the sun. Then I can do it with this new method. I could just cut those blocks out and then try a new method to see if it's an improvement.

The fading of the first images did not deter Mrs. Moore. As the technologies improved, she sent her treasured family photos off once again and eventually replaced the faded photo images with fresher, sharper ones less likely to wear out.

Although Mrs. Moore preserves a respectable number of her quilts in her home, she has clearly given away more quilts than she has retained. Not surprisingly, family members have been the beneficiaries of her largess. She recites, "My daughter in Shreveport had three children, and I gave each one of them a quilt. And then my oldest daughter had one daughter and I gave her one. Then I made her little girl one, a baby quilt. I gave another little niece one. I like to make children's quilts. I made the Colonial Lady for my oldest grandchild. It was appliqué with a lady in a skirt and a bonnet. I have given away quite a few quilts."

The first time I visited Mrs. Moore in December of 1997 she graciously showed me every quilt she had in her personal collection. She answered all of my questions thoughtfully and permitted me to handle the quilts, so I could measure them and hold them up to see the stitches. To capture them in the best possible light, we took several to her backyard so that I could photograph them. In spite of her warmth and generosity, I sensed a melancholy as she re-

flected on the age of the quilts, and I realized that she wasn't sharing any that she had recently completed. When I asked her about quilts in progress, she acknowledged that her second husband's death had doused her fervor. While alive, he was an unabashed fan of her handiwork. Without his encouragement, she had lost her inspiration. Without his enthusiasm for watching her transform scraps of fabric into finished quilts, she lost her ambition. Her hands still gravitated towards the dirt in her garden, but rarely did she pick up a needle and thread. She summarizes this period in her quilt history by saying,

> I made more quilts then [before retirement in 1984] than I do now. I don't know why, maybe it was relaxing when I came home. But I tell you what, a lot of people say that they do work when they are depressed. I do work when I'm happy. Well, I lost my husband in '92 and my son, too. And look like I have gone through a period of five or six years of being very sad. And I can't get into quilting as much as I did when he was living because every time I'd make something I'd say [to him], "See this? Look what I made and I finished that." The Christmas before he died, and he died of a heart attack that January and was fixing to mow the lawn, and he died.

In 2003, however, Mrs. Moore wrote to tell me that two of her quilts had been selected for display at Southern University during Black History Month. A new quilt—one she had made since my last visit—was singled out for attention and the local newspaper selected it to accompany the story on the exhibit. Later that year I was able to travel again to Mrs. Moore's lovely home, and there I found her surrounded by new books, new photos, and several new quilts and pillows. She was also restoring quilts found in the home of an older relative. The "quilter's block" engendered by the death of her second husband had clearly abated, and she had once again taken to the thread. Just as books and the desire to document her family lured her into quilting in the first place, so, too, was it a book that served as a catalyst for her return to productive quilting.

THE ANDERSON UNDERGROUND RAILROAD QUILT

Mrs. Moore's return to quilting was fueled by the 1999 publication of *Hidden in Plain View: The Secret Story of Quilts and the Underground Railroad* by Jacqueline

L. Tobin and Raymond G. Dobard. Since its release, the book has received extensive publicity because of its provocative thesis that slaves and their allies had incorporated a code in the quilt designs that revealed the safest paths to freedom. Privy to the secret code, fugitive slaves could read the quilts hanging on fences and clotheslines as maps that guided them from south of the Mason-Dixon Line to the free states of the North and Canada. (Chapter fourteen of *Crafted Lives* offers an extensive overview of the controversies triggered by *Hidden in Plain View*.)

Still a voracious reader, Mrs. Moore discovered the book soon after its publication. To her the book was a moving reminder of the hardships faced by all African American slaves and the myriad ways they pursued liberation before and after the Emancipation Proclamation. She isn't aware of any of her own ancestors who successfully navigated the Underground Railroad, but she does know that as soon as emancipation came her forefathers and foremothers pursued self-sufficiency. Mrs. Moore read *Hidden in Plain View* and was inspired to quilt a celebration of the journeys to freedom undertaken by Underground Railroad participants as well as by her own ancestors.

Finished in 2002, the Underground Railroad quilt currently hangs on a prominent wall in Mrs. Moore's family room. It can be seen from her dining room table and the love seat where she often sits to hand sew new quilts. More so than any of her other quilts, "Underground Railroad" exemplifies her ability to align her own family's remarkable history with significant developments in black history. This quilt combines her passion for African American history, her tenacious attachment to her family, and her technical skill as a quilter.

The eighty-three-by-eighty-five-inch quilt contains a total of twenty blocks juxtaposed against a deep wine red and tan paisley cotton background. The eight squares that frame the quilt's sides are the blocks that Dobard and Tobin suggest were significant components of the code of Underground Railroad quilts. Shoefly, flying geese, sailboat, evening star, bear's paw, nine patch, drunkard's path, and basket are familiar patterns to many quilters. The center blocks are a wagon wheel and monkey wrench blocks. Again, both images were alleged to have had particular significance to nineteenth-century runaway slaves. To further individualize this quilt to her personal heritage, Mrs. Moore did not construct the prominent wagon wheel block in this quilt. Instead, she incorporated a vintage block from an unfinished quilt of a distant relative. Within the context of the modern quilt that she has crafted, there sits one block sewn by another black quilter from an earlier time.

The prominent top center square contains a photo transfer image, etched in thick gold-colored braid, of Harriet Tubman, easily the most well-known Underground Railroad conductor. The other ten blocks in the quilt are images of people and places important in Mrs. Moore's own family.

During my 2003 visit Mrs. Moore agreed to stand next to the quilt and talk about its components in much the same way a teacher would stand next to a chalkboard and walk her students through a series of lessons. Her most salient points as she traveled from block to block were these:

[Block One] They are my ancestors that were slaves. This is my paternal grandmother. She was a slave. She was what you call a house slave. She read and wrote very well. She belonged to a Captain Allen. He taught her to read and write in a boy's military school in Virginia. She was quite literate. [Block Two] That's my dad. At that time, you know, schoolteachers could have taught school with a little learning after they had finished high school. But the salary wasn't sufficient. He went out to California for a while. But the only thing he could do out there was shine shoes. He came back to Texas. He saw an ad in a paper where you could be a railway mail clerk if you studied and went down to take an examination in Houston at that time. And he did. So he was a railway mail clerk for thirty-seven years. He sent eight of his children to college. Which at that time, in the thirties, that was remarkable. At that time that was a good salary, my dad was making two hundred dollars a month with a government job. Schoolteachers were making sixty dollars, fifty dollars. [Block Three] This was his uncle. I have a letter his uncle wrote to him. That's Dr. Charlie Harris. He was my father's mother's brother. I don't know whether he bought his freedom. But he went to medical school. After slavery he opened a sanatorium in Texas. I have a letter that my dad wrote my mother and it's dated 1905. That's after they finished high school. And he was telling her that his Uncle Charlie wanted him to go to Meharry Medical College to be a doctor. He said to her, "I know you don't want to wait four years until I come back." They didn't get married until 1909. He didn't go to medical school. They did get married. [Block Four] This is his father, it's such an old picture. And he's pushing some mules and a plow. He was a blacksmith. . . . [Block Five] I put Harriet Tubman's picture on because I made this at the time they were having a celebration of her birthday in Ohio. And I heard from a lady saying to send a quilt to her. I wasn't quite through with it so I didn't get it there on time. Southern [University, a historically black university based in

Baton Rouge] had it up there last year for Black History Month. They had a quilt show. [Block Six] Over here, that is one of my daddy's aunts, right there. I didn't know her either, but I had heard my parents talk about her. [Block Seven] That's my mother. She was Lucinda Barnett Anderson. She and my dad knew each other from elementary school. And they stayed in school because they had older sisters and brothers. Usually, back in those days, they had to stop and work. But my mother and father finished eleven grades. That was unusual for small towns. I saw that school one time when I was a little girl. The abolitionists came down to Bastrop, Texas. They built this two-story frame school. They called it Emile High School. . . . That's where they went to school. [Block Eight] That was her mother. She was a younger sister. Her mother was fifteen years old when the slaves were freed. I knew her, she didn't die until '36. She was almost a hundred years old. She had a very mean master. When he told them to get off the plantation before sundown, she put her little sister Frances on her back and walked down the road. A friendly white guy asked her if she wanted to work and she started to cook. I don't have a picture of my daddy's daddy. He was a mulatto, light-skinned man. He ran the ferry across the Colorado River. She always was industrious and played the piano real well. And all of us she taught beginning music. Her brother was going to send her to Prairie View. I remember there was an old brown trunk in our house on the back porch when I was growing up. He was a carpenter, and he was injured. She stayed home and sewed. In 1909 she and my dad married. My mother read a lot. My mother always took the *Ladies' Home Journal*. My daddy had to read a lot. He would pull slips. He would attach those slips on the train to the bags of mail he was going to drop off at certain stops. The mail trucks would pull up to the train. He always had to wear a pistol. That was to guard the mail car. My mother died at sixty-one, my dad died at sixty-nine. He retired the year she died. They were married thirty-seven years. [Block Nine] That's her mother up there, Amelia Barnett. She lived until she was in her nineties. My dad had eight children. He sent all of us to college. My oldest brother was a medical doctor. He taught science at Wiley College, a Methodist school that was close by. He finished college in 1932. My second sister is ninety-one, and she's in Texas. She taught over forty years. She taught elementary school. My next sister is eighty-nine and she's in Los Angeles. I have three sisters in LA. They went out there in the fifties. She taught reading. I had a brother between me and the twins. My brother taught school for awhile. He went into service in WWII. He got in the OCS program.

Mrs. Moore finishes her documentation of the quilt with a roll call of the eight children of Lucinda and Charlie—the survivors range in age from their late seventies to early nineties. Several of them were lifelong professional educators. To her, they have fulfilled all of their parents' dreams as well as those of the Harriet Tubmans of black history.

Several scholars have dismissed *Hidden in Plain View* as inadequate for increasing our understanding of how the Underground Railroad operated. But the publication of the book served a profound purpose in the world of Mrs. Daisy Anderson Moore and the family members and friends who are so enthralled by her quilts. In that it prompted her to resume making quilts, the book served a positive function. The book was a celebration of black history and a particularly inspirational stage of black history. It focused on the power of quilts. A maker of story quilts, Mrs. Moore wanted to make a quilt that could celebrate black history in general and the history of her own family in particular. In the fabric of a single quilt she sought to document them both.

A BOOK OF QUILTS

The loneliness and fear induced by having her first husband in combat drove Mrs. Moore to take the scraps of her childhood clothing and make them into a quilt top. With her mother's discarded dress fabric, she began a volume of quilts that would tell the story of her family's life. When her husband returned and their family grew, she devoted herself to the hard work of raising her children and working as a high school science teacher. Noting the difference between her vocation and her avocation she says, "Everybody usually ask me, you must like home economics. I was as far from home economics as you could be when I taught. I taught physics and chemistry for thirty-two years."

It was towards the end of this teaching career that she began to devote so much of her free time to making quilts. But about ten years after she resumed quilting, she temporarily put it aside due to her second husband's death. Without her husband's support, the task of designing the quilt, assembling and purchasing the fabrics, and measuring, cutting, and hand sewing a quilt temporarily overwhelmed her. Charlie and Lucinda's daughter relied on other creative interests to enhance her life's purpose. She found solace in her garden and in her music. Watching her children assume adult responsibilities and raise her grandchildren, she witnessed the realization of many of her parents' deferred

dreams. She let herself mourn. And then the opportunity to revisit a set of stories—those of the Underground Railroad—triggered in her the desire to add a chapter to the book of quilts she had begun with the top of her unfinished quilt pieced during World War II and the family tree quilt, the AKA quilt, and the others she followed up with in the 1980s and early 1990s.

The Underground Railroad quilt is not the final chapter. In a spring 2004 interview, eighty-seven-year-old Daisy Anderson Moore sat in her rocking chair with a hoop on her lap and told me, "I have so much that I have to do." Some people write books to tell their family's stories. But to best understand the story of the Andersons and the Moores, you have to be able to read the quilts.

RESTORING THE SOUL:
ELLIOTT CHAMBERS

Commenting on how comfortable he feels sitting behind the vintage black sewing machine he had inherited from his Alabama-born grandfather, retired Ph.D.-holding college administrator Elliott R. Chambers slyly observes, "Some people have wives to beat up. I don't have a wife. Some people have dogs and cats to kick; I don't have either. But I have a sewing machine, and I can sew." It is hard to imagine a scenario in which the soft-spoken, well-groomed gentleman would harm a wife, a companion animal, or any other living thing. Elliot Chambers's life has never focused on damage and destruction, but rather on construction and restoration. Chambers's present multicolored business card identifies him as a quilt maker specializing in restoration, but this is just one of the enterprises he has pursued that reflects his predisposition to work creatively with materials that others might have ignored, overlooked, or discarded.

Chambers is a goal-oriented person, but he did not make his first quilt because he needed a bedcovering. That first quilt had indeed been constructed as a means to an end, but the goal he then had in mind was the warm heart of a fetching young coed, Mildred Clarice Hudson. After graduating from Central High School in Mobile in 1949, Chambers had done a stint in the military. He then enrolled in the local community college, where the much-sought-after Mildred caught his eye. Wanting to set himself apart from the competition, he knew that the conventional modes of male athletic posturing were unlikely to work for him. His short stature and his lack of experience as a high school athlete meant that other suitors would fare better in the competitive arena of college sports. Besides, he reasons, "If you win a race, the race is over and

that's it. I wanted something that would last." The "something" was a quilt. To capture Mildred's attention in a way no other suitor could, he made a quilt with red satin on one side and blue satin on the other and presented it to her. "She liked it very much apparently," he reflects, "because we were married for over forty years."

During those forty years, the Chambers couple pursued additional educational degrees, migrated from Alabama to California, raised a family, and served as dedicated members of their church. This didn't leave much time for quilting, and Chambers did not miss it, because "I had no interest in making quilts. I was only trying to impress my wife." But in the late 1990s, Chambers found himself gravitating towards his grandfather's sewing machine. Stacks of fabric and spools of thread began to appear in his recreation room, and when his pals came over to play pool, they often had to maneuver around sewing paraphernalia in order to use the pool table. Chambers was now a married quilt maker.

BACKGROUND

Born in 1933 in Mobile, Alabama, Elliott Rogers Chambers is from a family of ten children, five girls and five boys. During his childhood, he was exposed to quilting by his mother, but he inherited his sewing machine, one he still uses today, from his grandfather. As he describes the role quilt making played in his parents' household, his story echoes many others concerning the ubiquity of utilitarian quilt making in the South:

> My mother quilted. All African American women quilted, because they wanted to keep their children warm during the winter. That was the primary reason that quilts were made. It was very fashionable; when a girl would marry, all of the women in her mother's circle would make quilts for her to start her trousseau. As young men married, their parents gave them quilts so they can stay warm. There was very little fashion in it. We maintained the quilts for warmth. The houses in that period did not have insulation. You could hear the winds blowing through the walls. You could sometimes look up at the ceilings and see the sky. It would leak when it rained, so we needed the quilts to keep warm.

Chambers's mother did not insist that her offspring learn to quilt. Indeed, Dr. Chambers claims that none of his five sisters became an able quilter. How-

ever, Chambers's family had a small mattress-making company, and from the age of twelve, he worked in the family business. He explains, "[Mattress making] involves sewing, putting pads between two covers. That's the same concept quilts are based on." Thus it was several years of mattress-making experience that Chambers drew upon in the making of Mildred's first quilt.

Although his family managed to have a small business, he was not shielded from the limitations imposed by 1940s Alabama. His six-room home in Mobile did not have electricity, and for light, "We had a[n] [oil] lamp. I must say we had two lamps; we had a six-room house. When an adult went from one room to the other, they took a lamp with them. If you were a youngster, you were in the dark looking at each other." Just as the black neighborhoods did not have electricity, his all-black school was deprived of the standard equipment allotted to its white counterparts: "I recall vividly in our chemistry lab we had three microscopes. But the white high school had microscopes for every one of its students." Chambers's recollections also include affirmative ones about members of the white Alabama community: "The [white] chemistry instructor lent our [black] instructor two microscopes. I was very grateful to him for that." Chambers was an excellent student and graduated from Central High at the age of fifteen.

From high school Chambers signed up for the military, where his travels included a brief sojourn in northern Africa. Using the benefits from the GI bill, he then pursued higher education at a Mobile junior college, followed by two years at Alabama State. Never afraid of hard work, following graduation he both bought a half interest in his grandfather's mattress-making business and took a job with the federal government, working for the army depot.

But opportunities for blacks beyond the Black Belt of Alabama beckoned. He welcomed the opportunity to transfer to northern California in 1965. After four more years in his government job, he explains, "I saw the opportunity to expand my education as well as to make a contribution in education. I started teaching at the community college. My wife was already a teacher in Alabama. She transferred from the Alabama teaching system to the California teaching system. In addition to that, we became more congruent when we both taught, we had a lot more in common."

Mildred Chambers loved teaching and working with young people, and Elliott Chambers took to it with shared passion. When he walked up to the blackboards at San Joaquin Delta Community College, he knew he had found his life's work. After finishing an MA degree from Sacramento State, he pursued

and finished a Ph.D. With these advanced degrees on his curriculum vitae, Dr. Chambers was qualified for more advanced instructional and administrative positions at San Joaquin Delta Community College. He taught African American history and computer science, and he was the administrator for the ethnic studies division, for the affirmative action and student recruitment programs, and for the Educational Opportunity Program (EOP). He sums up his attitude toward the career he fashioned by noting, "I couldn't wait to get back to them [my students] every day." Even after his retirement in 1995, he has remained engaged in education: "I go back to schools to give talks during Black History Month. I talk to elementary school kids, because I think it's important for them to know that they can do if they only try. I use myself as an example to let them know that I was once where they are, many years ago."

In 1995 Chambers retired from his position at San Joaquin Delta Community College. Two years later he reluctantly resumed quilting. He recounts his transformation from a reluctant quilter to an enthusiastic one:

> My father passed away and we [Chambers and his son, Michael] were in Alabama clearing [his house] out. There were quilts there; they were old and musty. And my intention was to get rid of them—call Goodwill or Salvation Army, have them take them away. But my son says, "No, Dad, I want the quilts." He lives in Los Angeles. I said, "Just take them on." I thought that was the end of it. But before long, he brought a quilt down to me, asked me if I would sew up a few holes in it. I did. And guess what?! About a month later he brought the next one down. Asked me to sew up a few holes in it. I didn't realize then, but I was restoring quilts. That's what I do now. I restore many quilts. After I began to restore quilts, I got some enjoyment in it. Then I began to make quilts for myself. I was impressed with that. Then they asked me what I specialize in. I specialize in using African fabrics as one side of the restoration. And so from that time I've made, conservatively, one hundred quilts.

MAN-MADE QUILTS

Chambers is the only member of his family to have pursued quilting. Although his mother and grandmother quilted, none of his five sisters has shown any sustained interest in making quilts. In fact, they send him the quilt tops and pieces they inherited so that he will repair and finish them. Quilt scholars have

long observed that African American males have participated in quilting much more than their white counterparts. Chambers's life and his forays into quilt making shed light on the reasons why some African American men come to embrace quilt making.

Since his family had a mattress company, he was also accustomed to seeing his grandfather and other males sewing. Upon entering adolescence, young men and women in his family were expected to participate in the family business. But even African American men whose exposure to sewing was limited to domestic spheres often embraced quilt making and needlework. Carter B. Woodson, often known as the father of black history, was a skilled needleworker. Quilt scholar Roland Freeman documented other black male quilters and is himself an accomplished quilter. Within the black community, these domestic occupations are not as "feminized" as they can be in the mainstream community. Ex-slaves interviewed by the Works Progress Administration recalled that task-oriented parties such as quiltings and corn huskings were popular social gatherings at which young black men and women could meet. Although black women were more likely to be charged with the making of the family quilts, there were no cultural reasons to discourage a young male who showed any interest and talent for making quilts. Chambers did not worry that quilt making would in any way "sissify" him in Mildred's eyes. He had a hunch that Mildred would see that a man who made her a quilt was good husband material, and would cast aside other suitors. He was right.

MILDRED'S SECOND QUILT

The year 1997 was a difficult one for Chambers. In addition to cleaning out his late father's possessions, his beloved Mildred, in words familiar within the black community, passed. Just as he had to go through his father's Alabama home to select what to keep, donate, or discard, he had to mine Mildred's possessions as well. After giving many of her clothes away, he was left with several significant ensembles.

Unable to part with her more treasured clothes, Chambers "took many of her clothes and made quilts for my [three] boys and me and my wife's good friends." The quilt he made for himself hangs on a wall adjacent to the stair landing in their spacious northern California home. Describing how he selected the clothes for the quilt, he points to the quilt blocks as he details,

"Some of them are her favorites, and some of them are mine. I gave many of her clothes away. But I didn't want to give these away. This was the last dress that I bought her—she was ill. She needed a dress. So I went with her. And I told her that I liked that one, and she did too, so we bought that one. This was a formal dress, and she wore it to many functions—this was a suit, a two-piece suit, and this was a suit as well—and the others were dresses that she wore— the border was a house dress—this backing is an African print."

Mildred Hudson Chambers had good but eclectic taste in clothes. The "last dress" is a deep blue, gold, and burgundy paisley print that would have been suitable for church or social occasions. It's the kind of fabric that never really goes out of style. In fact, Dr. Chambers was wearing a similar paisley tie on the afternoon when he gave me my first overview of Mildred's second quilt. The suits that he described are conservative brown and gray wools with tasteful pinstripes and subdued checks. But he and his wife also had an appreciation for cheerful colors. Mildred had, as every woman should, a garment with pink polka dots, which Chambers sewed into his quilt. Other blocks, comprised of bright turquoise and fire-engine red synthetic fabrics with dashes of black, enliven the quilt as well. The "formal" dress described by Dr. Chambers is also a synthetic print that contains small, medium, and large pastel-colored daisies and tulips. The border, made from a mustard and white print housedress, is enhanced by the toffee-colored print African fabric he uses for the back.

The quilt's structure is a simple one often referred to as a "one patch." Dr. Chambers clearly designed it to fit the space in his stairwell, with five twelve-inch square blocks horizontally and nine twelve-inch square blocks vertically. Within the quilt, the forty-five blocks are not further arranged into four or six patch groupings. Dr. Chambers balances lights against darks, but his wife didn't choose her wardrobe with a symmetrical quilt in mind.

Mildred's quilt, like those that were often made by southern African Americans, is tacked. Hence, the three parts of the quilt—the brown, African-inspired back or bottom of the quilt, the filling, and the top—are held together by pieces of red yarn that Dr. Chambers has brought through the three layers and tied off at the corners. The largish size of the blocks allows the viewer to really see each block as fabric intended for clothing; thus the quilt in no way disguises that its material was intended for another purpose. Mildred's identity is clear in one block that denotes her identity as a member of the Delta Sigma Theta sorority. Another block made from one of her suits features a well-tailored pocket, and the corner of a dollar bill peeks out from it. Chambers explains that

when he went to cut down that garment, "A dollar was in her pocket. I left it in there. Many times kids come here, they want to take it. I say leave that dollar alone." In order to appease his young visitors, Dr. Chambers keeps a large jar of change not far from the quilt, and he encourages children to take a handful or two of the coins in exchange for leaving the currency in the quilt.

RESTORATION

His wife's untimely death coincided with Chambers's enchantment with quilting. Once his son had cajoled him into repairing the quilts found in his father's Alabama homestead, Dr. Chambers was hooked by the satisfaction that restoring or making a quilt provides him and by the delight that his new or repaired quilt work brings to its recipient. His restoration methodology does not conform to the standards that antique appraisers would value. Using one quilt as an example, he explains his approach with a lab teacher's precision. Pointing to a partially repaired quilt, he says,

> This is an example of a restoration project. Note we have cotton coming in and out. This [two adjoining blocks] is very frayed. Note the size of this quilt. It's roughly sixty-nine inches, and with the growth of people in today's society, being seven feet tall, this would not cover their feet. So I have restored a portion of this quilt by lengthening it as well as patching up some of the rough spots. There are several patches [new cotton blocks in complementary colors] here. Note that we did not interrupt the integrity of the quilt by putting patches on. So that if a person has a quilt that has had its best days, I can restore them and allow them their integrity. They can remember what their parents left them. Most of the earlier quilts had just a white muslin back. And again, maintaining the African motif, I like to put the African fabric on the reverse side. And that's what we have here. It has a completely different look on this side but we've maintained the integrity of the other side. I hate to see abused quilts, like this one. I just use it as one of my props to show what can be done with a bit of restoration.

Elliott Chambers takes old quilts that were once made for double beds and increases them to fit queen- or king-sized beds because the latter are more common in today's world. He attempts to match colors and fabric types when

he repairs the surface of a quilt, but he does not insist on vintage fabrics and threads. Quilts that once had flour sacks for backing are now affixed with bold African prints.

Chambers's approach to Mildred's second quilt—indeed, to all of the other quilts he has made since the late 1990s—reflects his worldview. As a youngster, Chambers had to grapple with the second-class citizenship imposed by the Jim Crow South. Yet he persevered and optimized the education that Central High School in Mobile offered. He doesn't denigrate his understaffed, underfunded, segregated high school. Speaking of his classmates he says, "They never had a reunion until I was there, until I was in Alabama one summer. And I suggested that we have one. I gave them the first contribution for a bank account. And we started having reunions as a result of that."

To further support reunions, Chambers also made a reunion quilt to be raffled. Since he had grown particularly fond of that one while making it, he made himself a duplicate. Even though he has retired from his position as an educator, he still accepts offers to interact with young people: "I work with students who, for the most part, are disadvantaged. They think they are disadvantaged. I tell them some of my stories, and they think their life is a picnic." Elliott Chambers wants them to learn what he seems to have understood from a very early age, that you take what you've been handed in life and convert it into something functional, something pleasurable. His beloved Mildred passed before they could enjoy all of the fruits of a long retirement together. He couldn't just give away her clothes; instead, he turned them into a patchwork tribute. Technically speaking, taking pieces of used clothing and converting them into a quilt is not a restoration project the way taking a worn quilt and repairing it is. Yet in the wise and nimble hands of Elliott Chambers, the clothes of Mildred Hudson Chambers were restored to their best advantage.

RITES OF PASSAGE:
ED JOHNETTA FOWLER MILLER

Reflecting on her parents' cautious approach to her early aspirations in Carolyn Mazloomi's *Spirits of the Cloth: Contemporary African-American Quilts*, Ed Johnetta Miller says, "I always had a longing to be an artist, but when I was going off to college, in the late 1960s, my parents said, 'It's hard enough for a young black woman to get along in life, and you want to be an artist? Are you for real?' So I put my dreams on the back burner and studied business administration. But after working in the business world, at a certain point I had to follow my heart and let the artist in me take over." The decision was a wise one: letting the artist in her take over has carried her far. Today, her much-admired textile art has been showcased at such premier venues as museums in New York City and Capetown, Africa, as well as at the Renwick Gallery of the Smithsonian Institution in Washington, D.C. Her artistic talents have been widely acknowledged. Yet amidst all the acclaim, both national and international, it is the 1994 opening reception for her one-woman show at the Wadsworth Atheneum in Hartford, Connecticut, that stands as a personally defining moment in her artistic life. For her, that moment celebrates the background story of a kind of personal rite of passage.

Since 1972, Hartford has been the geographic nucleus of Miller's artistic life. Although she travels extensively and has studied under artistic masters in hot Ghanian enclaves and near the beaches of Jamaica, the Bahamas, and Haiti, her home studio is in the less temperate climes of Hartford, and this is where she transforms thread, yarn, and fabric into the weavings and quilts that so colorfully adorn the walls of art in galleries, museums, hospitals, and private homes. At the same time, she is teacher, community activist, and curator

of her own small studio gallery. During Hartford's humid summers, she conducts classes and workshops where she passes on her skills and wisdom to aspiring artists in their teens. During Hartford's frosty winters, she turns her attention to senior artists finding their muses after a lifetime of less aesthetically satisfying pursuits. In 2003, when a former Hartford mayor decided to adorn his restaurant with very large framed black-and-white photographs, he called Miller and told her to expect his photographer. Hartford clearly is Ed Johnetta's home.

And Hartford also is home to one of the nation's first great museums, the stately Atheneum. Since 1842 the Atheneum has displayed the great arts of the world, and a one-person exhibit in this setting represents the epitome of artistic success. Thus, for Ed Johnetta Miller, the 1994 opening reception to her show would understandably have been a memorable event.

But it was more than the impressive location of this reception that imbued it with particular meaning for Miller. It was, quite simply, the fact that she was able to share the occasion with her parents. That night at the Atheneum, track lights zeroed in on their daughter's quilts. Formally attired patrons of the arts praised the creativity and skill of the Fowlers' daughter. Journalists sought out the Fowlers with questions such as: How old was she when started sewing? Did she always have such a bold sense of color?

Here at last, observing the many people eagerly crowding to meet the guest of honor, their daughter, and to view her much-heralded work, the Fowlers finally saw her as an artist—a very gifted African American woman who had defined the career she wanted and shaped it with the same care and invention she uses for her textile masterpieces.

Today, Miller shows no signs of resentment for her parents' early conviction that she should set aside her creative inclinations in favor of the business world. In Spartanburg, South Carolina, where her parents had been raised, opportunities for black women were limited. There had been no role models of black women who were able to support themselves through their artistic creativity. Following her father's World War II stint in the navy, the Fowlers relocated to Providence, Rhode Island, in order to raise their children in a less racist environment. Young Ed Johnetta (expecting a son, her parents had selected Edward John as a name) always loved the arts and contemplated the nearby world-renowned Rhode Island School of Design for college. Uneasy about what future an art degree would provide for a black woman, her parents convinced her to pursue a business degree. Ed Johnetta complied and found

aspects of the curriculum satisfying. Even then Ed Johnetta realized that she had been blessed with two loving parents who were able to provide her with access to a good education and that she had entered her adulthood with social, economic, and cultural advantages unavailable to many other young African American people of the 1960s. Now, years later, "following her heart" to become an artist had taken her down an unknown and potentially risky path. And that 1994 day, to have her parents enter Hartford's renowned Atheneum and witness their daughter as she was seen in the arts world brought deep fulfillment and pride on both sides.

QUILTS AS ART

Ed Johnetta Miller is easily the most well-known quilter profiled in this book. If success is equated with financial security and fame, she has certainly reaped more monetary rewards from her quilts than any of the others documented. Her work has enjoyed widespread national and international acclaim, and has been featured on television segments such as HGTV's *Modern Masters* series. She has been widely exhibited, and several of her quilts are featured in Carolyn Mazloomi's well-known *Spirits of the Cloth: Contemporary African-American Quilts*. Another of her quilts was featured prominently in the exhibit and catalogue that accompanied the Oakland Museum's Women of Taste exhibit, as well as Roland Freeman's seminal volume and exhibit, *A Communion of the Spirits: African-American Quilters, Preservers, and Their Stories*. But as will be discussed later, Miller herself would likely reject the notion that the income she can command from her art and the visibility she has achieved make her "successful."

Like many full-time textile artists, Miller begins the process at a different starting point from her counterparts who quilt in off-hours. The utilitarian quilters I have interviewed are very often motivated to finish a quilt so that someone who needs it can sleep under it. They are making their quilts during evenings and weekends. They begin the quilting process with purchased or recycled fabrics. Although Miller occasionally uses some mass-produced fabrics, she sometimes starts at an even earlier stage, with the threads and yarns for creating the cloth that will be used for the quilt. She experiments with dyes until she's created just the right palette. To get the tactile effects she wants, she embroiders, appliqués, weaves, tufts, and sews.

She constantly searches for new approaches. To master techniques and become facile with once-foreign materials, she frequently travels to another country to study and learn from another master artist. With each tradition she sets out to learn, she adds skills and indigenous resources to her artistic tool kit. She has apprenticed, for example, in several West African communities. There, in using the raw materials of African textiles, she must master the manipulation of bark, mud, gourds, wax, and clay. As a result, multiple hours can be invested in a quilt before she has even created the fabric from which she will construct it.

"RITES OF PASSAGE": THE QUILT (1996)

"Rites of Passage" (1996) is a 53-by-63.5-inch quilt that demonstrates many aspects of Miller's artistic acumen. Miller describes the inspiration in Mazloomi's *Spirits of the Cloth*: "While watching a rehearsal for the Sankofa-Kuumba African Dance Ensemble, I was enthralled by the colors of their costumes and the fluid movement of their bodies. I wanted to create a quilt for them to dance under, dance on, and embrace as they go through the 'rites of passage' into adulthood."

A wide spectrum of colors and a tableau of patterned materials conveying intense movement characterize the quilt. Miller anchors "Rites of Passage" with culturally symbolic African motifs. Bogolanfini, better known as mudcloth because of the soil-based dye used to produce its rich colors from the ponds near Bomana, Mali, is interspersed with adinkra-stamped cloth (Ashanti/Ghana) in thick, irregular strips that frame and foreground other design elements. The adinkra cloth contains symbols such as the bull's eye, the most valued symbol; the ram's head and windmill are also liberally used. Even though a lexicon of adinkra symbols would include several dozen distinct icons, Miller creates continuity by limiting herself to about three or four in this quilt. "Rites of Passage," like many of Miller's quilts, contains several clues to her first textile love, weaving. Miller went to Ghana to learn the techniques of weaving kente cloth, now popular in the United States, from West African craftsmen; the quilt features three significantly sized strips of kente cloth.

Although African aesthetics dominate this quilt, it is punctuated by several prominent examples of textile traditions from other cultures. The quilt's interior contains three zones, each juxtaposing the African with non-African motifs. A red and white mola, a woven fabric associated with Panamanian in-

digenous peoples, functions like a medallion in the center zone of the quilt. This mola's motif is very reminiscent of the flying geese pattern favored by many quilters. The center zone, as well as those on the right and left, features Hawaiian quilt motifs neighboring the African fabric. A bright orange-on-white "Breadfruit," probably the best known of Hawaiian quilt blocks, holds its own in a frame of mudcloth.

There are no genuinely large swatches of fabric in the quilt. This and the fact that Miller uses fabrics of varying degrees of thickness suggest that the actual sewing of this quilt was more complex than for a quilt with more closely allied fabrics. A few pieces of solid fabric are incorporated into the quilt. Upon close inspection, we can see that Miller has reserved her fancier stitches for these solids, thus allowing the intricately sewn thread to create texture.

By and large, Miller uses rectangular-shaped fabrics of varying dimensions throughout the quilt. However, there are four thin, jagged scraps of indigo fabric appliquéd on the quilt surrounding the central mola. Set against the multiple rectangles, these indigo pieces are the most essential to creating the sense of movement Miller was seeking in this quilt. They may be said to resemble the lithe bodies of the accomplished dancers who originally inspired this work, and they give a sense of movement to the quilt.

Commenting on her attraction to quilts, Miller notes in *Spirits of the Cloth*,

I am influenced by the colors and patterns of the natural world, the power and beauty of traditional African textiles, and the spirit of improvisation and play found at the heart of African American creativity. But more than anything else it is my love of fabrics that attracts me to quilting. I want to create works that are visually challenging and pleasing. Textiles provide all of the ways in which I enjoy expressing myself. I love form, color, balance and harmony, all of which merge into satisfying creations.

I have designed a limited edition of cross-cultural quilts that are composed of textiles from a variety of countries and cultures. The cloth conveys my sense of how the cultures of the world can be woven into patterns that are both harmonious and unsettling. My improvisationally arranged, recycled fabrics express my sense of motion and color, and I delight in these new and unexpected combinations.

The care Miller used for "Rites of Passage" is replicated in her other pieces. With each new quilt, she is able to incorporate newly discovered methodologies.

Although she has been rightly characterized as a master artisan, she self-identifies as a learner, an artist dissatisfied with relying on an established and unchanging repertoire of skills, and one who would tire of a familiar array of fabrics. Her steady hands and perceptive eyes demand new challenges.

RITES OF PASSAGE (SUMMER OF 2003): THE APPRENTICES

Intertwine Studios is about six blocks from the prestigious Wadsworth Atheneum, where Miller was featured in her one-woman show. Intertwine is one of several rehabilitated urban spaces that the Greater Hartford Arts Council uses for summer studios for adolescents. The brainchild of Faithlyn Johnson, director of education of the council, the immersion summer curriculum is designed to give motivated teens an intensive learning experience with modes of artistic expression that can produce concrete career possibilities for them. About seven hundred Hartford high school students apply each spring. About a hundred of them are accepted into the studios. Those who make the cut spend their July mornings in academic courses on writing and art as a profession. In the afternoons, they apprentice with a master artist. Most summers Miller enrolls twenty or so in her Intertwine classes.

Johnson's original notion was to persuade Miller, easily Hartford's most well-known fiber artist, to conduct one of the afternoon courses. But Miller's unabashed passion for connecting teenagers to art resulted in her assuming a much broader role in the whole program. Miller has tackled the summer studios in the same way she approaches a new quilt project. In addition to her artistic skills, she also relies upon her pedagogy, counseling, marketing, business, and even maternal skills to shape the summer program at Intertwine. The students, staff, other teachers, and assistants are the pieces of fabric, and though she assembles them in unconventional ways, they all fit together.

Although the physical space of Intertwine is under the auspices of the Greater Hartford Arts Council, Ed Johnetta's influence is thoroughly apparent. Intertwine is part commercial space. The front of the studio is an attractive, albeit sparsely outfitted, storefront that contains finished products crafted by the students. Miller's business training underscores her development of the commercial side of Intertwine. She has analyzed the market and makes sure the students spend their time on objects that will sell. Consequently, while they

make a few fifty-dollar quilted wall hangings, they make far more thirty-dollar handbags and silk scarves, because she has observed that "people are into buying the wearables. . . ." She is eager for the students to have the satisfaction that comes from seeing their items purchased.

All of the students' works are available for sale, and if students want to keep one of their own pieces, they must pay for it. Hand-dyed silk scarves and shawls, woven handbags, wall hangings, and jewelry are all colorfully displayed, with discreet price tags reminding purchasers that the profits support the arts council's outreach work.

Intertwine is also part art gallery. All of the gallery walls are adorned with colorful African American quilts from Ed Johnetta's personal collection. Miller, like most quilt artists, is an ardent and well-informed fan of the works of other talented quilters, and she boasts a sizable personal collection of quilts made by other hands. In the summer of 2003, when I was visiting Intertwine, she had decided to display quilts made in the Alabama region that had been made famous in the Gee's Bend exhibit.

Most of Intertwine's usable space is a working arts classroom. Just beyond the business space, five large looms are set up where several of the young weavers pedal away until their yarn becomes scarves and wall hangings. A massive rocking chair sits in the corner, where students crochet or knit. Students can work on one of several sewing machines that have been set up farther back on two long utility tables, using supplies from a nearby wicker shelving unit that stores spools of thread and yarn.

A large side studio is almost completely utilitarian in purpose. It contains huge tubs where students can dye yarn and fabric. Here there are more looms and large tables with more sewing machines and table-top ironing boards. Massive shelves hold bolts of fabric, and bins hold fabric scraps. On one of the days when I was visiting, a huge boom box played Al Green. Music is a backdrop to the other artistic endeavors.

Intertwine is also part living room. On any given summer day when the program is in session, a multitude of people populate the textile studio. Some are transitory visitors. Customers occasionally are drawn to the window display and come in to purchase a meticulously beaded bracelet or an intricately dyed scarf. Ed Johnetta's family members drop in to strategize about an upcoming family reunion. A freelance filmmaker comes to document the goings-on. Musician friends stop by to try to coax Ed Johnetta into attending their next performances. A folklorist friend writing a book on quilters occasionally

intrudes herself with a minicamcorder and an ever-present notebook. Students and teachers participating in the other summer studios come and go in this lively interactive setting.

Miller has appointed Intertwine like the bottom of a firm quilt. It is a sturdy space in which the students, interns, apprentices, and co-teachers she assembles can pop out against each other just like the blocks of fabric on one of her quilts.

When Miller constructed her "Rites of Passage" quilt, she featured textile practices mastered in other settings. At Intertwine, she incorporates a cast of co-teachers with whom she has worked in the past. They anchor the summer in the same way that the molas and breadfruit anchor this quilt. I had a chance to witness this special process with three of these co-teachers who were present during the 2003 summer of my visit: Billie, Grace, and Zoe.

Billie

Miller knew that a course on basket making would be a good addition to the program, having herself studied under a master basket maker, Billie, in Ghana. She therefore arranged for a sponsor to support Billie's travel to Hartford so he could spend July teaching for the arts council. He lived in Miller's home. She quickly discovered that the language differences were going to be a greater challenge than she'd first imagined. The clothes that he brought from Ghana were ill suited to the hot, humid Hartford summer. Further, his dietary preferences did not match hers, and he initially expected her to prepare his preferred foods. For her part, she had assumed that he would take a more "when in Hartford" philosophy and take responsibility for his own meal preparation.

The initial cultural dissonance originally extended to his work for the arts council. The elephant grass he wanted to use was coarse and rugged, making it very difficult for novices to manipulate. The techniques he used for dying the elephant grass were complex and dangerous to replicate in her Hartford kitchen. Although Miller believes in learning artistic techniques from other artists, she follows common sense safety measures. Toxic fumes are a by-product of Billie's usual dying technique, so she insisted he learn how to achieve his color preferences with the liquid dyes she uses.

At the beginning of July, all of these ostensibly thorny issues were apparent, and Miller was patiently working her way through them one day at a time.

With Billie sipping beer and Ed sipping iced tea, they debriefed their days in the evening on the wide porch that wraps around her Queen Anne house. Each day the students, in addition to learning how to make the baskets, had the experience of watching the two artists negotiate the cultural distance between them. At the end of July, Billie's Hartford students had created strong, lovely baskets to sell. Miller was dreading Billie's return to Ghana. In honor of his friend and his sojourn in Hartford, he used much of his earnings to build a porch around his home in Africa, a constant reminder of his Hartford experience and his generous hostess. As she had done with the Hawaiian mola on the largely African-inspired "Rites of Passage," she had made Billie fit at Intertwine.

Grace Butler

If Billie is a mola, Grace Butler is raw silk. Grace is an apt name for her, as the pretty African American woman moves with grace and a cautious but uncompromising dignity. Grace was assigned to Miller by the Veterans' Administration. As a former army sergeant, Grace was able to instill discipline in her troops, but was the victim of a man's harsh, cruel discipline in her personal life. The abuse frayed her and temporarily unraveled her feelings of self-worth. The Veterans' Administration assigned her to Miller so that her long unused sewing skills could be revived. In the process of finding her textile talents, she regained her spirit and sense of self. She quickly moved from student to co-teacher and fellow artisan. Butler now has her own business with cards as colorful as the clothes and floppy hats she favors. She sells quilted denim bags made from discarded jeans and lively patterned cloth and jewels. When Miller watches Butler display her handiwork, she beams with more pride than she shows when one of her own quilts is chosen for display by a posh gallery.

Zoe

Zoe started out as one of the eager artistic high school students selected to participate in Miller's class. She has a cherubic face and bright blonde hair, and clearly lives for her art. Miller has invited her back each summer, giving her increased opportunities to move from the role of novice to master apprentice. Zoe's experience with Miller clearly made her more competitive for a coveted slot in the Massachusetts College of Art and Design. During the summer

of 2003 Miller encouraged Zoe to show the students how to use the shiburi technique she had learned at school. Miller proudly told a freelance documentarian, "I learn from my students."

Zoe is white, and her beloved mentor, Miller, is African American. I've probably given this more thought than either of them ever has. Since the original goal of the Greater Hartford Arts Council was to provide opportunities for Hartford teenagers, it is not surprising that the majority of the students are African American. That enrollment scenario reflects the demographic pattern of the greater Hartford area. However, there are white students in Hartford, and they are as likely to want to pursue careers in the arts as are their African American counterparts. At Intertwine, no discernible tension separates the black students from the white ones. The fact that they all share an identity as art apprentices seems to trump any interracial identity conflicts that might develop. Further, that kind of conflict would erode the beauty of the quilt Miller makes of Intertwine, and she would not tolerate that. So Zoe takes over Miller's class to teach them all a Japanese textile practice. At Intertwine, this makes sense.

Miller moves throughout this space, turning teaching into a near-aerobic activity. The textiles students include teens with some academic and personal experience with sewing, and others with none. It's a female-dominated class, but one handsome young man tenaciously makes a place for himself and seems to always have a needle in his hands. Within a day or two Miller has no need for the name tags that the program requires the apprentices to wear. She insists that they be referred to as apprentices rather than as students. The apprentice label implies that this is the first step towards professionalism. Although she knows their names, she has a wide lexicon of terms of endearment for them all. Hugs and embraces are routine, but reprimands also are given, particularly when the students are guilty of "attitude." Giving less than one hundred percent is the most serious offense an apprentice can commit. Miller quickly reminds any blasé apprentices that their places are coveted by other applicants.

With input from the senior apprentices and co-teachers, Miller quickly learns the students' strengths and weaknesses. Intuitively, she knows when to insist that they rip out a seam and start again and when to tell them that an imperfection might prove to be an interesting design element. She positions them at the looms, the sewing machines, the dyeing tubs in much the same way she would try to find the right space for a particular piece of fabric in a quilt.

This blue silk doesn't stand out against the green corduroy, so it will be placed where its luster will shine somewhere else. This apprentice will never become a confident weaver, but with the sense of color she shows with the dyes, she'll succeed in another medium.

For Miller, shaping the apprentices' sense of identity is just as important as helping them develop their artistic skills. In the summer of 2003, the program leadership purchased denim workshirts for Miller and the other teachers. Although Miller wore hers for the first day or two, she quickly procured one of the cotton T-shirts that the apprentices are expected to wear. By wearing the same shirt as the apprentices, she forges a closer relationship with them and makes her life seem more accessible to them. As they sit at adjacent sewing machines and looms, their conversations move back and forth between the challenges of getting a seam straight and the challenges faced by friends who aren't in the program. Two young women lament the plight of a friend who is pregnant "again." Miller is wagering that instilling her apprentices with a sense of occupational purpose will deter them from being caught in the traps that ensnare so many urban teens.

CONCLUSION

In the early summer of 2003, Miller was honored at an occasion almost as satisfying as her earlier reception at the Atheneum. Recognizing Miller's extensive creative achievements and her dedication to public service, Governor John G. Rowland presented her with one of the coveted Governor's Arts Awards. Her spiritual sister, Farah Jasmine Griffin, professor of English and comparative literature at Columbia University, concluded her eloquent introduction by noting:

> Those of us who are fortunate enough to meet her in life can attest to the power of her presence. Those who encounter her through her art (whether in a museum exhibition, on one of her numerous television appearances, or in a number of publications that contain reproductions of her work) are also changed forever. Ed Johnetta's work is distinctive for its color, its movement, its devotion to an inclusive, multicultural vision of the world. Because she never seeks to censor the chaos or conflict in her work, it is never easy or sentimental. It's all there, all the vibrancy that makes our interaction as human beings so

interesting, unique and valuable. Her work says, "Wake up! Step into this whirl-wind; take risks. You'll be better for it." And better we are, if a little shaken.

Miller sees infinite possibilities in fabric, places, and humanity. She pushes herself to do more good for more people. Her quilts pounce on the eye, and her presence compels those around her to find their best selves.

Chapter Five

REDIRECTING THE PAIN:
ORA KNOWELL

For more than sixty years, fabric dolls and homemade quilts have consoled and protected Ora Poston Knowell. This therapeutic affinity was first nurtured in the kind of drafty shotgun house typical of rural black southern communities. Knowell relates,

> My first doll [mattress] was made of croker sack and stuffed with hay because of my anemia. It was spread by the fireplace at night for me to sleep on and placed in a corner, out of the way of traffic, during the day. I remember the quilt placed on me at night made from the cutting up of old wool and cotton clothes, three layers sewn together, by my mother and myself. These quilts were so heavy for a child my age that I could barely move—so I was stuck in one position all night. I miss what some people call the hard times—for me they were the best times of my life.

Although as a young adult Knowell relocated from Mississippi to New York to California, her dolls and quilts have remained constant companions. Her oversized doll mattress soothed her as a child, and as a mother now she takes solace from larger-than-life-sized quilted human figures that she makes as tributes to the many men and women who are murdered each year in the city where she lives—Oakland, California. No mission is closer to Ora's tender heart and artistic soul; she has lost two beloved sons to urban violence. Every year, on April 15, she displays a quilt on her west Oakland porch commemorating the anniversary of the 1995 shooting of Christopher Michael James.

Twenty days later on May 5, the quilt she made to honor his brother, Daniel Knowell III, killed in 2002, swings from the porch roof.

BACKGROUND

Ora was born in the small town of Victoria, Arkansas, on June 2, 1945. Her parents' marriage was a volatile one that ended in divorce. The divorce judge's approach to custody was a simple one: Ora's mother was assigned Ora and her brother, while her father was given Ora's two other siblings. Ora's mother took the two children to the Mississippi plantation where her own family worked as sharecroppers. In spite of these inauspicious beginnings, Ora's recollections of daily life during her early childhood are not bitter: "I was taught how to hand stitch fabric at a very early age because it was a way of life. I learned at an early age that walking miles to gather food from the fields, water from the bowers or river was a way of life, and to chop wood for cooking and warmth was important." Ora did not consider the daily chores that came along with life in houses that lacked indoor plumbing, running water, and electricity particularly onerous: "I learned how to make do with what I had and to be happy about what I could not afford. I learned to substitute one item for another. In my life there were many things I learned before I was even prepared to go to school."

Eventually, Ora's mother remarried and was able to improve their standard of living slightly; Ora moved to a house in Marks, Mississippi, where she no longer had to "go out in the cold to the outhouse. No more sleeping on the floor on my homemade doll mattress placed by the fireplace." Although the elementary school in Marks was superior to the makeshift one she had first attended at St. James Baptist Church, Mississippi school districts were hard pressed to serve "typical" healthy black children, whose parents often needed to pull them out of school to work in the fields. Black students who brought additional problems with them to school found few, if any, services to support them. Ora not only suffered from persistent anemia, but she was also afflicted with learning disabilities that confounded her efforts to learn. The multiple-mile walk to school fatigued her; as a result, she says, "I missed more school days than anyone I know."

In elementary school, Ora's cooperative nature and her competent motor skills kept her moving from one grade to the next. Shortly after arriving at the Marks Elementary School, she won a first place ribbon for the best coat and

dress made in the class. In 1955, when Ora was ten years old, her stepfather's dead body was found on the riverbanks, with all evidence pointing to the local Ku Klux Klan as his killers.

The high school curriculum was too much for Ora to manage. Discouraged by her inability to keep up with her peers, she dropped out after two years. Needing to carry her weight in the household, she went to work in the fields, picking cotton for two dollars a day. Her health problems plagued her, making her the slowest of the cotton pickers and thereby inciting the wrath of one of the female landowners. After a confrontation in the fields, Ora was dismissed. A more benevolent white woman helped her to find local janitorial work, and she supplemented her modest paycheck by putting her sewing skills to good use by making baby clothes. She fell in love with a local guy and had his child. He enlisted in the military and was sent overseas. The fact that Ora had sassed a white woman continued to have repercussions for others in the family, and she knew her mother and siblings would be more secure if she was out of Marks.

At eighteen, she left her child with her mother and accepted an opportunity for a "sleep-in" domestic job on Long Island in New York. This job was followed by a brief marriage that left her with four more children. Again, she was able to augment her pay from domestic work and other low-paying jobs, this time by making dolls, lace doilies, and other craft items to sell. New York City's cold winters exacerbated her health problems. In 1978 she switched coasts, moving her whole family to Oakland, California. She was able to resume her education, earning a GED at the East Bay Skills Center and taking classes at Merritt College. Still, making ends meet was never easy for Ora and her children. In the 1970s and 1980s, Oakland's black community faced a deteriorating school system, the proliferation of illegal drugs, and escalating gang violence. Ora's family was not immune to the temptations of street life. Perhaps it's a good thing that Ora had learned how to do without as a child: in terms of material things, she has had to do without her entire life.

In 1985, she was severely injured in an automobile accident that left her bedridden for many months. Once again her proclivity for doll making enabled her to endure the struggles she faced. She tells how she "began to see doll faces and how they should be made in my sleep. I would begin flat on my back to sew or crochet faces as I had seen them in my dream the night before."

Ora had unsettling premonitions in the spring of 1996. She was taking a sculpture class at Merritt College, and imperfections that resembled tears

surfaced on the visage of her piece. She discovered an indentation on the chest of the statue. She was also having dreams about an angry young man. She's not sure why she led her eleven-year-old granddaughter through the front door instead of the back on April 15, 1996; she almost always entered the house through the back door, but on that day she made a different choice. Shortly after they entered the house, they heard the sounds of garbage cans rattling. The eleven-year-old discovered the body of her uncle, Ora's youngest son, Christopher, dead from gunshot wounds. Ora believes that Christopher was killed elsewhere, and that his assailants dumped the body at home. The police believe that he committed suicide in the backyard.

Ora believes the police moved the body to support their suicide hypothesis. Although there is little common ground between Ora's understanding of the tragedy and the official law enforcement position, they might well concur that twenty-five-year-old Christopher Michael James was a victim of the futile visions that many poor young black men in inner-city Oakland possess. Either Chris himself or someone else saw no value to Chris's life.

Chris had enormous value, however, to his mother and the rest of his family. To Ora, Chris was a politically oriented, music-loving, strong young black man. He was a good son—just a week before his death he had helped her, as he always did, to prepare the Easter baskets for her grandchildren and to hide all of the eggs for the annual Easter egg hunt.

CHRIS'S QUILT

To assuage her grief over the loss of Christopher, Ora sought solace from both artistic and political pursuits. Artistically, she again turned to the doll- and quilt-making skills that had sustained her since childhood. To commemorate Chris, she made an eighty-eight-inch-long, fifty-three-inch-wide quilted panel. The back of the quilt is a hefty, upholstery-style fabric. The top layer comprises two pieces of cotton fabric. The top half is the antiseptic white associated with hospital linens, and the bottom is a bright apple red. The border is royal blue, making the whole effect patriotic. The full body of a young black man is appliquéd to the red, white, and blue panel. She transferred a photograph of Chris at age thirteen to fabric and stitched this onto the top of the quilt. Below the face, the body is wearing a black T-shirt. In the upper right-hand corner of the T-shirt, Ora has added a small cluster of plastic Valentine's hearts, probably

originally intended to be party favors. She has used a caramel brown cotton fabric to construct the arms, which flair out to the side of the body. On Christopher's quilt as well as the quilts she has crafted for other victims of violence, the hands are wearing pink knit gloves. Ora explains that she puts the gloves on as tributes to the mothers and their desire to hold and protect their sons. Christopher's hands hold candles, like the ones marchers often cradle during their vigils at antiviolence rallies. When she first made Christopher's quilt, she added a watch to the wrist. But she noticed after displaying it multiple times that somewhere along the line, the watch had disappeared. Below the T-shirt, a pair of worn, wrinkled, tan corduroy jeans is sewn to the fabric. Two pieces of dark blue print color fabric, cut to resemble feet, are appliquéd to the bottom of the corduroy trousers.

The political path Ora pursued in the aftermath of Christopher's death is captured in the words and pictures on the black T-shirt. It contains a circular collage of photo transferred images of dozens of faces of other victims of Oakland violence. The faces are clustered around a slightly larger image of Ora as a young mother holding one of her sons in her arms. Lower Bottom Fatherless Children Foundation (LBFCF) is imprinted in red letters below the black-and-white face collage. Ora is the founder and most consistently active member of this organization, which was formed to bring both internal and external attention to the children of murder victims. "Lower Bottom" refers to the residential section of the westernmost edge of Oakland, a mostly industrial border of the city near the Port of Oakland and the base of the Bay Bridge. All of the social, economic, and health problems that afflict the African American urban underclass are evident in the Lower Bottom. There are maps that pinpoint where Oakland murders occur, and many of the points are in the Lower Bottom.

Under the auspices of the LBFCF, Ora and other members take advantage of every possible public opportunity to increase the visibility of the family members of murder victims. Wearing the T-shirts, LBFCF members cart the quilted panels and posters outside of the Lower Bottom to Martin Luther King, Jr., Day events, Black History Month activities, and marches such as the Washington, D.C., Million Mom March in 2000. They also march through the Lower Bottom itself, in conjunction with community support activities such as the annual August campaign to collect donations of school supplies for local youth.

Thus, Chris's quilt has traveled extensively and been touched by many hands. Ora rolls or folds it, and often carries it with other quilts, posters, sewing materials, and miscellaneous items. In other words, she does not treat it

like a precious piece of art. Although it was never intended to be the kind of functional quilt that provides warmth on a bed, Chris's quilt does resemble many of the well-worn utilitarian quilts made by women with little time and money to devote to making bedcovers. Chris's quilt has large uneven stitches, the measurements are imprecise, the panel is not an exact rectangle, and it's not without blemishes. If the threads that are holding the T-shirt to the top surface of the quilt should fray, Ora can resew them. She can mend the worn places. With the quilt, she gets to do what she couldn't do in life—continue to work on and nurture Chris.

DANIEL PLUS 112

On the first anniversary of Christopher's death, Ora penned a memorial for a local newspaper that closed by saying: "Street Soldiers, Hip-Hoppers, Player Haters, each time you kill a brother, you take a family life, not just mine, but yours as well." Ora doesn't know if Chris's older brother Daniel was shot by a street soldier, hip-hopper, or player hater. But six years after Chris's death, Daniel, who often accompanied Ora to antiviolence rallies, was also murdered. He was gunned down in de Femery Park in the Lower Bottom, and his picture is included in the 2002 poster that identifies by name all one hundred and thirteen of that year's murder victims and the places where they were assaulted. No eyewitnesses came forward, even after the governor of California announced a fifty-thousand-dollar reward for information. Daniel's killing and the consequences these deaths have had for family members have further galvanized Ora as an antigun, antiviolence advocate. Chris and Daniel also left behind seven children, and the mother of Daniel's three daughters died prematurely as well.

Ora's cause extends beyond her family; she additionally mourns the loss of all of the others. Following Daniel's death, she has continued to work on both artistic and political fronts. She made a quilt for Daniel comparable to the one for Christopher, and through a community-based project housed at the local library, by Black History Month 2003 she had made a large quilt intended to document the one hundred and thirteen victims of the prior year. The posters, placards, and flyers all describe the one hundred and thirteen men and women as victims. Ora realizes that within the group there were individuals who themselves had perpetuated violence. But she doesn't see that as any kind

of justification for the vigilante-style retribution. Ora views Oakland's poor communities as victimized by racism, inadequate social services, and limited educational and occupational opportunities. She's convinced that external attention to these issues would stem the tide of violence.

Arts instruction has become a passion for Ora. She takes advantage of any opportunity to teach the skills that sustain her. Ora's students have included recovering drug-addicted women living at Mandela House, a residential drug treatment facility, and privileged teenaged men and women at an alternative high school in the Piedmont section of Oakland. The Piedmont students, whose multimillion-dollar hillside homes are usually complete with jaw-dropping views of the Oakland bay, live and attend school less than fifteen minutes from the Lower Bottom. But the homicide maps don't have pinpoints in these Oakland hills. Recently, when Ora shared Chris's and Daniel's quilts with one group of students taking a life skills class, they suggested the project of making comparable quilts for all of the 2006 victims. Ora embraced their suggestion and began to assemble volunteers to assist her in making a quilt panel for each of the individuals murdered in Oakland in 2006.

REDIRECTING THE PAIN

Ora's drive to make commemorative quilts for Oakland's victims of violence—and Chris's and Daniel's quilts in particular—are profound indicators of how she copes with and envisions the world. She recognizes the therapeutic dimensions of crafting the quilts. In the CD autobiography that she has self-published, she summarizes her artwork as offering "a fraction of healing by redirecting the inner pain." In a conversation with me during one of our late 2006 meetings of the African American Quilt Guild of Oakland (AAQGO), she admitted that when memories of her sons were "driving me crazy" the night before, she had decided to get up and had worked on the quilts. Ever since she worked on the doll mattress quilts in the 1940s, crafting human images with fabric and thread has helped her to grapple with the many obstacles she has encountered.

In spite of the fact that she has been surrounded for her whole life by fractured families and communities, she remains fiercely loyal to both her own family and the community that fostered the contempt that killed her sons. She's determined to dignify the lives of the murder victims with individual quilts.

Although she has solicited volunteers and her arts program students to aid in the making of the quilts, if one hundred and forty-eight quilt panels are made for the 2006 victims, Ora Knowell will have done the lion's share of the work.

The victims' quilts are all roughly the same size as the ones she made for Chris and Daniel. When she has a family member's assistance on one, it resembles the victim. Although most of the victims were black males, this is not the case for all of them. Ora wants quilts for anyone who was killed. A football fan's quilt dresses the victim in a helmet and the black and gray colors associated with the hometown football team, the Oakland Raiders. A more professional man is commemorated in a suit with a real tie stitched to his neckline. For some of the faces, she does abstract appliqué; for others, embroidery; and she often uses various photo transfer images she has from her own sons for the faces. She sees Christopher and Daniel in each victim.

In terms of their structures, the quilts do not exemplify a high level of technical ability in quilt construction. For one thing, Ora has set an ambitious deadline, so she doesn't have the time to rip out every less-than-straight seam. Further, she doesn't have unlimited resources to spend on the project; she tries to rely exclusively on scrap fabric and recycled clothes for the quilt panels she creates. An employee of a local fabric store sometimes gives her the upholstery remnants that don't sell. But resources and expediency aren't the only factors. Ora herself is the first to mention the technical imperfections that are discernible in the murder victims' quilts. A very competent seamstress, she explains while sharing an example: "I could have done it better, I don't care about mistakes, I deliberately make mistakes because nobody is perfect; I could have done this better." She says, "We all have something under the cover, things we don't want to expose."

Wrinkle-free, perfectly stitched, well-executed quilts would not be the appropriate commemorative vehicles for her sons and most of the other victims. "Nobody is perfect" is a mantra for her. She doesn't care that within the one hundred and forty-eight victims there were social misfits, some of whom were probably guilty of murder. She wants the killing to stop; she wants children to grow up with their fathers. In her own life, she had limited contact with her father after her parents separated. But he lived to be ninety-five, and she treasures the photographs she has of him from her last visit to see him in Arkansas. She hates that her grandchildren will never get to see their fathers as old men, and that they've come to fear black men, thinking that murderers are commonplace.

CONCLUSION

These days Ora Knowell almost always wears an oversized T-shirt like the one that is appliquéd to Chris's quilt. She has black ones and white ones. From the checkout clerk in the grocery store to the students in her arts classes, all who look at Ora see the pantheon of faces of the victims. Wearing her T-shirts in Oakland, California, comforts her in much the same way as sleeping under her quilted doll mattress did in Marks, Mississippi. Fashioning quilt panels for those who have been killed offers her a measure of solace and purpose, enabling her to move forward in spite of the pain.

Chapter Six

IT'S ALL GOOD:
MARION COLEMAN

When Marion Coleman's youngest son moved out of the room that had been the "boys' bedroom" in her northern California home, she moved her quilting supplies in. Where the bunk beds that her husband Nyls had constructed for the boys once stood, there are now six-shelf utilitarian Metro carts he brought from his own warehouse to hold her plastic tubs filled with fabric and notions. The electrical outlet that used to host the boys' fancy stereo equipment now accommodates a state-of-the-art sewing machine. The student desk has been replaced by a worktable designated for rotary cutting mats and rulers. The wall that was once plastered with music and movie posters now serves as a design wall where Marion auditions fabrics for use in her utilitarian and art quilts, and where she projects overhead transparencies in order to trace figures she wants to appliqué on her quilts. Although Marion is aware that the boys may not have shared with her all the activities that transpired in the room, she is quite confident that none of them ever ironed in it, and now, she is delighted to have a place where she can keep an ironing board set up at all times. One of Marion's favorite features is the overhead lighting Nyls has installed so that she can see better when threading needles, selecting fabrics, or embroidering edges. Since the house has four bedrooms and all of the offspring are adults, there's still a bedroom available when any of them come to visit. Thus the family is pleased with the good work that now comes out of the boys' room.

Since moving from sewing in the kitchen and family room to her own studio, Marion has greatly increased her output. She's made numerous bed quilts for her own family, for gifts, and for charities. Fascinated by the potential of photo transfer technology, Marion has made dozens of quilts capturing im-

ages of her own family and friends. For a while, she ran a Web site advertising memory quilts and pillows for sale. Customers would send her treasured family photographs, and she would make graduation, anniversary, and birthday gifts from them. Most recently, Marion has used the studio to make quilts that have won awards, been captured in magazines, and adorned walls in nearby San Francisco, as well as in Birmingham, England, and South Africa. Marion Coleman has a work space other quilters would envy, and she makes good use of it.

BACK IN THE DAY

One of the quilts that Marion made in her comfortably appointed studio bears the title "Texas Backroads." The wall quilt captures the key components of her childhood in north and central Texas. One image on the quilt is a colorful vintage road map, and indeed, the quilt itself can be read as a guide to key landmarks within Marion's childhood and young adult life. The quilt's surface includes a rendition of a gas station and a car, a house, images of Marion, and several relatives, based on pictures taken of them in the 1950s, all appliquéd onto a surface depicting the dusty, dry landscape of her part of Texas.

There are four human figures depicted on "Texas Backroads." A preadolescent Marion, who was born in 1946, stands in front of a wooden-planked shotgun house. She shares the scene with her maternal grandmother, who made such a house her home in Cameron, Texas. The image of Marion's grandmother represents the extensive female kinship network that shaped Marion's childhood. Her great-grandmother introduced Marion to quilting, although Marion preferred to be out in the garden rather than inside with a needle.

Her great-grandmother's daughter, Carrie, also known as Catherine, was a particularly significant influence on Marion. Because Marion was born "out of wedlock," as they used to say in the day, her grandmother Catherine assumed much of the responsibility for raising her, particularly during the school year. They lived in Wichita Falls, Texas. Although Marion started out life in a shotgun-style house that was rented to her grandmother by one of her bosses, the family did relocate. She recalls, "When I was a youngster, we first lived in the white part of town in the servants' quarters. We lived on this alley type of street. This person [her grandmother's employer] had three or four sort of shotgun houses that he rented only to black people. Then we bought a house in

the black part of town; we were delighted; I was glad because I could interact with more black kids." In addition to her maternal grandmother and great-grandmother, Marion was also nurtured by her mother's partner in her beauty shop, many great-aunts, and her father's mother and grandmother as well as the woman he eventually married. Marion was always eager to spend time with her many relatives and is particularly proud that "I knew my great-grandparents on both sides of the family."

Although she spent more time with her grandmother than her mother, the latter was still a positive force in her life. Marion also includes a quilted image of her mother and stepfather, both decked out in their nicest clothes and leaning on a curvaceous Oldsmobile. Eventually, her mother settled in Temple, Texas, where she met and married a man who worked in a civilian job at the nearby Fort Hood army base.

Overall, the quilt commemorates the ways in which Marion's family sustained their connections in spite of the hundreds of miles that sometimes separated them. As the title suggests, they got used to the Texas backroads, making their way from one house to another, usually in an Oldsmobile such as the one her mother and stepfather are pictured leaning against. The long-distance treks were not without some risk: "driving while black" could be much more dangerous in the 1950s than it is today. In order to mitigate the potential for incurring the displeasure of white drivers or law enforcement officials, the family always dressed nicely for their road trips. Marion recalls, "[Black] folks dressed back in the day. It was a safety precaution. You dress up. It helps eliminate confusion if you have to stop."

Marion attended the segregated school in Wichita Falls, a small industrial city in the northern part of Texas. Home to Sheppard Air Force Base and Midwestern State College, Wichita Falls had more to offer than the central Texas communities where her mother and other relatives lived. She loved to read and enjoyed cooking with her grandmother and gardening with her grandfather. In addition to a supportive network of women, Marion also had a sizeable contingent of male relatives who looked after her. Even though she learned to drive on one of the family's many Oldsmobiles, her uncle Robert functioned as her driver during her teen years, taking her to and from dances and any kind of meeting or service that took place after dark.

At one of those dances, Marion met one of the airmen stationed at Sheppard. In spite of Uncle Robert's proximity during some of their dates, David Coleman eventually found a way to propose, and they soon married. Life as a

military wife meant moving several times, and eventually Marion found herself in Riverside, California. Having started college at Midwestern in Wichita Falls, Marion continued her education at UC–Riverside, where she graduated in 1972. After that marriage ended amicably and without children, she moved to the Bay Area, completing a master's degree in counseling at California State University, Hayward, in 1978. With her degree in hand, Marion was finally able to embark on a career serving the needs of children. Marion credits her grandmother Catherine, who ran school kitchens, with instilling in her the selfless sensibilities of a good social services professional: "She was a model for me for social work. I'm clear that she would hire kids who weren't getting enough food: she hired them to do the dishes because a meal came with the job."

Over the years of Marion's career in social services, she, too, looked out for children. She worked at a Salvation Army–run maternity home; she worked in child protective services; and towards the end of her social work career, she worked for Alameda County assisting the developmentally disabled. Surrounded by children and families in need, Marion decided to invest more than her work time in finding solutions for them. She augmented her professional commitment with a personal one. She adopted a two-year-old boy, Melvin. When asked about the decision to assume so much responsibility as a single parent, she matter-of-factly recalled: "I had been married before, and I was single ten-plus years in between. So I'm not sure I'm going to find the right man again. At that time I worked for social services and they were actively recruiting parents. So there were several of us social workers who adopted kids." Commenting on her first impression of Melvin: "He was two, and feisty and talking—and he still is." Shortly after initiating the process, she met Nyls, a divorced father of four children, whom she eventually married. Nyls then became "the only father Melvin has ever known."

A case could be made that Marion's present family lends itself to a quilt metaphor. Nyls and the four children he had fathered before meeting Marion are white. Marion and Melvin are African American. Nonetheless, Melvin's fair complexion and soft wavy hair cause him to resemble Nyls, who now has silver wavy hair. Marion says that Melvin "looks like he could be our [biological] child. He's amazing." A professional chef, Melvin also shares Marion's and Carrie's affinity for cooking. Marion plans to use her favorite photo of Nyls and Melvin for one of her quilt portraits. From Marion's point of view, the extended family of her youth in Texas and the biracial family of her adulthood in California are gifts of immense and abiding importance to her.

FINDING QUILTS

Marion, like most southern girls of her generation, learned to sew in her childhood, while living in Wichita Falls, where she enjoyed making her own clothes. And she also learned to crochet. She continued to make clothes and crochet throughout her years in California, noting, "There are still testaments to that [crocheting] in all of my girlfriends' houses." Although she grew up sleeping under quilts, it took a museum exhibit to entice her to participate in the world of quilt making. By the late 1980s, African American quilts were periodically on display in northern California. Marion doesn't recall which of the exhibits she attended that triggered her interest, but she does know that she came home one day determined to try it for herself. Although she can't remember many of the details of the exhibit and venue, she recounts, "I do remember it had a very old quilt made by a woman who had taken all of her mourning clothes for it. They were all black. Something about that really touched me. Someone saving their garments and showing her respect and love for a relationship and showing that by dressing a certain way, then taking that and transforming that so that she could still have it to cover her. That was something I could really get into, recycling, although I don't think the term recycling was common."

Inspired by the exhibit, Marion started to quilt and hasn't stopped. In quilting, she found a connection to her career in social services: "I have been connecting with that [social services] experience in making my art. I use a great deal of imagery. I'm interested in history. So I use old photographs, trying to tell stories about my personal past, my cultural past, our present, looking at issues that I'm interested in as a woman, as a mother, issues like our children, our future and so forth."

The interest in quilting fueled by the exhibit was further enhanced for Marion by two other developments in the realm of quilting. One stemmed from increased access to ethnic fabrics: "I was delighted to be introduced to African fabrics. When they became available, oh my goodness, this was great. I think there was a connection to Africa, something I really knew came from there besides my ancestors. I started trying to incorporate those fabrics into my designs of my own." The other was the potential to incorporate the family artifacts she treasured. She says enthusiastically, "Then with the advent of technology, with scanners and digital cameras I had an opportunity to use those old photographs."

Before long, what had started as a hobby turned into a business and a gradual shift in Marion's professional identification. She was able to retire from her position as intake supervisor and children's coordinator for Southern Alameda County, and she began to devote herself full time to teaching, promoting, and making quilts. She sees much of the teaching as an extension of her social work. She's taught quilt classes in juvenile hall, where "they were very excited to see the variety of fabrics. The boys were as enthusiastic as the girls. We didn't have any disruptions; they were engrossed in what they were doing."

As she made the transition from quilt making as an avocation to quilting as a profession, Marion took several steps. She sought opportunities to teach. While she has volunteered her skills for some of these classes, such as the one at juvenile hall, she receives stipends for others at quilt shops and art centers. She began to submit her work to juried competitions. For example, when the American Quilt Exhibition called for entries to commemorate the two hundredth anniversary of the Lewis and Clark Expedition, she designed, constructed, and submitted a quilt dedicated to York, a manservant owned by expedition coleader William Clark. Since this was her first entry into a juried competition, Marion was slightly apprehensive. She tells how she overcame her anxiety over the prospect of judges evaluating submissions by reasoning: "I can't tell myself no. We can expect we'll hear some nos. I've had my share of yeses and nos. I keep putting it out there. And seeing what happens."

Marion also sought out the company of other quilters. She first joined a local quilt guild where she was the sole African American member. While this offered her the opportunity for fellowship with other quilters, her fellow guild members did not share her fondness for African-inspired fabrics or commemorations of significant moments in black history. Looking for that kind of interaction, she found an online group of African American quilters. From one of the other members of that group, she learned about the nearby African American Quilt Guild of Oakland (AAQGO).

The AAQGO proved to be a better fit for Marion. Founded in 2000, the guild is predominantly but not exclusively African American. Although it meets at a branch of the Oakland Public Library, its members come from throughout the greater Bay Area. Within this amicable group, Marion found women (and one gentleman) who share her attraction to African fabric and who seek opportunities to connect their fondness for black history with their love of quilting. In fact, Marion was such a good fit that she served as president of the guild from 2004 to 2006. The same skill set that contributed to her promotions to leadership

positions within social services agencies also fostered her ascension within the guild. Stating what she's most proud of, she says, "During my presidency we established a board." Having an active executive board allowed those attending the regular monthly meetings to focus more on quilting, a welcome development. According to Marion, "I saw my role as to help put some things in place. And also to motivate people. I did a lot of stroking. I did that in my role as manager [for Southern Alameda County]. You know, you get a lot more work out of honey than out of ugly."

HOT FLASH

The African American Quilt Guild of Oakland was invited to partner with San Francisco's de Young Museum in conjunction with its 2006 exhibit The Quilts of Gee's Bend. During December, the guild was identified as the de Young's artists-in-residence, and Marion was one of five guild members to display her quilts and conduct workshops in the Kimball Education Gallery. On the first of Marion's workshop afternoons, I sat with her as she coached very receptive patrons in the art of making fabric postcards. Most patrons came to the gallery after having viewed the Gee's Bend exhibit upstairs.

As patrons walked around the gallery, they saw quilts strikingly different from those in the Gee's Bend exhibit. The guild's quilts were meticulously constructed and painstakingly executed. Some had the dimensions of a bed quilt, but most were made for display. Many of the female attendees paused at a vibrant red quilt depicting a black woman with her hair in sisterlocks—dozens of short interlocking braids—with her eyes looking upward. Hundreds of tiny strips of red and orange fabrics pulsated, giving the impression of a woman on fire. When they looked at the wall label, almost all of the women laughed unabashedly: "It's called 'Hot Flash'!" Marion always acknowledged, "It's a self-portrait."

"Hot Flash" seems to resonate with all who see it. Young women who have decades ahead of them before menopause sets in seem to be tickled by this glimpse into their future. Men who have lived with a woman going through what used to be called "the change" respond to it. Even though the image is of a black woman with braids, it clearly echoed with the many white women with perms, who often kept coming back to it as they walked around the gallery.

"Hot Flash" began with a series of digital photographs Marion snapped of herself. After printing out the preferred image on an overhead transparency sheet, she enlarged it, and projected it on her design wall. She then traced the projected image onto a muslin background. She pieced assorted shades of tan and pale yellow to the muslin for a contrast with the brightness of the reds, purples, and oranges that she then used to build her hair and neck. A range of colors from this palette is used in the face itself. The small strips of fused fabric that she uses give the piece a sense of movement that women who have experienced a hot flash recognize as indicative of the heat that suddenly starts to undulate through the body. Marion free-motion machine-quilted the piece, using a variety of wavy designs and several threads, including a purple metallic one that accentuates the hair on the quilt. In addition to being included in the de Young exhibit, "Hot Flash" was also featured in the By the Hand exhibit at the Bedford Gallery in Walnut Creek, where it earned a cash prize.

IT'S ALL GOOD

Most women are inclined to complain about their hot flashes, and many seek pharmaceutical relief to tame them. Marion opted to create a quilt out of hers, intending to share it with other women so that we can chuckle about the good and not-so-good parts of being female. Marion notes that she often quilts at five in the morning, when "the time of life I'm in" makes sleeping impossible. Quilting takes her mind off her discomfort.

When I shared an early, partially finished quilt of my own making with Marion and pointed out my many missteps, she was quick to offset my self-criticism by saying, "It's all good." When I had stitched the mitered corners of the border too close to the edge of the fabric, she helped me fix it without starting from the beginning, saying, "We can make this work."

Since the time when she was a youngster in Texas, Marion Coleman has made things work for herself and others. Rather than bemoan the distance that often separated her from her mother, she relished the proximity she had to her grandmother and other surrogate maternal figures. She enjoyed the hot dusty trips back and forth between central and northern Texas. In her career as a social worker, she facilitated better lives for her clients. No doubt there are those who would only see the potential for tension in the mixed-race family

she cherishes, but cherish them she does, and with Nyls as a partner, she has made this work. "Hot Flash" and all of the other quilts in Marion Coleman's corpus are the products of a woman raised to enjoy and embrace all of the rides that come her way, be they on the backroads of Texas or through the hormonal highways in her body.

Chapter Seven

THE TIES THAT BIND: RICHÉ RICHARDSON

Riché Richardson, Ph.D., sleeps under a milky white crocheted lace duvet with copious lace-trimmed pillows on an ebony black wrought-iron four-poster bed swathed with filmy mosquito netting across the top. Vintage furnishings, including a dressing table with a round mirror festooned with family photographs, complete her Sacramento, California, bedroom. The quilts she makes in a tight corner of her living room don't adorn her bed or anyone else's. Using traditional appliqué techniques along with fabric construction methods she's developed for herself, Riché designs and creates quilted portraits of individuals and icons important to her personally and professionally. Included are portraits of her own grandmother, Emma Lue Jenkins Richardson, as well as of celebrated entertainer and activist Josephine Baker; of her uncle, Joseph Richardson, and of Supreme Court Justice Clarence Thomas, to name just a few.

In 2008, Riché's portrait quilts will be moved from the walls of her California apartment—called "Paris in Sacramento" by her friends—to the gallery walls at the Rosa Parks Museum at Troy University in Montgomery, Alabama, where she'll be featured as the museum's "Alabama artist of the year." Like the noted civil rights heroine for whom the museum is named, Richardson is a quilt maker and a native Alabamian. When Parks and the many other women and men protested Montgomery's segregation practices in the 1950s, they risked their own well-being in order to ensure better futures for the next generation of African American children. Indeed, Riché's great-aunt, Johnnie Rebecca Carr, had persuaded Parks to join the Montgomery branch of the National Association for the Advancement of Colored People (NAACP) in the first place. Because of the activism and commitment of civil rights movement leaders such

as these, Riché's family was able to offer her opportunities in the 1970s and 1980s that had been forbidden to black children of the 1950s.

With grace and gentility (traceable perhaps to the charm and poise classes she took at Gayfer's Department Store in 1983), Riché has lived a life demonstrating that, when the trappings of segregation and second-class citizenship are eliminated, African Americans will thrive. While she's been constructing the quilts for the exhibit, Riché's *real* job has been an academic one. She made her first quilt, a tribute to her sorority, Delta Sigma Theta, while at Spelman and writing term papers on African American autobiography. When she was a graduate student at Duke University, she assembled seminar papers such as one on contemporary African American author Terry McMillan, and also started a quilt depicting her fascination with Africa. After receiving her Ph.D. in 1998, she accepted her first faculty position at UC–Davis and commenced working on her first book, *Black Masculinity and the U.S. South: From Uncle Tom to Gangsta*; squeezing in time on Friday nights and Sunday afternoons, she also completed several series of portrait quilts. For hundreds of years, black women born in Alabama had limited occupational and artistic options. In cities such as Montgomery, Mobile, and Birmingham, these women often worked during the day, making the beds of people who wrote books, and during the evening, making quilts for their family's use as bedcovers. Riché's Montgomery gave her a solid foundation, allowing her to choose her vocation and avocation. Her accomplishments signal a new day.

BACKGROUND

The Alabama that emerges in Riché's descriptions of her youth is not the Alabama portrayed in the grainy media footage of the civil rights boycotts and marches or in the televised reports focused on its most notorious governor and one-time presidential candidate, George Wallace. Riché grew up in an extended family in a bungalow with a carved fireplace, French doors, and eleven-foot ceilings on an African American street in a middle-class neighborhood. The home represents the aspirations and hard work of her grandparents, native Alabamians who, during World War II, moved to Pensacola, Florida, where her grandfather Joe and her grandmother Emma Lue were able to get good jobs in defense-related industries. Her grandfather was able to further expand his construction skills in jobs building barracks. Her grandmother did sundry

jobs such as inventorying and distributing uniforms. With her grandfather's broad construction experience and a financial nest egg, they were able to return to Montgomery after the war, better positioned to support a family. By the time Riché was born on May 26, 1971, the family was secure and comfortable.

From a very early age, Riché displayed talents in both academic and artistic arenas. In fourth grade, she received an honorable mention in a city-wide poetry contest sponsored by First Alabama Bank. She played Harriet Tubman in a school play. Describing her interest in fabric and sewing, she recalls, "As a child, I was really into crafts, really always into crocheting and knitting. I was a doll collector, so I would make bedding ensembles for my dolls, decorate all my Barbie houses; this was pretty much where my creative energies as a child pretty much came out." For a few years in the early 1980s, Barbie had a competitor for the affection and allowances of little girls. Riché remembers when, "In 1983, things were taken up a notch in the wake of the Cabbage Patch Kids craze." Eleven-year-old Riché's response to the Cabbage Patch doll hoopla signaled both her academic and textile arts leanings. Like virtually every young girl in 1983, she coveted a doll of her own, but that wasn't enough for her. "There was a book of his [Xavier Roberts, creator of the dolls] that I saw in a department store, and my grandparents bought this book for me. I studied it very carefully, and got a sense of soft sculpture technique." If Riché's family hadn't known earlier that they had a budding intellectual by day / mixed media appliqué artist by night on their hands, this scientific approach to doll making should have confirmed her career trajectory.

The family invested in her talents by sending Riché to Montgomery's most elite private African American high school, St. Jude. The fact that they were attending Baptist church service on Sundays and that the school was Catholic was of little importance to them. Founded in 1946, St. Jude is a venerable institution in Montgomery. In the aftermath of World War II, St. Jude's founders wanted Montgomery's African American Catholic families to have access to an educational institution that served both spiritual and college preparatory education needs. Since there were no secular parties interested in high-level college prep curriculum, admission to St. Jude was coveted by non-Catholic black families as well. Just as the returning veterans Rosa Parks, Johnnie Carr, and other Montgomery blacks were unwelcome at the front of the city's buses, so, too, were they and their children excluded from mainstream public and private schools. St. Jude was an educational haven for black families with the financial wherewithal to patronize it. And the graduates of the 1940s and 1950s sent their

children, so that even after separate but equal schools were finally outlawed, loyalty to the institution was still well entrenched.

Senior pictures of all of St. Jude's alumni hang on the institution's walls, and it is commonplace for students to make pilgrimages to the portraits of their parents and other relatives. For the older generation of blacks depicted on the walls, St. Jude and a handful of other Montgomery institutions existed as black-created portals to the social, economic, and educational opportunities that segregated facilities denied them. To Riché's generation and subsequent ones who traversed the halls of St. Jude, their enrollment in the school and participation in other activities, such as the Phi Delta Kappa Ball, traditionally the debutante cotillion for African Americans in the city, were informed choices. The Richardsons and most other black Montgomery families saw no reason to abandon the institutions that their parents had built prior to the civil rights movement. St. Jude itself played a significant role in the movement, lending its forty-acre campus for use as the final camping place for participants in the infamous Selma to Montgomery march of 1965.

Throughout her childhood and as she came of age in Montgomery, Riché's world was almost exclusively a black one. The first organized integrated experience for her came when she and a couple of her friends enrolled in the charm and poise school classes sponsored by a local department store. The majority of the participants were white, but Riché and her friends enjoyed learning to curtsy, walk on a fashion runway, make formal introductions, and similar skills that would serve them well in their debutante seasons and beyond.

St. Jude was a good fit for Riché, and her affection for her alma mater is palpable. Clearly, the educational foundation it provided undergirded her undergraduate and graduate successes at Spelman and Duke. Intellectually, artistically, and socially she thrived at St. Jude. She was both vice president and president of the student council. Inspired by the Cabbage Patch doll phenomenon, she made her own soft-sculpture doll, which received an honorable mention in an art show sponsored by the Alabama Association of Federated Youth Clubs.

Social activities at St. Jude and in much of black Montgomery are highly formalized. With fondness, Riché notes that "coronation is the highlight every year," and that her cousins who also attended the campus followed in her footsteps, all three of them having been second runner-up in various categories at the St. Jude Coronation Ball, including the Miss St. Jude contest. Coronation was a suitable precursor for the highlight of the social season for black Mont-

gomery—the annual Phi Delta Kappa Debutante Cotillion Ball. She and her mother spent months looking for just the right gown, even shopping in Atlanta's swankiest boutiques and department stores. She recalls, "I tried on forty dresses in all. Two weeks before the ball, we still hadn't found one. We finally saw the right one in Gayfer's, a week before the ball." The Gayfer's seamstress altered it to fit Riché, her mother trimmed her long gloves with fabric from the dress, and, in her mother's words, "the dress . . . turn[ed] that ball out." When she left for Spelman, Riché left behind her St. Jude's uniforms and her nine evening gowns, and instead took her Calvin Kleins.

SPELMAN AND DUKE

As is the case for many female St. Jude graduates, Riché's next stop was a historically black college, one of those institutions which, like St. Jude, were originally built when other southern educational institutions were denying blacks admission. Her undergraduate career at Spelman was as distinguished and diverse as her high school one. From her very first semester, Riché worked as a writing tutor; she pledged a sorority, Delta Sigma Theta; and she founded a student organization whose mission is clear in its title, Sisters in Solidarity to Eradicate Sexism. She made her first quilts at Spelman. The many notable English professors at Spelman encouraged her to pursue her literary and critical gifts, leading her to attend Duke University for graduate school. Riché was well served by her many years of education in environments dominated by African Americans; she was well prepared to immerse herself in Duke's rigorous graduate curriculum, where she was awarded a DeWitt Wallace Foundation Fellowship. Her artistic work was forced to take a back seat to her studies, and she didn't do much quilting at Duke. But she did complete her Ph.D. in five years, an impressive accomplishment in and of itself. From Duke she came to UC–Davis, where she embarked on the simultaneous teaching, service, and research triumvirate expected of all faculty members, and where she has created several quilt series.

Her many family portraits well reflect Riché's worldview. These quilts are poignant and striking, exemplifying her strong and affectionate ties to her Alabama roots. She never misses a holiday with her family, even returning to Montgomery to attend the St. Jude Coronation Balls of her cousins, and her family has visited Sacramento as a vacation spot. Riché's family members are

featured in her series "Graduation," "Debutante," and "Family," so there is a wealth of family portraiture within her oeuvre. She also has colorful and interesting quilts in two of her other series, "Gone With the Wind" and "Paris." The quilts in the former embody her academic fascination with popular culture, and those in the latter, her long-term interest in French culture.

THE TIES THAT BIND

After capturing all of her immediate family members in at least one of her portrait quilts, Riché embarked on her political series, in which she creates portraits of well-known public figures such as Malcolm X and Clarence Thomas. She entitled the first quilt in the political series "The Ties That Bind"; it depicts John F. Kennedy, Martin Luther King, Jr., and Robert F. Kennedy. "The Ties That Bind" connects Riché to both her family and the comfortable lifestyle they provided for her, and the quilt initiates her experimentation with portraits of individuals beyond her immediate kinship network. An analysis of how and why Riché created "The Ties That Bind" offers a telling glimpse of her personal and cultural priorities.

An offhanded comment from one of her Duke graduate school professors was the initial inspiration for the quilt. This mentor observed that all African American homes in America at that time had a picture of John F. Kennedy, Martin Luther King, Jr., and Robert F. Kennedy on prominent display. Although her own family home in Montgomery lacked such a photograph, the statement rang true to her. From experiences with relatives, classmates, and others, she knew that numerous black households of the 1970s and 1980s had altar-like mantels or tables where either individual photographs of the three leaders were arranged or a collective one of all three was displayed. Often, other family keepsakes were nearby, and frequently a likeness of Jesus Christ, a cross, or a pair of sculpted praying hands completed the tableau.

Although her grandmother's preference for fully Victorian décor precluded any such photographs, Riché believes that the respect that led so many black families to visually demonstrate their connection to King and the Kennedy brothers (sometimes affectionately referred to as "the Big Three") was present in her home as well.

Indeed, my own experience is comparable to Riché's in this regard. Although many of their friends and relatives had such pictures in their homes, my

own parents never hung one in our house. But I saw dozens of these images, particularly when we visited family in the South. And King and the Kennedys, particularly after the assassinations, were always revered in my home.

Born in 1971, Riché obviously does not remember hearing live speeches of any of these charismatic leaders, nor did she personally experience the traumatic loss that so many older black Americans felt upon their assassinations. But her first awareness of politics stems from her family's recollections of those moments. Whereas many children comprehend George Washington and Abraham Lincoln as the first political figures of note, the attention of many black children is first directed to these three individuals, who are rendered as liberators—sometimes flawed, but heroes in comparison with any other similar public figures. Their speeches, accomplishments, and deaths in the 1960s represent the most significant twentieth-century threshold for many African Americans. Before John F. Kennedy's assassination, Jim Crow still had a vicelike hold on southern black life. By the time of Robert Kennedy's murder, Jim Crow's grip had been loosened. Families like the Richardsons could better enable the Richés of the South to prosper. "The Ties That Bind" is inventoried in the politics series, but in many ways it also fits with the family quilts.

No portrait photographs of JFK, MLK, and RFK together were ever taken. Hence Riché used individual photographs of each of them as templates. She appliquéd their faces on top of a quilted American flag. From left to right, JFK appears first, in a blue suit jacket. MLK, wearing a "preacher's" gray suit, is positioned in the center, between the two brothers. RFK, adorned in a camel's-hair suit jacket, is third. All three of them have on white dress shirts and wear identical burgundy red ties. By dressing them in the same tie and titling the piece "The Ties That Bind," Riché intended to suggest all the ways in which the three are linked. Further, she wanted to do a play on the kind of whimsical "tie" quilts, made by many African American quilters, that use dozens and dozens of men's ties as the surface layer of a quilt.

From a technical perspective, "The Ties That Bind" posed a new set of methodological challenges for Riché. Aside from having had art classes in elementary school, she is a completely self-taught artist. The twenty-two-by-thirty-three-inch cotton, felt, and synthetic fabric appliquéd quilt required her to stretch her skills. For the first time, she had to position three faces in one quilt. Using felt, faux hair, and paint, she had to render John F. Kennedy and Robert F. Kennedy as distinct from one another. Although the range of skin

tones in her own family had forced her to be scrupulous in her selection of fabric for the faces of particular black individuals, with the Kennedys she had to learn how to capture white skin tones.

The finished product resembles the many mass-produced photographs of the three men. In her apartment, this quilt is situated near a decorative cross. When it is displayed in the Rosa Parks Museum, it will be positioned with other quilt portraits, including ones of Malcolm X and Clarence Thomas. Elsewhere in the gallery, her "Paris" series, including portrait quilts of Gertrude Stein and Josephine Baker, will be featured. Her "Gone With the Wind" series includes all the usual stereotype suspects. The exhibit will be anchored by the "Graduation," "Debutante," and "Family" series.

BOUND TO THE SOUTH

"The Ties That Bind," like so many of her portrait quilts, is, in part, an homage to the stability of Riché's southern upbringing. In the earliest draft of the introduction to her book, *Black Masculinity and the U.S. South: From Uncle Tom to Gangsta,* Riché recalls her college days, when nonsouthern Spelman women, perhaps unintentionally, "slammed" her cultural underpinnings:

> In college, I did not think or talk much about having done things such as attending poise-charm classes and coming out as a debutante. For such experiences, I felt out of place in some ways on a campus dominated by feminist, black neo-nationalist and Afrocentric sensibilities, all of which posed an assertive challenge to many of the institution's time-honored traditions. Washington, D.C., seemed to be the only hip and happening place to be from. Its house music seemed to be an obsession. On the other hand, all things Southern seemed to be dismissed as passé, and were accorded little or no value. In fact, whatever was perceived as "tacky" or "country" was routinely dismissed as being "'Bama," a slang term for Alabama. People might use this word in my presence in good and well-meaning fun, without a clue that it just might be offensive to me as someone literally from the state.

It is easy to imagine that the spirit of gratitude evident in the many depictions of the Big Three, including the one in her quilt, would incur the disdain of many of Riché's more urbane classmates. Of course, the bashing and

ridiculing of all things southern is not an enterprise limited to Spelman under-graduates. In both her academic and artistic pursuits, Riché has made rethink-ing the South, particularly the black South, her project. Many of her scholarly articles, as well as her book, focus on the often misguided, frequently malicious construction of African American southern male characters and literature in popular culture. Summarizing her argument, she notes:

> [M]y study uncovers an amazingly consistent imaging of black masculinity in the South as cowardly, counter-revolutionary, infantile, and emasculated. It examines the marking of black men in the South as other to authentic notions of blackness and masculinity, and highlights instances in which Southernness has been construed as an undesirable ingredient, and even as a contaminant, in black masculine fashioning. I illustrate how such perceptions of black mas-culinity in the South have been related to class-inflected ideologies of uplift in the African American context, and to urban-centered definitions of blackness and masculinity.

With copious footnotes and extensive bibliographic references, her book tack-les over one hundred years of images of black southern men. One portrait at a time, her quilts depict individuals important to and of the South, as she ex-perienced it. Just as she did as a child, she takes pleasure in expressing herself through multiple media.

CONCLUSION

Riché has converted the second bedroom of her apartment into a study where she keeps her books, notes, computer, and the tools with which she does her scholarly work. For her quilt portraits, she has designated an eight-by-five-foot corner of her living room as her studio. She keeps all of her materials there, and all of her works in progress. She doesn't have a work table specific to the project, and she rarely even lets herself spread out her work on the dining room table. She's very aware that her income is generated from her teaching and scholarship, not the quilt portraits. Still, in an ideal world she would have more time for the artistic endeavors: "When the Nobel Prize—winning Derek Walcott visited our campus last year, he said something very interesting at a point. He said that when he wakes up, he never knows if he will paint or write.

And some day that's where I want to be in terms of how I engage my intellectual work on the one hand and my artistic work on the other."

It is Riché Richardson the artist who will be feted at the Rosa Parks Museum. The Richardsons, their extended family, and friends will gather in force when her Portraits exhibit opens there. As they have since she first started making doll clothes for her Barbies, they will support her impressive achievements—achievements that speak to their hard work and the wealth and richness possible in a post–civil rights movement upbringing.

Chapter Eight

GIFTS FROM THE HEART:
TIFFANIE NEWTON WILLIAMS

Born in 1973, Tiffanie Newton Williams started to quilt over one hundred years after former slave Harriet Powers, often referred to as the "mother of African American quilting," had crafted her well-known Bible quilts. For that matter, Jeanette Rivers and Daisy Anderson Moore can show off quilts they have made that are older than Tiffanie. Unlike Mrs. Moore and Mrs. Rivers, Tiffanie, whose date of birth places her in the cohort often known as Generation X, wasn't even familiar with quilts as a child. "I don't think I knew what a quilt was until I was almost an adult," she freely acknowledges.

There are those academics concerned with authenticity who might argue that Tiffanie doesn't really belong in a book about black quilting traditions. She didn't learn to quilt from her mother or her grandmother. She didn't even learn from other African Americans. In fact, at the age of twenty-four, she learned to quilt from an integrated group of co-workers in which, by a considerable margin, white quilters outnumbered her and the one other black quilter in the group. What they didn't teach her, she found in "how to" books. Further, she didn't begin quilting in either a southern rural community or one of the vibrant urban enclaves that attracted numerous black Americans in the twentieth-century North. Or rather, that's not altogether true. She *did* learn to quilt in the North—in the extreme North of Fairbanks, Alaska.

By examining the role quilting plays in the life of Tiffanie Newton Williams, however, we can get a glimpse into the worldview of a post–civil rights movement African American quilter whose life spans the twentieth and twenty-first centuries. I will not argue that Tiffanie is a "typical" twenty-first-century black quilter any more than I have tried to establish that any of the previous

quilters typify twentieth-century black quilters. Instead, I want to continue to make the case that, to tell the story of black quilters, you have to tell a lot of different stories.

In the interest of full disclosure, I should note that Tiffanie and I are related by marriage. She is my nephew's wife, and I first met her when I went to Nebraska to attend an African American quilt exhibit from the Robert Cargo collection acquired by the International Quilt Study Center at the University of Nebraska–Lincoln campus. Both an adult niece, Kim Cross, and my nephew, Mitchell Williams, live in Nebraska, and I was eager to spend time with them during this rare trek to the Midwest. I asked Kim to try to find any quilters in her circle of friends and church family. At that time Tiffanie was a new but apparently serious girlfriend of my nephew, and I was particularly eager to meet the young woman who had captured the attention of a young man who had extended bachelorhood far longer than most men in our family. Tiffanie, Kim, Kim's daughter Cyré, and I all went to the quilt exhibit. It was Tiffanie's first quilt exhibit, and she found herself mesmerized by the range of styles displayed in the gallery. But neither the quilts she made before seeing the Cargo collection quilts nor after resemble the "Afro-traditional" quilts featured in that exhibit.

BACKGROUND

African American Alaskans are accustomed to folks from the "lower forty-eight" expressing an almost confrontational curiosity about their decision to make "the last frontier" their permanent home. Tiffanie's father, Jimmy Newton, laughs at the times other blacks have said to him, "Why in the world would you want to live in that place?" But Fairbanks has been good to the Newton family. They came from Texas in the 1970s so that Jimmy could work on the Alaska pipeline. He found a very good job, and the company, Alyeska Oil, assumed oversight of the pipeline upon its completion, offering him a long-term career position in an engineering capacity.

By the time the permanent job was tendered, he was convinced that Fairbanks was a good secure place for him and his wife, Laura, to raise a family. Jimmy liked the wide-open spaces, the wildlife, and the people of Fairbanks. His sister's family had preceded him in the trek to Alaska and had already joined a local black congregation. Jimmy and Laura Newton immediately

joined the same church. The Newtons weren't the only black family in Fairbanks. According to the 2000 census, African Americans comprise just under 13 percent of the Fairbanks population of 30,224 residents. Fairbanks's slogan is "The Place You Want To Be," and over 3,000 African Americans agree.

Fairbanks met all of the Newtons' requirements for building a strong family life. The schools were good, the streets were safe, the jobs were secure, and the cost of living manageable. The cold, long, dark winters that intimidate so many of us were just environmental challenges that never particularly daunted the Newtons. At Tiffanie's wedding shower, one of her girlfriends boasted, "I've heard that snowstorms can cause schools to be closed down in the lower forty-eight. I can never remember school being cancelled here because of a snowstorm." Like other Alaskans, African Americans buy sturdy cars, warm clothes, and household snow removal equipment, and just deal with the winter weather. Jimmy and Laura live in a large, sprawling home on a beautifully manicured hillside with panoramic views of the city and surrounding landscape. Jimmy hunts, and their freezer contains ample portions of elk, deer, and bear.

Their faith permeates their lives. Just as snowstorms don't interfere with school attendance, so they don't let anything interfere with church attendance. And the Newtons go to church—often. Tiffanie documents their weekly engagement with the congregation: "We had Bible meeting on Tuesday, choir practice on Wednesday, choir on Saturday, full service on Sunday morning and a shorter service on Sunday evening." She recalls with pride that "I can count on one hand the number of times I missed Sunday service."

The Newton home is a Christian one, and no meal commences without a prayer of thanks. As a child growing up in the 1970s and 1980s, Tiffanie never heard secular music in her home. The Newton family's tastes included all genres of popular gospel music. If they were in the mood for a soulful male ensemble, they turned to the Mighty Clouds of Joy; if they wanted to hear a passionate soloist, they turned to Shirley Caesar; if they really wanted to "have church," the Mississippi Mass Choir could duplicate the sounds of a full choir anytime the Newtons turned on the eight-track player.

Although the Newtons joined a black church similar to the racially homogenous churches of their youths in Texas, the rest of their lives in Alaska was quite integrated. Tiffanie's best friend, who eventually served as her matron of honor, is white. As noted above, the group of women who invited Tiffanie

to join their quilting group was almost exclusively white. Tiffanie did not give their racial identity a second thought; the opportunity to learn how to quilt appealed to her, promising a distraction from another long Fairbanks winter. She recounts:

> My co-worker was interested in doing something creative during the winter months which are so long in Alaska, and she introduced me to her quilting group. It was a group of women who get together once a month. They were doing what they called a mystery quilt. You get the instructions. She went with me to get everything. I had an old 1975 sewing machine that my mother had. [My friend] taught me the basics of quilting, and I taught myself the rest. I wanted everything to match. If you talk to older quilters, it's not the same. But I wanted everything to match. It was about a six-month process. We'd take it home and work on it independently. If I came to a part I didn't get, I'd just call my friend. Only once a month we got together. There was about ten women. I was the youngest, about twenty-five, the oldest was sixty-five. There were only two black women. The rest were Caucasian. We took the summer off. For us, quilting was a winter activity.

It may have been a winter activity, but given the duration of Alaska winters, Tiffanie had plenty of time to devote to her new passion. She was hooked immediately. She enjoyed the camaraderie and creativity of working in the quilting bee, but it wasn't enough for her. After a few sessions with the bee, she began to make plans for her first independent endeavors. "The first quilt I made, I made for my mom," she recalls. After finishing her mother's quilt and giving it to her for Mother's Day, she began a log cabin quilt for her younger brother who was about to graduate from high school. "I started in Februrary. I took him to fabric stores. Do you like this color? Do you like this fabric? We are very close. Well, I tried to finish by May but the binding wasn't on it when I showed him the quilt. I got it ready for August when he was about to get on the plane for college. I was working on the binding while he packed. I actually went to visit him and saw it on his bed. I was very proud to see him using it."

Jimmy and Laura Newton were right. The coldest state in the union proved to be a good place to raise their children to be warm and caring people. Both Tiffanie and her brother are now college-educated working adults. Both are married; both retain their connections to church and family.

FROM FAIRBANKS TO THE MIDWEST

When I first interviewed Tiffanie in 2001, she hadn't made a quilt in several years. But this wasn't because her interest had waned. After leaving Fairbanks for work and further certification in the medical field in the Midwest, Tiffanie initiated a self-imposed moratorium on quilting. Since she was both working and attending school, her time and money were limited, and she was concerned that starting even one quilt would invoke temptation. She describes her rationale in terms similar to those one might hear from someone trying to give up an addictive substance or practice: "I worry that if I start a quilt now, I'd want to work on it when I get home, stay up at night until very late, then work on it in the morning. It becomes a big part of your day, your life." Convinced that she was incapable of quilting in moderation, she knew that she needed to put it aside altogether. Tiffanie's strong sense of self-discipline was evident in her ability to resist the many temptations that periodically surfaced. When a new friend became pregnant, she went into the fabric store and "it took everything I had not to buy fabric. It's almost an addiction. I won't get serious about it till I'm done with school."

Well, that wasn't quite how it turned out. Tiffanie succeeded in avoiding the lure of fabric stores until the need for a quilt developed in what was going to be her new family. In addition to balancing work and school, Tiffanie made room in her life for Mitch. Mitch's family took to Tiffanie immediately. His niece Cyré and nephew Curtis Junior (CJ) met her first when Mitch brought her and fast food over one Friday night when the children's folks were working late. Before long, she met their parents and members of the extended family. Given Mitch's prior lack of interest in introducing the family to serious girlfriends, the women in the family were particularly eager for him to state his intentions. She was the ideal partner for him, and no one wanted his state of bachelorhood to continue. We needn't have worried. After a suitable courtship, Mitch proposed and invitations to a summer Alaska wedding arrived.

But that wasn't the only family news that spring. "Uncle Mitch, God answered my prayers!" With these enthusiastic words, Cyré was the one to tell Mitch and Tiffanie that a third Cross child was on the way, and Cyré was thrilled at the prospect of being a big sister. So in 2002, the same year that Tiffanie Newton and Mitch Williams were planning a wedding in her home church in Fairbanks, the Cross family prepared for a third child.

BABY CURSHAUN'S QUILT

When she first met Mitch's only sister, Kim, Kim and her husband, Curtis, were the parents of two children. Tiffanie's sense that Mitch would prove to be a good father was, in part, based on her observations of what a good uncle he was to CJ and Cyré. During their courtship, Mitch and Tiffanie spent a lot of time with CJ and Cyré. When they got engaged, they asked the two to serve as junior bridesmaid and junior groomsman in their wedding party. Even though the prospect of getting the whole family to Alaska for a wedding was daunting, the family worked hard to enable the children and Kim to get there without having to miss much school or work. With the grandparents, aunts, great-grandparents, and in-laws pooling their energies and resources, Mitch and Tiffanie's wedding was an affirming ritual, one dear to the whole family.

Tiffanie was almost as excited as Cyré about the new baby. Her quilting moratorium was over—temporarily, at least:

> I knew instantly that that [quilt] was what I was going to make for us to give her for the baby shower. I went into the fabric store almost immediately after they told us. It was almost an excuse to get away from studying and buy fabric. I didn't really know if it was going to be a boy or a girl, so I was trying to get some neutral fabric. I went for the bear fabric. I had no idea that was going to be the scheme for the baby's room. I chose a real easy pattern because I was still doing the school thing. I wanted it to be simple. I chose the four patch because it is really easy, you just have to have blocks of four alternating with four squares of solid fabric. It was a good excuse. It's something I enjoy. I think Kim was pretty surprised. She knew I was going to school. I don't think she thought I could get a quilt done during that time. Between the wedding and going to school and all that, there didn't seem to be time. I made time to get it done. She was pretty excited. I like to see people use [quilts]. That's why I make them—so people will use them.

Tiffanie clearly wanted to combine efficiency and affection in the making of this quilt. She was going to school, working, planning a wedding, and getting married. But she knew she was going to be this baby's aunt from birth, and there was no doubt in her mind that she was going to craft a very personal shower present.

Mrs. Jeanette Rivers makes most of her own clothing, including this shirt.

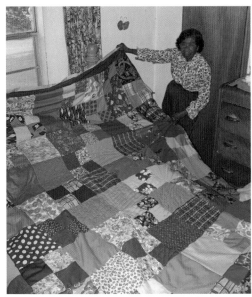

Mrs. Jeanette Rivers displaying her most recent creation.

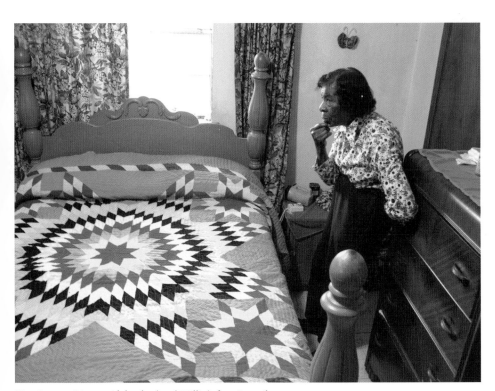

Mrs. Jeanette Rivers with her husband Willie's favorite quilt.

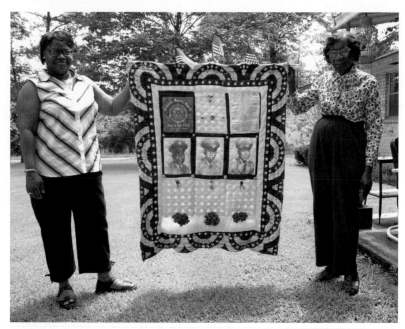

Mrs. Jeanette Rivers (right) and Carol Hall, Ph.D., with a tribute quilt made for the Zachary, Louisiana, American Legion.

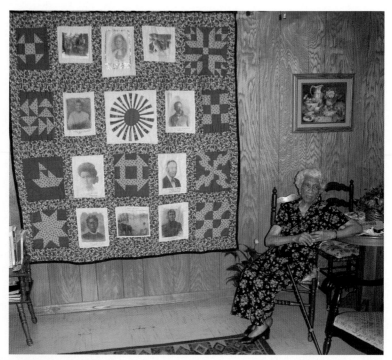

Mrs. Daisy Anderson Moore incorporates pictures of her own ancestors into an "Underground Railroad code" quilt.

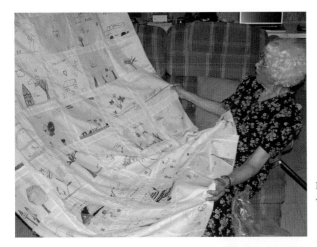

Mrs. Daisy Anderson Moore with school project quilt.

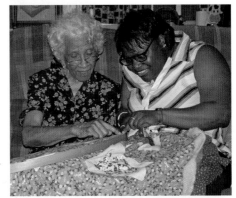

Mrs. Daisy Anderson Moore demonstrates her technique to textiles scholar Carol Hall.

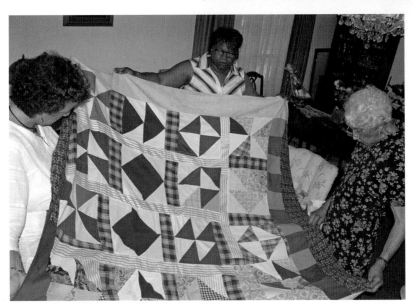

Mrs. Daisy Anderson Moore, Carol Hall, and the author inspect a Moore family quilt.

Dr. Elliott Chambers in front of a quilt he created from his late wife's favorite clothes. He incorporated the dollar bill he found in one of her suit pockets.

Dr. Elliott Chambers enjoys sewing African fabrics on his grandfather's sewing machine.

Ed Johnetta Miller teaches a master class.

Ed Johnetta Miller at work.

Ed Johnetta Miller encourages students to peruse books on fiber art.

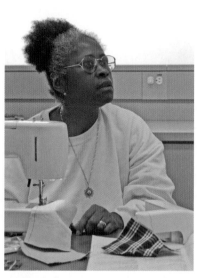

Ora Knowell at work.

Christopher's quilt.

Intertwine Studios in Hartford, Connecticut.

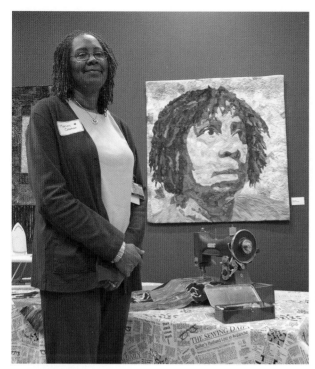

Marion Coleman with "Hot Flash."

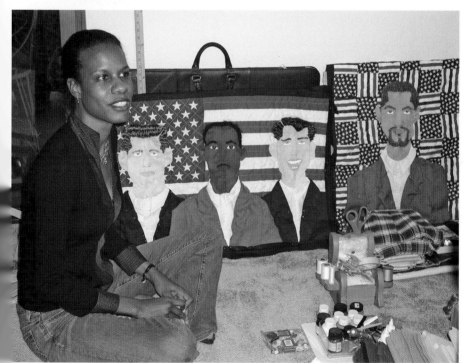

Riché Richardson, Ph.D., in her compact workspace.

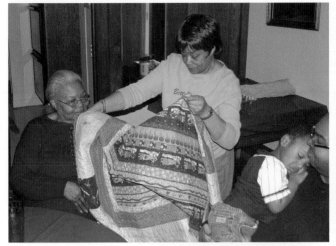

Ruth Turner Carroll presents a quilt she has made for her son-in-law's mother, Clara Mae Cross. Son-in-law Curtis Cross looks on while his own son, Curshaun, naps on his shoulder.

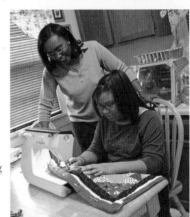

Tiffanie Newton Williams helping Cyré Cross with her first quilt.

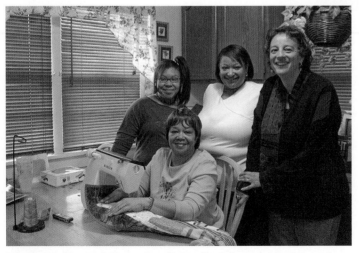

Seated at machine: Ruth Turner Carroll. Standing left to right: Cyré Cross, her mother Kimberly Cross, and the author.

Tiffanie approaches her quilts with all of the time management skills of a modern young woman who has always had to balance school, work, friends, and family. Curshaun's quilt contains only five different fabrics, and the shapes are all square or rectangular. There are no circles, stars, or any other complicated shapes. Even in the large fabric stores, Tiffanie doesn't loiter or agonize over quilt fabric selection. As soon as she sees complementary fabrics, she takes them to the counter to be cut and purchased. She often doesn't even look at the prices of the fabric. Normally a frugal young woman, she says she knows the range of prices charged in her favorite fabric stores. Tiffanie has a sizable selection of sewing tools and prefers the easy handling of a rotary cutter rather than the difficult manipulation of scissors. A rotary cutter board helps her keep her measurements precise.

For Curshaun's quilt, she chose a base fabric in a cream color, with jolly chocolate-brown teddy bears tumbling through it. An internal square is made of a small leafy green print. Within the frame there are thirty-six four-square blocks. Eighteen of these use teddy-bear fabric. These alternate with eighteen blue and burnt-orange calico blocks. The reverse side of the quilt is a single piece of pale blue fleece with large polar bears frolicking on it. She worked on the quilt over a period of several days, devoting four or five hours to it at a time. She likes to have contemporary gospel music—Fred Hammond, Kirk Franklin, Yolanda Adams—serenade her while she works. She had no problem finishing it in time for Kim's shower.

If Curshaun's quilt were stacked with other crib quilts, no one could find anything demonstrably "black" in its design. It contains no clues that this is a black quilter's gift to an African American recipient. Tiffanie's stitches are conventional, and the fabric is bread-and-butter infant fabric. There are no African motif fabrics, no strip construction. It looks like a sweet, well-made baby quilt.

At first glance, Tiffanie's motives for making the quilt could be ascribed to any young woman who is eager to share her affection for members of her new husband's family. No doubt there are thousands of young white women who have made teddy-bear crib quilts as shower gifts for their sisters-in-law. In wanting to offer a personal and carefully crafted quilt to Kim, Tiffanie was demonstrating a generous impulse present in a multitude of other quilters.

But when I asked Tiffanie about her aspirations for her new nephew, she raised concerns particular to a black family. She explains, "I want him to be a successful, God-fearing, hard-working young black man. I want him to have

gumption and the push to do well. He's going to be a black young man, and it will always be tough for him."

Curshaun was born in 2002, and he'll turn eighteen in 2020. Some might make the case that surely a young black man born to middle-class parents in the twenty-first century would not face any more obstacles than his white counterparts. Nonetheless, Tiffanie, herself blessed with a comfortable upbringing largely free of racial discord, is mindful that black men face internal and external challenges that could undermine their well-being. Curshaun has a strong and successful nuclear family and an extended family that dotes on him and his older siblings. Tiffanie inaugurated her relationship with Curshaun by taking the time to make a quilt for him. But the teddy-bear quilt is about her relationship with the family as a whole. It conveys her stake in the continued educational, social, and economic mobility of the family. The quilt is her way of saying, "I'll be here for this child, this family. I'll invest my time and heart into Curshaun's care." Such messages are subtly articulated in myriad ways. It's comparable to the message that Kim conveyed to Tiffanie when she and her family made the effort to get to Fairbanks for the wedding.

CONCLUSION

In many respects these twenty-first-century young black families are following a very old tradition of sustaining and affirming strong kinship networks. Families like the Crosses, the Williamses, and the Newtons believe themselves to be fortunate and blessed that they haven't had to experience the more oppressive aspects of black life that their parents and grandparents endured. But there's an abiding sense of diligence with which they approach their lives, a belief that the bad times could return if they aren't careful, if they don't pursue every possible opportunity, if they don't take care of themselves and each other.

So Tiffanie methodically uses the latest fabrics and ergonomically sound tools to make quilts. But she does so for reasons familiar to so many other African American quilters who have come before her. With the quilts that she bestows upon those close to her, she shares her aesthetic sensibilities and her faith in family, and she voices her willingness and readiness to extend herself on behalf of others.

Chapter Nine

GIRLS' DAY OUT:
CYRÉ CROSS

In February of 2001, eight-year-old Cyré Lechelle Cross attended her first African American quilt exhibit. Cyré and her family live in Omaha, Nebraska, about fifty miles from the University of Nebraska–Lincoln campus, home to the International Quilt Study Center (IQSC). During the first quarter of that year, the center, in conjunction with the campus's Sheldon Memorial Art Gallery and Sculpture Garden, mounted an exhibit of its recently acquired Robert and Helen Cargo Collection of African American Quilts. I was particularly pleased that the IQSC had acquired the Cargo collection because of Lincoln's proximity to Omaha, where my older sister's adult children, my niece and nephew, make their homes. Cyré Cross is my niece's daughter. On one of the days I attended the exhibit, Cyré, her mother, Kimberly, and her uncle's new girlfriend, Tiffanie Newton, took a "girls' road trip" with me from Omaha to a nearby restaurant for lunch and then on to the exhibit.

As we entered the museum, I deputized Cyré as my research assistant. I told her that I wanted to hear her opinions about the quilts, and I asked her to help me with some tallies. She agreed to count the total number of quilts on the walls of the gallery, to count the number of quilts that had the color red in them, and to make sure I paid particular attention to any quilts that depicted any kind of human or animal figure. Cyré, as she always does, took her assignment very seriously. She studied each quilt carefully, and made comments about what she liked about them. She did not grow impatient with our scrutiny of the quilts, and was at all times the model of good behavior. According to my notes, she found evidence of the color red in twenty-seven of the quilts. Although she did not start her own first quilt until two years later, I like to

think that this exposure to the Cargo collection stimulated her interest in quilt making.

BACKGROUND

Born in October of 1993, Cyré belongs to a close-knit, hard-working middle-class African American family. She is the middle child, sandwiched between an older and a younger brother. Her parents are homeowners, and her mother has always had a career outside of the home. During Cyré's early years, her mother both worked and pursued a master's degree. Her mother's brother and several of her father's siblings and other relatives live nearby, and Cyré and her brothers are very close to the extended families, who get together frequently. She enjoys special relationships with both of her grandmothers. Since her father's mother lives nearby in Omaha, she gets to see her quite often. Her maternal grandmother, my sister, visits her offspring in Omaha several times a year, showing up from Texas, usually with a suitcase full of presents, for holidays, birthday parties, and ballet recitals. Cross family vacations frequently focus on trips that will allow them to spend time with remotely located relatives; when Cyré was a toddler, they spent a Thanksgiving holiday followed by a visit to Disneyland with me and my family in California.

As a toddler, Cyré liked to play house, and she liked to play school. Her affection for her home, her family, and education has matured. Whereas she used to make pretend food for her dolls and stuffed animals, by the time she was ten, she could prepare simple meals for herself and her brothers. She no longer plays teacher, but is an attentive and ambitious student. Asked about her extracurricular activities, she notes, "I enjoy dancing, because I've been doing it for seven years. I enjoy hanging out with my friends and going to sleep-overs."

Unlike most of the older quilters profiled in this book, Cyré and her nuclear family never experienced the need to make homemade scrap quilts. Nonetheless, her father did inherit a family scrap quilt that holds a privileged place in the Cross household. According to Cyré, "My dad, his aunt made a quilt that we have. And it's a very heavy warm quilt. I've slept under it, and it keeps me warm." Although her paternal grandmother did grow up in a home in Arkansas in which African American girls were encouraged to make quilts in order to keep their family members warm, Grandmother Cross is in that generation of black women who put quilting aside when they migrated away from southern fields

to northern cities. Able to afford blankets, bedspreads, and comforters, Mrs. Cross and her contemporaries weren't required to keep the quilts coming.

Cyré's initiation didn't come from Grandmother Cross; rather, her uncle's wife, Tiffanie Newton Williams, profiled in the previous chapter of this book, infected Cyré with the quilting bug. Describing her first lesson, Cyré recalls, "My aunt Tiffanie and I were having a girls' day out, and she said it would be fun for us to make quilts. So we went to the fabric store, and we picked out fabric. We went back to her house, and she brought out the sewing machine, and she also took out a book that had a lot of different patterns in it. So I wanted a simple pattern that wouldn't be hard, and this was my first time using a sewing machine." Although it took them several sessions to finish, some at Cyré's house and some at Tiffanie's, Cyré completed her quilt. A broken sewing machine and a busy schedule have deterred her from starting another quilt, but she has plans to keep quilting because, she says, "It was really interesting to me, so now it's becoming one of my hobbies."

Cyré Cross's initial foray into quilting gives us a glimpse into the future of African American quilters. By examining Cyré's first quilt and her own perspective on it, we can access the worldview of one young African American girl who is coming of age in the twenty-first century.

CYRÉ'S FIRST QUILT

Cyré's first quilt came about as a result of a "girls' day out." These are days when Cyré's brothers are occupied with their father or uncles, and Cyré and Tiffanie devote themselves to the kind of activity the males would eschew— going shopping or attending an age-appropriate chick flick. A quilter herself, Tiffanie knew from Cyré's fascination with the quilts she had made that her young niece was interested enough in quilting to want to learn how to do it herself. Because Tiffanie had spent a fair amount of time with Cyré, she was also confident that the mature ten-year-old had both the attention span and the motor skills to execute basic quilting skills. For Cyre's first foray into quilt making, they went to the fabric store, where the ten-year-old selected three fabrics.

Describing her choices, Cyré recalls, "I chose polka dots. I thought it would be cool to have all polka dots. Then I chose the main fabric, which has puppies. I chose puppies because puppies are friendly animals, some of them, and

they like to play around, and so do I." One of the polka dot fabrics is a deep red with black dots; the other is rich green with black dots. The puppy fabric is what quilters refer to as a "novelty" fabric. It has a blue background with frisky little Dalmatians, terriers, and golden retrievers frolicking with each other and with pet toys. Cyré did not select a dark green and a light red; the blue of the novelty fabric and the red and green of the polka dot fabric all share the same color value—that is to say, the intensity of the colors is comparable.

With Tiffanie's guidance, Cyré selected a fairly simple block design. The quilt comprises multiple square blocks, so Cyré could focus on learning to rotary cut straight lines and match equal-sized squares of cloth. The quilt contains four patches of the puppy fabric. Thus, if her cutting, fabric matching, and sewing are not perfect, it is less conspicuous because all four squares are from the same fabric. The puppy four patches are adjacent to four patches containing red and green polka dot squares. Imperfect fabric alignment would be more conspicuous in these alternating polka dot squares. But Cyré is a fledgling perfectionist, and Tiffanie is an exacting teacher. Cyré's seam allowances are the recommended quarter-inch size, and her corners match up snugly. Describing the process she undertook to complete her first block comprised of four four-patch squares, she recalls, "It took maybe an hour and a half, because we did have to do a few things over. She taught me how to use the sewing machine and she taught me how to cut the fabrics. It took a little while, but it was really fun. I liked sewing it together, because it was my first time using a sewing machine. A few times I went a little too fast, and a few times I went too slow. And that taught me that we aren't perfect, but we can figure things out."

Cyré and Tiffanie focused fully on the quilting lesson. Cyré, a serious music fan who likes rhythm and blues, hip-hop, and salsa, explains that they did not have any music on during the lessons, because "she was giving me direction. We had water [to drink], and we were ironing at the same time."

Cyré's first quilt is not particularly fancy, but it is very well made for a first quilt. She is proud of her effort, and appreciates the connection that quilt making gives to her Aunt Tiffanie, her two grandmothers, and her great-aunt (me). As she continues to quilt—and I don't see her as a one-quilt quilter—she'll tackle increasingly complex designs. To Cyré, challenges are fun. Ballet lessons were physically demanding, but the opportunity to dance and perform on stage with her peers was very satisfying. Doing well in school requires hours of homework during the evening, but she looks forward to the As that always appear on her report cards. Cyré's own solid value system is reflected in the

observations she made as her much-treasured younger brother climbed onto her lap: "This is my little brother. He is one year old. He likes running around just like a little kid. He's a nice kid. He likes to laugh and smile a lot. He likes to make you laugh. He's very smart. He knows how to say thank you. He has good manners. He's fun. Most of the time he's pretty cool. He makes me laugh."

Cyré herself is a very "cool" young woman, completely current on contemporary fashion, music, and dance. She's also well-mannered, nice, funny, and smart. Just as there was no such thing as a typical African American quilter in the nineteenth and twentieth centuries, there certainly will be no such thing in the twenty-first. Still, Cyré Cross's first quilt, completed in the first decade of the twenty-first century, demonstrates that commendable African American cultural and familial traditions will be carried on in ways that Harriet Tubman, Harriet Powers, Rosa Parks, and the other great quilters of the past would applaud.

Part Two

STUDIES OF AFRICAN AMERICAN QUILTERS

An Overview

As I hope the "Stories" section of *Crafted Lives* indicates, I found the process of interviewing the quilters and documenting their quilts very satisfying. While I was fostering relationships with individual quilters, I was also looking for black quilts in popular, artistic, and academic settings. I found them. Following up on my eye-opening experience at the Smithsonian in 1986, I attended festivals and fairs where black quilts were likely to be displayed. I read or reread slave narratives, short stories, poems, and novels in which black quilts were discussed. I patronized as many museum exhibits dedicated to quilts made by African Americans as possible. I kept abreast of the scholarly works on African American quilts.

For most of this period of twenty years or so I was also teaching courses in African American studies. I began to realize that I could use my research on quilts and quilters to exemplify most of the larger points I wanted to make about African American history and culture. To talk about the artistic inclinations of late nineteenth-century African American women as well as the limitations the Jim Crow South imposed on them, I could have my students read about Harriet Powers, whose Bible quilts continue to mesmerize viewers but who was unable to genuinely profit from her artistic endeavors. To demonstrate the changes that World War II brought about in American culture, I could use the prize-winning quilts dedicated to Frederick Douglass and Harriet Tubman crafted by an integrated group of Californians interested in what was still called "Negro" history. To explore the changes wrought by the civil rights movement, I could point to the success of many art quilters. On the other hand, the possibility of exploitation could be demonstrated with a

discussion of the abuses that many rural black quilters have endured at the hands of unscrupulous dealers and curators. In short, quilts and quilters can be used to tell the most important stories about African American history and culture.

What follows are five studies that exemplify this point. In the first of these chapters, "Of February, Fairs, and Folklorists: Black Quilts Come Out," I return to the fairs and festivals that ushered me into the world of quilts and quilters in the first place. Here the focus is largely on utilitarian quilters who made their quilts as bedcovers but whose handiwork was significantly noteworthy to warrant inclusion in state fairs, folk festivals, and Black History Month showcases. The next four chapters are thematically linked, and all deal in one way or another with what happens when black quilts are displayed in highly visible settings. In some instances the settings are high-profile museums such as the de Young in San Francisco and the Whitney in New York. But other settings are literary ones, such as Alice Walker's celebrated story "Everyday Use" and the nonfiction best seller *Hidden in Plain View: The Secret Story of Quilts and the Underground Railroad* by Jacqueline L. Tobin and Raymond G. Dobard. Collectively, the five studies are intended to demonstrate the ways in which the status of African American quilts and quilters reflects the obstacles, challenges, and achievements of black America.

OF FEBRUARY, FAIRS, AND FOLKLORISTS

Black Quilts Come Out

Discussing the narrative quilt she had designed to celebrate the Underground Railroad, Daisy Anderson Moore told me, "They displayed it last February for a Black History Month quilt exhibit. . . ." February is the most popular month for exhibits of African American quilts. For that matter, February outperforms the other eleven months for PBS specials on the black experience, ballets featuring African American dancers, and newspaper series on the role of race in America. Any black musician who can't book a gig during February ought to find another profession. Noting the number of calls he gets for speaking engagements and media sound bites, a colleague of mine wryly refers to it as "full employment month for black intellectuals." Since I began to share the results of this research over a decade ago, I've been invited to give many a slide show on African American quilts in February. And Mrs. Moore is certainly not the only black quilter who has entrusted her best work to a local museum or gallery for February display. When quilters are present to tell their stories and an academic is there to provide some of the background about the ways scholars have looked—and not looked—at quilts, audiences are likely to receive a uniquely informative return on their investment of February time.

Venerated African American historian Carter G. Woodson, the father of Negro History Week (precursor to Black History Month), would have been gratified by the increasing attention to African American quilts that is manifest in so many of the celebrations. When he proposed the original observance in 1926, he wanted to direct serious attention to the overlooked contributions made by peoples of African descent. For fifty years African American churches, social organizations, clubs, and schools scheduled events focusing on black achievement during the second

week of February. Following the surge of scholarship on and by African Americans that was stimulated by the modern civil rights movement, however, black organizations found that one week was insufficient, so February was declared Black History Month. By this time progressive organizations—not just black interest groups—had begun to schedule their tributes to black history for February.

Nowadays, some would argue that black history season really begins on the third Monday in January, when the birthday of Martin Luther King, Jr., is celebrated. Many contemporary black Americans are ambivalent about this time of year. On the one hand, most older black Americans can easily remember when their history was rarely acknowledged, documented, or respected. They never studied Frederick Douglass or Harriet Tubman in their classrooms, they never saw black actors playing serious roles on screen, nor did they find the books of black authors on bookstore shelves. Woodson's Negro History Week broke this mold by coaxing blacks to retrieve and share the stories of their ancestors' accomplishments. Further, with February being but one bleak, truncated month, whites could consume a palatable dose of black culture. On the other hand, having one month dedicated to black history creates an unfortunate, if unintentional, topical ghettoization. Schedulers for various venues feel obligated to feature "something black" in February. And all too frequently, if they do "something black" in February, they feel relieved of any responsibility to diversify their programming similarly during the rest of the year. African Americans who feel compelled to support each other's efforts during February often breathe a sigh of exhausted relief when March 1 appears on their calendars. This somewhat vexing dilemma of Black History Month resurfaces annually.

Although February is by far the best time to look for an African American quilt exhibit, even among those with an interest in African American history the study of black quilters has gained credibility only in fairly recent times. By following the progression of the study of black quilts from their initial appearance in fairs, festivals, and Black History Month exhibits, we encounter virtually all of the major debates that have influenced the study of African American individuals, institutions, and issues relevant to American culture.

LATE NINETEENTH-CENTURY FAIRS

In the 1890s, a good thirty-plus years before the advent of Negro History Week, some fledgling efforts were undertaken to increase the visibility of Afri-

can American contributions to the United States. Among the more prominent occasions were the 1893 World's Columbian Exposition in Chicago and the 1895 Cotton States and International Exposition in Atlanta. Both events featured quilts made by black women, probably the first occasions at which black quilts were widely visible to a large audience—and both events provoked significant racial attention and tension.

For the Columbian exhibition, Queen Victoria submitted as part of the British needlework exhibit a "Coffee Tree" quilt made by former American slave Martha Ann Ricks. Ricks had been one of many American blacks to move "back to Africa" in an effort to establish a colony in Liberia from which Christian blacks could set themselves to the task of converting Africans from their indigenous religious beliefs to Christianity. According to research conducted by quilt historian and quilter Cuesta Benberry, Ricks was one of many seamstresses in this black migration to Liberia, and had long dreamed of presenting a quilt to Queen Victoria as a testimonial to Great Britain's early recognition of Liberia's sovereignty. By including the Ricks quilt in "Her Majesty's British Needlework," the queen was clearly honoring the skills of a former American slave.[1] Its inclusion may indeed have served a secondary purpose as well. Selecting the Ricks quilt may also have been a British jab at the United States. As they showed in their widespread support for former fugitive slave and black abolitionist Frederick Douglass, the British liked to seize opportunities to point out the hypocrisies of the country that had used lofty phrases about liberty and freedom to justify its war severing the colonies from the United Kingdom.

Two other black females associated with the fair achieved even more notoriety. One of the fair's most successful ongoing demonstrations featured Nancy Green, a former domestic servant, flipping pancakes as part of an effort to convince merchants to stock the newly concocted Aunt Jemima pancake mix. A completely different role was assumed by African American journalist and antilynching crusader Ida B. Wells, who was so dissatisfied with the fair's limited attention to Negroes that she and other activists protested regularly outside the fair's gates, distributing copies of a pamphlet entitled *The Reason Why the Colored American Is Not in the Columbian Exposition*. Wells's decision to urge a boycott of the fair irritated whites and even some blacks. She was an uncompromising individual, and more temperate African American leaders often feared that her constant agitation might do the cause for equality more harm than good.

In the end, none of these three black females was completely lost by history. Wells's volatile pamphlet still makes an impression on today's reader, and although she was late in getting her due from historians, Ida B. Wells is today an established figure, even making it to the exalted realm of black Americans who have been featured on a postage stamp. And although the Aunt Jemima icon has undergone numerous makeovers, the breakfast food products inspired by Green are still readily available. Regarding Ricks the quilt maker, Kyra Hicks has followed up on Cuesta Benberry's original research and painstakingly investigated Ricks's life, even writing a children's book on the courageous quilter. The recognition accorded to Ricks's quilt by Queen Victoria remains an important early indication of future appreciation awaiting black quilters and quilting.

Two years later, southern organizers of the Cotton States and International Exposition in Atlanta wanted to put the American South back on the map as a travel destination and a legitimate center of commerce. It was time to make up for the economic losses incurred as a result of the embargoes of the Civil War. Yet in the 1890s, hardcore Jim Crow–style segregation was actually much more intense and entrenched than it had been in the late 1860s and early 1870s. Lynchings were on the rise, and dogmatic white supremacist attitudes were the norm, not the exception. Fair organizers hoped, however, that showcasing some black accomplishments would differentiate the turn-of-the-century South from the South of the pre–Civil War era in the public's mind. Booker T. Washington, president of Tuskegee Institute, was invited to deliver one of the speeches scheduled to open the fair. At a time when southern blacks were prohibited from voting and even from going to a theatre, Washington was considered a very prudent choice to address a national audience about black progress since the end of the Civil War.

During his early years as founding president of Tuskegee, Washington had succeeded in building an institution of higher learning for Negroes in the heart of the southern Black Belt without unduly antagonizing local whites. He had accomplished this remarkable feat by publicly professing allegiance to an accommodationist perspective on race relations. By persistently reasoning that the improvement of Negro skills would reap commercial advantages for whites, he mollified potential critics. He took the unexpected position that Negro educational and economic progress would result in improved economic circumstances for white businessmen. He did not prioritize social progress, and when he used the platform of the opening of the world's fair to proclaim that

"[i]n all things that are purely social we can be as separate as the fingers, yet one as the hand in all things essential to mutual progress," southern whites were placated.[2]

For obvious reasons, Washington was much better received by whites in Atlanta than his frequent nemesis Ida B. Wells had been in Chicago. Many African Americans applauded his speech and were proud of the praise it received from national and international leaders. But there were also blacks who deplored his seeming acquiescence on social issues and his refusal to use this forum to agitate publicly for racial equality.

Interestingly enough, Washington does make a somewhat caustic remark about African American quilts in the speech. To illustrate a point about Negro advancement since the Emancipation Proclamation, he says, "Starting thirty years ago with ownership here and there in a few quilts and pumpkins and chickens (gathered from miscellaneous sources), remember the path that has led from these to the invention and production of agricultural implements, buggies, steam engines, newspapers, books, statuary, carvings, paintings, the management of drug-stores and banks, has not been trodden without contact with thorns and thistles."[3] With this demeaning comment Washington stigmatizes quilts as emblems of an impoverished black past; hand-crafted patchwork or appliqué bedcovers are but quaint and trivial artifacts of slavery. Old quilts are merely vestiges of the past; paintings and statuary are the totems of progress. The parenthetical comment on "miscellaneous sources" gave humorous credence to the widespread belief that ex-slaves had stolen these products at the end of the Civil War. No doubt because of the poultry reference, the comment triggered gales of unembarrassed laughter from his white audience.

Despite the disdain for these artifacts expressed in this section of the speech, other evidence suggests that Booker T. Washington and the Tuskegee Institute endorsed the development of the kind of sewing skills that would enable young Negro women to become capable seamstresses. Not only did Tuskegee's classes teach sewing, but eventually its extension agents taught quilt making to the daughters and wives of rural sharecroppers unable to enroll in college. Thus, for Booker T. Washington and virtually all of his contemporaries, making quilts was a worthwhile skill to develop, although no thought was given to any aesthetic dimensions of the practice.

Booker T. Washington received international acclaim as a result of his speech, but Harriet Powers, the ex-slave whose Bible quilt was displayed in the Negro building of the Atlanta exhibition, garnered little sustained attention.

To construct a biography of Powers's life, folklorist Gladys-Marie Fry did extensive historical detective work with a meager set of public documents. Powers had first exhibited the Bible quilt at a more modest local exposition in 1886. There, the quilt's unusual appliquéing of animals and celestial images caught the attention of a white artist and art teacher, Jennie Smith, who offered to purchase the quilt on the spot. However, Powers refused to sell. The evidence suggests that Powers had not constructed her quilt purely for utilitarian purposes. Even accounting for the size difference found in nineteenth-century beds, the Bible quilt's dimensions aren't really suited for use as a functional bedcover. Powers's initial refusal to sell her quilt reveals her strong attachment to it. But several years later, her desperate need for some quick cash caused her to reluctantly take the quilt to Smith for sale. Smith was unable to pay the original ten dollars Powers requested, so the quilt changed hands for five dollars. Fry quotes from Jennie Smith's diary that her goal was "to exhibit this quilt in the Colored Building at the Cotton States Exposition in Atlanta, and I hope all who are interested in art or religion in their primitive state will take the time to go see it."[4] Smith's objective was partially realized. The quilt, with its vivid Old Testament imagery, caught the attention of a group of faculty wives from Atlanta University, who commissioned a second Bible quilt from Powers.

In her book *African-American Art*, art historian Sharon F. Patton uses a striking picture from Harriet Powers's Bible quilt to open her chapter "Nineteenth Century America, the Civil War and Reconstruction," and she concludes the chapter with a discussion of the career and impact of African American genre painter Henry Ossawa Tanner. Tanner was a presence at both the Chicago and the Atlanta fairs. At the Chicago venue he delivered a speech entitled "The Negro in American Art," where he maintained that "actual achievement [in the arts] proves Negroes possess ability and talent for successful competition with white artists."[5] But two years later, when the time came to determine where to submit one of his paintings for inclusion at the Cotton States Exposition, his white patron proposed that they be displayed in the Negro building, reasoning that they "would have lost their distinct race influence and character if placed in a general art exhibition" and that his purpose was "to get the influence of Mr. Tanner's genius on the side of the race he represents."[6] As much as Tanner wanted his paintings to be evaluated by the same aesthetic yardstick as was the work of other fine artists, during his lifetime his talents would be circumscribed by the boundaries of his racial identity.

But as a trained artist born in the North and a male one at that, Henry Ossawa Tanner fared much better than Powers. Booker T. Washington refers to a chance encounter with the painter during a visit to Europe:

> When we told some Americans that we were going to the Luxembourg Palace
> to see a painting by an American Negro, it was hard to convince them that a
> Negro had been thus honoured. . . . My acquaintance with Mr. Tanner reen-
> forced in my mind the truth which I am trying to impress upon our students
> at Tuskegee—and on our people throughout the country, as far as I can reach
> them with my voice—that any man, regardless of colour, will be recognized
> and rewarded just in proportion as he learns to do something well. . . .[7]

It may be that Tanner himself would have disagreed with Washington on this point. He was one of the first generation of black American artists to exile himself to Europe in order to work and live in a less racist environment than existed anywhere in the United States. Washington goes on to say, "When a Negro girl learns to cook, to wash dishes, to sew, to write a book, or a Negro boy learns to groom horses, or to grow sweet potatoes, or to produce butter, or to build a house, or to be able to practice medicine, as well or better than someone else they will be rewarded regardless of race or colour."[8]

Harriet Powers had learned to sew, to sew in an aesthetically sophisticated fashion that earned her praise from both white and black women who could look at a quilt and see a piece of art. But neither Booker T. Washington nor any other prominent male leader acknowledged her talents during her lifetime, and she certainly lacked any of the connections that Tanner was able to gather, connections that might have allowed her to travel to Europe to pursue her art. Contemporary art books may partner Tanner and Powers in the same chapters, but during their lifetimes Tanner faced racism, while Powers faced an intertwining web of intractable obstacles that included racism, sexism, and the fact that she was limited to a mode of aesthetic and spiritual expression that lacked widespread credibility.

Today, no slide show or PowerPoint presentation on the history of African American quilters is ever complete without images from Harriet Powers's extant quilts. And the reaction by audiences after viewing the extraordinary image of one of her quilts and then hearing the tale of the transaction from which Powers netted half of the price she wanted often includes audible sighs of condemnation at Smith's villainy for having cheated the economically vulnerable black seamstress.

Opinions over the economic transaction may vary. From my perspective, however unfortunate the price of the quilt turned out to be, I see no reason to think that Powers's quilting dexterity would be known to us today had Smith not purchased that first quilt and submitted it for display at the exposition. Further, what little access we have to the inspirations for Powers's quilts is contained in a brief oral history recorded by Jennie Smith. Long before folklore documentation techniques were widely disseminated, Smith collected Powers's story in the ex-slave's own vernacular language. At one point, Powers explained a particular block to Smith by saying: "The falling of the stars on November 13, 1833. The people were frighten and thought that the end of time had come. God's hand staid the stars. The varmints rushed out of their beds." With this explanation, Fry was able to connect the arrangement of figures in Powers's quilt to the Leonid meteor storm of 1833, an event that, according to scientific knowledge at the time, was so startling and inexplicable that generations of blacks and whites pondered its original meaning for the next several decades.[9]

Martha Ricks, the ex-slave whose quilt was featured at the Chicago fair, seems not to have had anyone as interested in the story of her quilt as Smith was in that of Powers. Even so, there are parallels in the circumstances of these two women: both black quilters' work came to the attention of fair organizers through the intervention of white women. Ricks's work was submitted by British royalty, while the Powers quilt's advocate was a highly respected local artist. But it should be remembered that at the turn of the twentieth century, even well-placed white women lacked the clout to elevate the creative products of their own minds and hands, let alone those of black artists. No one was thinking about how to preserve white women's handiwork in any kind of systematic way, so it's hardly surprising that black women's work was ignored. For them, the obstacles were clearly enormous—and magnified. In the stories of quilters Powers and Ricks we can see a much larger story about the extent of the struggle for recognition faced by black women at the turn of the twentieth century.

EARLY TWENTIETH-CENTURY FARMERS INSTITUTE FAIRS AND WPA FOLKLORISTS

Booker T. Washington's 1895 speech enhanced his stature and further exposed him and Tuskegee to white northern philanthropists willing to provide sig-

nificant financial support for Negro higher education—Booker style. These resources enabled him to expand the school and its curriculum. As the nineteenth century was coming to an end, he succeeded in converting a cluster of discarded outbuildings into a respectable and modern campus. But he perceived Tuskegee Institute's mission as empowerment for all impoverished African Americans, and to fulfill that mission he and the staff needed the campus to do more than just offer classes to young people fortunate enough to attend. He and his faculty knew that higher education was far beyond the reach of the vast majority of Negroes in the Black Belt. In order to serve that population, Washington hired agricultural scientists such as George Washington Carver and former student Thomas Monroe Campbell, who would establish extension programs that would allow Tuskegee to reach to the farthest corners of the state. Extension agents taught black farmers how to optimize the fertility of their land, and taught women how to run modern households.

Farmers Institute Fairs were annual occasions developed so that rural black Alabamians could showcase the crops they grew outdoors and the textile arts they crafted indoors. With each passing year, the fairs' products reflected improvements. As historian Allen Jones has noted, "[T]he samples of their crops and livestock and of the women's needlework and quilts and canned goods were abundant and of the best quality and variety."[10]

George Washington Carver, best known for a multitude of agricultural advancements, was himself a quilter. Although other examples of his domestic handiwork have been preserved at Tuskegee, his quilts have been lost. But his extension curriculum did much to perpetuate quilting practices among rural black Alabamian women.

Carter G. Woodson was certainly not the first serious black historian, but with his leadership in the formation of the Association for the Study of Negro Life and History, his inaugural and long-running editorship of the *Journal of Negro History*, and approximately thirty books to his credit, he had a profound influence on what aspects of African American life were studied for the bulk of the twentieth century. After an economically impoverished childhood and irregular opportunities for formal schooling, Woodson successfully navigated the most elite educational institutions of his day, receiving his B.A. from the University of Chicago in 1907, studying at the Sorbonne in France, and then earning a Ph.D. in history from Harvard in 1912. Very aware of the neglect of African American history in the mainstream academic literature, he wanted to establish the study of black history as a viable and essential enterprise. In

addition to substantiating the intellectual achievements of African Americans, Woodson wanted the pages of his pathbreaking *Journal of Negro History* to illuminate and document black folk culture. He therefore encouraged and accepted articles that captured everyday black voices. In 1935, a lengthy article was devoted to firsthand comments by ex-slaves about the conditions of slavery. In a section on slave responsibilities, the author quotes Mrs. Lue Bradford: "I was taken into the home first as a little girl and taught first how to spin and card. Of course, I stayed in the house, but had to sleep on the floor winter and summer with only one quilt. Sometimes in the winter I would catch afire trying to keep warm, as the fire would get so low I had to roll close [so?] that my clothes or quilt would catch afire." [11]

As a result of Woodson's editorial inclinations towards the publishing of folklore, the journal contains numerous worthwhile articles on African American religious practices, proverbs, spirituals, and other standard genres of folk discourse. But references to quilts, such as the one above, are quite scarce, not just in the *Journal of Negro History* but also in the other publications that followed on its heels to chronicle aspects of black life. Perhaps a clue is evident in the comments found in a retrospective essay penned by Woodson in 1925, after ten arduous years as editor and advocate for the journal: "[The journal] has stimulated and trained young men with the capacity for research according to the methods of modern historiography. Above all, it has made the world see the Negro as a participant rather than as a lay figure in history." [12]

In incorporating articles about folklore in a scholarly journal during the first decades of the twentieth century, Woodson was parting company with his counterpart white historians, who were slower to move away from the study of elites. But he did emulate some of their biases, and the assumption that historians would be male and that the data worthy of documentation would focus on males is evident. It seems not to have occurred to him and his contemporaries to document female customs and crafts, particularly those associated with black women.

Nonetheless, questions at least were being asked about African American customs and practices. During this era more scholars were more diligently answering the call issued in 1888, when the American Folklore Society was established, "to collect the fast vanishing remains of folklore in America: the relics of English folklore, the lore of the Negroes, and the lore of Indian tribes. . . ." [13] That brief manifesto in the inaugural issue of the *Journal of American Folklore* stands as one of the first clear statements endowing black culture with academic

significance. To its author, William Wells Newell, and his folklore colleagues, the relevant folklore was orally transmitted. Thus, quilts and other examples of material culture were not considered appropriate for rigorous study, while verbal idioms such as are found in African American proverbs, spirituals, riddles, and folktales were collected and analyzed. A few prominent African American scholars, such as Jessie Fauset and Zora Neale Hurston, were engaged in folklore collection, but most of the academics who pursued folklore were white. All were much more likely to be trained as anthropologists than as historians.

SURVIVALS

Before long, a debate surfaced that was to have an impact on the discussion of virtually all subsequent twentieth-century studies of African American cultural productivity. And even by the time in the early twentieth century when scholars finally determined that quilts belonged in the realm of folklore research, this debate would continue to exert a profound influence on the perspectives that emerged about the sources of black quilt styles.

The debate boils down to this question: did African American folklore evolve primarily out of cultural retentions that had been passed down from the first generations of Africans who were captured and traded into slavery, or do the folktales, jokes, spirituals, quilts, and other folk idioms constructed by blacks echo more loudly what they have learned from their European captors? In the early years the debate was at least as political as it was academic. For many westerners, Africa was an uncivilized, dark continent inhabited by ferocious animals and primitive peoples. No genuinely respectable cultural developments were attributed to the sub-Saharan region, and peoples of African descent were considered incapable of high-order thinking. For many years this culturally elitist doctrine dominated the discourse. Unfortunately, these biases were so strongly defended and so thoroughly disseminated that they were often internalized even by African Americans.

In his inaugural issue of the *Journal of Negro History*, Woodson published an essay by Monroe Work that detailed positive cultural and scientific advancements from West Africa. Work concluded the article by urging African Americans to be inspired by the accomplishments of their ancestors and to pursue similar achievements in the United States.[14] By contemporary standards, Work's closing comments seem pathetically patronizing. But at that time, in his

willingness to praise Africa and in his belief that American blacks were capable of great things, he was taking a marginal and unpopular position.

The more pervasive view held that New World blacks possessed all of the negative character traits ascribed to their African ancestors. Any praiseworthy characteristics that were identified in a particular individual were believed to be the product of exposure to Europeans. In its fourth year of publication, the *Journal of Negro History* published an article that promoted that side of the debate. Sociologist Robert Park dismissed as unfounded any notions that African Americans bore any of their ancestors' cultural imprints and said, "In fact, there is every reason to believe, it seems to me, that the Negro, when he landed in the United States, left behind him almost everything but his dark complexion and his tropical temperament."[15]

Probably the most substantive contribution to the debate came with the publication of *The Myth of the Negro Past*, in which anthropologist Melville J. Herskovits, a student of Franz Boas, methodically made the case that sub-Saharan African cultures were complex ones and that much of African American expressive culture stemmed from its origins.[16] Herskovits's work did not end the debate, but for the remainder of the twentieth century the number of academics who subscribed to the belief in African retentions increased.

While scholars were engaged in lively discussions about the origins of African American culture, ex-slaves and their daughters and granddaughters were making quilts. The scholars were arguing about whether blacks carried African aesthetic values to the New World. The quilters who were participants in the great migration—the movement of hundreds of thousands of African Americans from the South to the North—were making decisions about whether to bring their quilts with them. Arbie Williams, eventually a National Heritage Foundation fellowship winner, did not take with her to the North the twenty-five to thirty quilts she had made in Texas and Oklahoma.[17] On the other hand, a Mississippi woman who was one of many southern Negroes to write to the *Chicago Defender*—a prominent black newspaper—for help in finding a sponsor to buy her a ticket from Mississippi to Chicago, prioritized the transport of her quilts: "I would like to come up there and get a job of some kind I can wait table cook house girl nurse or do any work I am read to come just as soon as you send the passes to us I want to bring a box of quilts and a trunk of clothes so you please send us the passes for me and my daughter."[18]

Northern California quilters who had left the South to work in the industrial regions of this western state during World War II have told me that they

left behind many quilts, but did bring just enough for the family members who were making the move. Thus, the decision on quilts varied from household to household. Some blacks left quilts behind, some brought all of their accumulated quilts with them, and some selected a few choice quilts to accompany them into their new life.

There are slightly better records available to reveal that quilting was still commonplace for those women who did not participate in the migration. When the researchers employed by the Federal Writers' Project (FWP)—a New Deal project to collect and preserve firsthand accounts of slavery—went looking for ex-slaves to interview, they discovered that many of the interviewees had a quilt in progress and several were supplementing their meager incomes by selling quilts. Although familiarity with folklore collecting techniques was uneven within the ranks of the field workers employed by the FWP, its leaders had organized the whole endeavor with the goal of documenting ex-slave perspectives on their lives. When visiting black Arkansan Margret Hulm, interviewer Annie L. LaCotte found the ninety-seven-year-old working diligently: "While Margret was giving this information she was busily sewing together what looked like little square pads. When examined they proved to be tobacco sacks stuffed with cotton and then sewed together which would make a quilt already quilted when she got enough of them sewed together to cover a bed."[19]

Rachel Austin also found that Margrett Nickerson, about eighty-nine or ninety years old, "spends her time sitting in a wheel-chair sewing on quilts. She has several quilts that she has pieced, some from very small scraps which she has cut without the use of any particular pattern."[20] These references are representative of the others, giving precious little information about the style, color, size, and look of the quilts. A particularly frustrating reference comes from 104-year-old Kittie Stanford, who told her granddaughter to "Show her that las' quilt I made." Apparently interviewer Bernice Bowden commented favorably upon the work, but she doesn't tell the reader what she saw. We learn only that Stanford responded, "Yes'm I made this all by myself. I threads my own needle, too, and cuts out the pieces. I has worked hard all my life."[21] What those pieces looked like we'll never know.

Evidence from the narratives does indicate that the quilts must have been attractive and functional enough to earn the women some money. When interviewer Samuel Taylor visited Ellen Cragin, he was pointed to a sign above the home that read ALL KINDS OF BUTTONS SEWED ON MENDING TOO. Mrs. Cragin

elaborated: "I've always sewed for a living. . . . I can't cut out no dress and make it, but I can use a needle on patching and quilting. Can't nobody beat me doin' that. I can knit, too. I can make stockings, gloves, and all such things."[22]

Preston Klein was one of the field workers eager to capture a rather folksy idiom in her interviews and quotes Roxy Pitts as saying, "Yassum, I kin see plenty good enough to sew, cep'n' I can't tread de needle, en I has to keep atter dese triflin' chilluns to hep me. You see dis quilt I'se piecin' Miss Lucy gwine gib me tree dollars fer it, coz she say it be made right, en dat's de way I makes em. Miss Lucy know she got er good quilt when I gits t'ru wid it."[23]

POST–WORLD WAR II AND THE NEGRO HISTORY CLUB OF MARIN CITY AND SAUSALITO

For African Americans, the years between the end of World War II and the mid-sixties saw more social change effected than any other era in American history. Wartime industries had brought black civilians to jobs and homes in the North, East, and West. By the end of the war, African Americans had established communities in most of the forty-eight states. Black veterans who had served valiantly in the segregated armed forces were eager to claim the rights and privileges taken for granted by their white counterparts. Although racism was widespread, at least the harshest strictures of Jim Crow segregation were less codified outside of the South. The making and displaying of two quilts at the beginning of the 1950s proved to be a positive harbinger of the social, political, and cultural victories that would be wrought during the civil rights era.

In 1951, the same year that Oscar Brown filed suit after the Topeka Board of Education refused to enroll his daughter, Linda, in the closest school to their home, an integrated club made a quilt containing a full-sized image of African American fugitive slave, Underground Railroad conductor, and quilter Harriet Tubman. White artist Ben Irvin and other members of the Negro History Club of Marin City and Sausalito undertook the project as part of their efforts to increase their understanding of black culture. The quilt received the second-place ribbon at the 1952 California State Fair. Unfortunately, little is known about this remarkable group of individuals who put racial differences aside long before it was common to do so. The response to the Tubman quilt was

sufficiently satisfying to the group that they crafted a similar tribute to African American abolitionist, activist, and journalist Frederick Douglass. Both quilts were displayed in San Francisco's Grace Cathedral. Eventually the quilts were purchased by black theologian Howard Thurman, and they now are on permanent display in the Robert W. Woodruff Library at the Atlanta University Center. [24]

The existence of quilts that commemorated black activists and were made by an integrated group of Californians drew no attention in the corridors of the South where another quilter initiated the boycott that led to the demise of segregated bus travel in Alabama. In an interview documenting her passion for quilting, Rosa Parks paints a picture of a southern black female childhood in which the making of quilts was taken for granted but was a nurturing practice from which she and her mother derived enormous personal satisfaction. Virtually every description of Parks identifies the civil rights movement's premier heroine as a seamstress. When asked in the 1980s if she was a quilter, Mrs. Parks replied, "Any good woman my age from Alabama knows how to quilt."[25] Born in Tuskegee, Alabama, in 1913 and raised in nearby Pine River, Parks recalled, "My mother and my grandmother would be making quilts and I started making quilts, you know, piecing quilts when I was very young—about six years old."[26] She acknowledged that all of her family members slept under quilts and that she continued to make quilts throughout her life. Her comments about why she liked to make quilts may suggest something about the tenacity that she demonstrated during the bus boycott. Asked what she enjoyed about quilting, she responded, "Well, I liked the finished product, and I also like the fact that when you do your sewing and put aside the scraps, that you can make use of the small scraps by making quilts."[27]

This determined focus on a goal appears typical in Parks. Although she was given several opportunities to avoid arrest, on December 1, 1955, Parks remained in her seat and gracefully accepted the consequences of her refusal to follow the driver's directions to move to the back of the bus. For over a year she and other black Alabamians refused to patronize the bus company. An argument could be made, of course, that since most black female Alabamians were quilters, my desire to tether Parks's quilting perseverance to her activism is sentimental but fundamentally flawed. However, as Parks would be the first to admit, it really was a generation of black female Alabamians/quilters whose selflessness made the boycott succeed. Rosa Parks was one of many women who were challenging the Jim Crow segregation of the buses in the post–

World War II era. She happened to be the one arrested on December 1 and the one that E. D. Nixon, president of the local NAACP, believed could stand the invasive scrutiny that would accompany the boycott. But the boycott required thousands of black Alabamian bus riders, most of whom were female domestic workers, to eschew convenience, affordability, and safety, and tenaciously determine to stay off the buses. Women who knew that keeping their families warm required them to save and sew scraps of fabric together also possessed the perseverance required to sustain a lengthy boycott. If Mrs. Parks was right in saying that any black Alabama-born woman of her generation knew how to quilt, then it was a cohort of dedicated quilters who finally brought to an end the powerful reign of segregated travel.[28]

The *Brown v. Board of Education* case, the Montgomery bus boycott, the Little Rock, Arkansas, school integration battle, and other episodes in which black Americans confronted oppressive manifestations of Jim Crow segregation had a profound effect on the nation and the world. The civil rights era battles were captured by television, in full view of a citizenry who professed that equality was a fundamental value. The civil rights movement, with its manifestos demanding equal rights for African Americans, stimulated a new interest in black culture.

If the politics of the late 1950s were marked by attention to civil disobedience and nonviolent resistance, the musical history of the late 1950s was marked by widespread crossing over of black vernacular music into the mainstream. When African American musicians began to be heard in commercial venues, the floodgates opened. Black music was not merely "accepted"; it was critiqued, copied, and celebrated. Soon it was common to hear that African Americans were responsible for the only truly American music. This development cast the survivals debate in a different light. Suddenly the beats that had been abhorred as primitive rhythms were characterized as sophisticated syncopation.

Black dance, poetry, fiction, and other black art forms were similarly embraced. Fewer critics were inclined to claim that African American culture was rooted in European aesthetics. African civilizations were not dismissed as inferior, and the proposition that the United States is the better for African Americans' artistic contributions was no longer anathema to many whites. By the mid-1960s African- American aesthetic production was more visible than it had ever been. Visibility contributed to credibility, and the academic study of black culture accelerated.

THE 1960S, THE FREEDOM QUILTING BEE, AND THE
SMITHSONIAN FESTIVAL OF AMERICAN FOLKLIFE

For blacks and whites alike, the 1960s saw a plethora of changes in every domain of American life. Within this particularly chaotic period, two institutions—both aspiring to empower ordinary people—were born that had and continue to have a profound impact on how African American quilts, particularly utilitarian ones, are valued and understood. First came Alabama's Freedom Quilting Bee (FQB). In 1965, a decade after Rosa Parks's steadfastness initiated the bus boycott as a mechanism of social and economic parity in Montgomery, a group of African American women eighty miles to the west of Alabama's state capital initiated a project to effect much-needed economic empowerment. To the women of Wilcox County, Alabama, the need to improve their socioeconomic well-being was at least as important as establishing their full rights to citizenship. With the initial assistance of Francis X. Walter, a white Episcopal priest, they formed a grassroots collective and began to market their visually striking quilts far beyond the borders of Alabama. The FQB remains the most significant organized group of utilitarian African American quilters in the United States. In the past few decades the collective has both enjoyed a number of successes and endured several setbacks. But no other group of black women quilters has been able to use its textile practices to sustain its members as consistently as the FQB.

Second came the Smithsonian Institution Festival of American Folklife. In 1967, four years after the March on Washington witnessed the temporary transformation of the National Mall from a bucolic park setting into a pulsating but peaceful arena of human determination, the leadership of the Smithsonian decided to conduct a major outdoor annual celebration. The Smithsonian secretary at the time, S. Dillon Ripley, "believed that museums had to do more to engage the public, that their artifacts had to be reunited with the people who made and used them."[29] With the folklife festival, the Smithsonian could add the celebration of folk cultures and grassroots movements to the more conventional offerings available in its carefully appointed galleries. Far more than those who typically organized state fairs and other outdoor festivals, the organizers of the Smithsonian festival were committed to contextualizing and documenting the underappreciated traditions on display. Rather than having judges evaluate submissions made by the public and award ribbons for best in show, the academically trained Smithsonian staff selected participants and

facilitated the presentation of the tradition in a way that historicized the object, performance, or custom. Further, just as the Smithsonian museum allows visitors to find out more about its exhibits via gallery photo-text cards, docent-led tours, and exhibition catalogs, the Smithsonian festival was planned to incorporate museum-quality signs, academic presenters, and a catalogue with information about the participants, usually referred to as tradition-bearers.[30] In that first 1967 festival and in the next one, Smithsonian staff selected the FQB women from Wilcox County to bring their quilts to be documented, displayed, and discussed with the tens of thousands of spectators who visited the festival.

Much had happened to the members of the FQB during their first two years as a group. They transformed themselves from individual women who made quilts for their own family's needs to a collective that made quilts to market to the public. Before the civil rights movement, white purchasers had shown only limited interest in black quilts. To be sure, some talented black quilters had been able to sell their quilts, but for low prices akin to the wages they were receiving for taking in laundry or cleaning houses. Quilts and other examples of women's work had possessed minimal economic value in general, and artifacts made by blacks were even less noteworthy. But the sixties was a decade during which conventional tastes were being interrogated. The FQB's quilts became immediately popular and fetched decent prices.

There are at least two explanations for the willingness of the public to purchase the quilts at this time. With their bold, asymmetrical, and unconventional patterns, they bore an uncanny resemblance to many examples of modern art, so that connoisseurs of Pablo Picasso and Jackson Pollock would find them quite appealing. Collectors drawn to abstract art found many of the design features of these quilts attractive. Other buyers were attracted by the fact that the quilts had been crafted by disenfranchised black southern hands. Whites and blacks who sympathized with the goals of civil rights activists but who had not come south to participate in the freedom rides or march from Selma to Montgomery could purchase a black-made quilt. Liberal-minded consumers could appropriate a piece of the movement and use their discretionary purchasing power to proclaim their allegiance with the noble women who marched by day and sewed by night.

In 1967, then, four black women from the FQB made the long trek to the Washington mall to showcase their quilts. Their selection to participate in this first festival was facilitated by Bernice Johnson Reagon, a sister black south-

erner, a civil rights activist, and a cultural historian. At that time, Reagon was best known for the leadership role she had played in the Student Nonviolent Coordinating Committee's (SNCC) Freedom Singers. In order to raise money to underwrite the efforts of students to dismantle Jim Crow segregation and degradation, she and a group of musically talented activists toured the country performing politically trenchant folk songs that were rooted in the southern black sacred and secular music traditions.

Reagon was one of the first individuals to possess two complementary sets of credentials. As a black Alabama-born female, she was easily able to establish a strong rapport with the FQB—their quilts weren't all that different from those of her own family and church. And her academic credentials enabled her to have genuine clout within the context of the Smithsonian power structure that was charged with organizing the national festivals. She made the case that African American quilters were folk artists worthy of celebration and docu-mentation. The FQB was featured in the 1967 and 1968 festivals, and since that time African American quilters—indeed, quilters from many American folk traditions—have been routinely included in the Smithsonian festivals as well as in a multitude of smaller folk festivals that have proliferated in the past few decades.

The members of the FQB were not token African American folk artists in the festival. Other black tradition-bearers included Bessie Jones and the Geor-gia Sea Island singers; Ed Young and his family, who comprised an African American fife and drum group; and John Jackson, a Virginia-based blues man. As noted earlier, the varied genres of musical performances by these other black participants had been a staple of African American folklore study since the 1950s. The inclusion of quilts and other examples of folk art at the 1967 Smithsonian festival coincided with the increased availability of courses on material culture in undergraduate and graduate curricula on folklore at Ameri-can universities. Whereas prior to this era, academic attention had centered on aural modes of folk expression like the shouts performed by Bessie Jones, the blues sung by Johnson, or the syncopated percussion of the Young family, now quilts and other material objects were being studied in the classroom and were viable objects for display at the festival. Thus, the Smithsonian and subsequent festivals could rely upon ethnographically competent interpreters who were trained to contextualize the physical artifacts of a community.

For the first time in American history, black quilters and quilts had a place alongside proverbs, folktales, blues, spirituals, and the other verbal genres of

American folklore. The survivals debate that had dominated the study of the verbal genres quickly subsumed the study of quilts and other modes of vernacular aesthetic expression. For folklorists, authenticity and origins are key, or at least they were in the 1960s. The FQB quilts were particularly tempting texts because the Wilcox County quilters had had little contact with external (European) cultural mores. A strong case could be made that this population would be highly likely to sustain African aesthetic values. The 1960s quilters had learned from the 1940s quilters and so on back to the mid-nineteenth century. Just as the spirituals and shouts performed by Bessie Jones and her choir reflected the call and response patterns indicative of African verbal expression, the FQB quilts, it could be argued, contained strips because of an innate African-derived sensibility and taste.

It wasn't long after the Smithsonian festivals featured the FQB quilters and quilts that folklorists began to publish dissertations, articles, and books about them and to organize exhibits of them. A dissertation on the FQB itself was filed in 1969. During the 1970s, Gladys-Marie Fry and John Michael Vlach curated exhibits and wrote essays about black quilts and quilters. As these and other scholars began to write and publish about black folk art and quilts, they foregrounded the ostensibly African-derived features of the quilts. In Vlach's groundbreaking exhibit catalogue entitled *The Afro-American Tradition in Decorative Arts*, a map of Africa detailing significant locales in the western portion of the continent is afforded a full page opposite the introduction. Vlach offers a very complete historical overview of the controversy about the origins of African American aesthetic creativity. He maintains, "The crucial cultural source that gives black crafts their special identity is, of course, their African heritage."[31] In his chapter on quilting he meticulously compares blocks within Harriet Powers's Bible quilts to strikingly similar Fon appliquéd textiles. He also includes plates of several more contemporary black quilts that are stylistically consistent with those of the Wilcox County quilters. He concludes this remarkable chapter by noting, "Harriet Powers' achievement recalls a single ethnic source. The strip quilts, in form and particularly in style, reflect the widespread heritage of African textiles. What may in the end be regarded as the single most important feature of Afro-American quilting is the apparent refusal to simply surrender an alternative aesthetic sense to the confines of mainstream expectations. Euro-American forms were converted so that African ideas would not be lost."[32]

As is often the case, the first authors to document a tradition establish the framework for subsequent discussions. As the first folklorists to struggle to

place quilts within the context of African American folklore scholarship, John Vlach and Gladys-Marie Fry quite correctly identified practices and techniques used by some African American quilters that strongly connect their quilts to West African textiles. The daughter and granddaughter of talented black quilters, Fry used most of her research time in the 1970s just looking for examples of slave quilts, textiles, and needlework for herself and other scholars to scrutinize, knowing that without actual texts to document, conclusions about origins and aesthetics would be superficial at best. Because of her indefatigable detective work, many examples of textiles made by slaves were discovered.

Just as Vlach had done, art historian Maude Southwell Wahlman includes a map of western Africa opposite the first page of the introduction to her book. In *Signs and Symbols: African Images in African-American Quilts*, she elaborates on her Yale doctoral dissertation on Africanisms in African American quilts. The traits she isolated include (1) an emphasis on vertical strips, (2) bright colors, (3) large designs, (4) asymmetry, (5) improvisation, (6) multiple-patterning, and (7) symbolic forms.[33]

Such arguments on Africanisms can be useful: the blocks in Harriet Powers's Bible quilt do bear a striking resemblance to Fon appliqué. When a picture of a strip quilt crafted by an African American is compared to a picture of kente cloth or other African textiles dominated by strips, the connections between the two are extraordinarily conspicuous.

But as a result of repeated comparisons between African textiles and some African American quilts, a dimension of black quilt evaluation and scholarship developed that probably dismayed this generation of folklore and art history scholars. Not all black quilters make quilts that look like African textiles. Some black quilters make quilts that are visually indistinguishable from quilts made by white quilters. But because the first quilts to be taken seriously seemed to be so African in orientation, the quilters who chose to make more "conventional" quilts garnered little praise or attention. Some have had to endure disdainful remarks that they aren't as talented as "authentic" black quilters or that their quilts aren't "black enough." Particularly during the 1970s, their quilts were less likely to be sought out for festivals or Black History Month displays. Collectors were unlikely to pay as much money for a black quilt that looked like a white quilt. Quilters who did want to sell their quilts were pressured into complying with the African-inspired standard. Roland Freeman describes one of his encounters with this puzzling situation by recalling his fieldwork

in Tutwiler, Mississippi, where a group of nuns have endeavored to develop a collective with goals similar to those of the FQB:

> As I passed among these quilters I was intrigued to hear them refer to the types of quilts they were making as "African-American." Then in the Center's library, I noticed that there were about twenty copies of Eli Leon's book, "Who'd A Thought It." In all my travels, this was the first time I'd come across a situation where African-Americans were being trained to make "African-American quilts." The director had a dedicated team of white nuns on hand to train the women in "African-American quilting techniques."[34]

Most of the writers who have sought to establish connections between African American quilts and African textiles do acknowledge that their conclusions are based on a specific set of quilts by a particular group of quilters. But the maps of Africa, the pictures of African textiles, and the profusion of quilts with strip construction contribute to the perception that there exists a preferred kind of black quilt that is demonstrably linked to Africa.

This view has been challenged by several other writers, including quilt historians Cuesta Benberry and Jennie Chinn.[35] Their quilt documentation efforts, particularly from black communities in Arkansas and Kansas, reveal a multitude of kinds of African American–made quilts. In their exhibits and books they are eager to establish a credible space and value for beautiful but non-African-inspired quilts made by black men and women. A later chapter will focus on African American art quilters and will include their perspectives on this dimension of quilt scholarship. For many of them, the dilemma is a troubling one.

THE 1980S AND BEYOND: FROM THE SMITHSONIAN TO THE NATIONAL BLACK ARTS FESTIVAL

African American quilters have flourished so abundantly since the 1980s that it would be impossible to do justice to each development. Children who have read Faith Ringgold's *Tar Beach* routinely visit the Guggenheim Museum in New York City asking to see the quilt that inspired the beloved best-selling children's book. The number of traveling African American quilt shows has increased each year, and venues compete for the privilege to mount them.

Many curators organizing a quilt exhibition around a theme such as food-ways or mothers and daughters will pursue African American examples for inclusion.

The advantages of the Internet for communication and education have not been lost on black quilters, and they have accessed the World Wide Web for a number of uses. In spite of these obvious steps forward, old and even some new issues continue to confront many in the world of African American quilt-ers. Since several of the issues relevant to other aspects of the post-1980s quilt world will emerge in later chapters, I will continue to focus here primarily on the role folklorists and festivals have played in public and academic analyses of black quilts and quilters.

Understanding the status of African American quilts from the 1980s to the present does require an understanding of certain outcomes from the civil rights and women's movements. Although the relationship between black women and feminism is itself a cumbersome topic, even those critics who believe that African American women were ill served by feminism per se would agree that black quilters did derive some benefit from the victories of the women's move-ment. Feminists had laid claim to quilting as a treasured female art form. In-dividually and collectively, many women were taking up needles and scissors in efforts both to connect themselves with undervalued female artists and to express their own aesthetic impulses. More and more venues were available for quilt display. Quilts not only were featured at festivals, churches, schools, and fairs, but were also gaining wall space in upscale lofts and posh museum galleries. Visually appealing, technically superior, or historically significant quilts—whether they were made by whites or blacks—became collectible. Pri-vate individuals developed quilt collections, and museums acquired valuable quilts for their permanent collections.

The hard-earned gains of the civil rights movement resulted in improved educational and socioeconomic circumstances for many African Americans, allowing them to exert more control over the analysis and dissemination of their cultural production. Fascination with black cultural productivity did not diminish. African Americans were still invited, encouraged, and cajoled to participate in local, regional, and national festivals, fairs, and exhibitions. Usually, such events followed the pattern associated with the Smithsonian fes-tival: African American quilters might be adjacent to Italian American bakers or Polish American accordion players. If events were organized for black his-tory season—the weeks between the birthday of Martin Luther King, Jr., and

the end of February—a whole program would be devoted to African American artistry. (As a result of the women's movement, March became recognized as Women's History Month. Thus, some events featuring the work of black women are timed to span February and March.) But with newly earned financial flexibility, blacks were also quite able to organize their own events and to control the criteria for inclusion.

Folklife festivals did continue to feature African American quilts and quilters. As noted earlier, my own introduction to black quilt study dates back to the 1986 Smithsonian Festival of American Folklife which showcased a group of Alabama quilters. Although some of these women quilted together at a senior citizens' center, they also made quilts for their own families. Roland Freeman and Phyllis May-Machunda had performed the initial documentation in Alabama, and Gladys-Marie Fry interpreted at the festival. Using these quilts, the three ethnographically facile African American scholars were able to document a nearly complete range of utilitarian African American quilt types. Using Mary Scarborough's double wedding ring and flower basket quilts, they could offer up quilts virtually indistinguishable from those made by white women. Using some of Mary McKinstry's quilts, they could demonstrate the connections between some African American quilts and African textiles. Thus, a broad range of African American quilt types was presented on equal terms at this festival.

Just as 1880s academics and others committed to folklore worried about the possible disappearance of significant cultural legacies, so, too, did 1980s scholars and fans worry that commercialism, industrialization, and technology might contribute to the erosion of traditional folkways. Scholars of the 1880s addressed this concern by forming the American Folklore Society and launching the publication of the *Journal of American Folklore*. A century later, public sector advocates of folklore proposed that particularly talented folk artists be recognized with a prestigious national fellowship. In 1982 the first group of National Heritage Fellowships was awarded by the National Endowment for the Arts Folk Arts Program. Inspired by Japan's Living National Treasures honors, the National Heritage Fellows "are selected not only because of their outstanding achievements as individual artists, but also because they represent entire traditions. In honoring them, whole traditions are acknowledged and brought to the public's attention."[36]

During the second year of the fellowships, the first of six African American quilters received an award. Lucinda Toomer clearly fit the criteria estab-

lished for the award. Toomer's quilts were among the first to be recognized and celebrated for their bold improvisational styles. Vlach, Wahlman, and other scholars had repeatedly singled out Toomer's quilts as exemplars of the ways in which African aesthetic impulses were rendered in African American quilts. Toomer had grown up in an isolated agricultural enclave in Georgia. As a child she had learned to quilt from her mother, and she continued to quilt prodigiously throughout her adult life. She did have some limited exposure to quilt motifs in magazines, but she claimed responsibility for the choices she made for her quilts. Explaining her stunning level of productivity, she noted, "I didn't make them to use. I just made them because I know how."[37] Toomer shared with other recipients of the fellowship a largely unambiguous link to her ancestors. She hadn't made a deliberate choice to start making quilts; rather, she had inherited the tradition and quilting was to her a very natural thing to do.

Subsequent African American award recipients who are quilters were also predisposed towards quilting in the manner they had learned from their mothers and grandmothers. Arbie Williams and Gussie Wells, 1990s recipients, had led much less isolated lives than Toomer had. Their families had migrated from the South to the urban environs of the San Francisco Bay Area, where they were exposed to many more kinds of quilting styles. Nonetheless, the fellowship committee recognized in their quilts what had come to be known as traditional elements of African American quilt making.

Lucinda Toomer, Hystercine Rankin, Arbie Williams, Gussie Wells, Nora Ezell, and Mozell Benson—recipients of the National Heritage Fellowships—are all extremely deserving of the praise and respect their quilts have earned for them. To a woman, they all endured early lives marked by racism and economic hardship. The obstacles they faced seemed only to have made them stronger, and perhaps their eclectically designed quilts were influenced by the struggles they met along the way.

At the same time that these black women were being so appropriately honored for making quilts, other African Americans were becoming increasingly engaged with quilting. Some of them had learned to quilt from a mother or grandmother who had taught them techniques and styles allegedly more European in origins. Their grandmothers had taught them how to do precise appliquéd flower basket quilts or subdued Sunbonnet Sue block quilts. They didn't prefer strip organizations or scrap materials. Their stitches were precise and their quilts were arranged in a symmetrical fashion. But because the black quilts that had received the most positive publicity possessed other attributes,

these quilters were sometimes forced to explain and defend their quilts on the grounds that theirs did not look like "real" black quilts. To many quilters, what others thought about the authenticity of their quilts didn't matter a great deal. They made quilts for baby gifts or for wedding showers or for their own family's use, and if the recipient of the quilt liked it, it really didn't matter how folklorists, quilt historians, or museum curators might have classified the quilt.

But other quilters were eager to be part of a community of quilters, and they wanted the record to show the full range of African American quilts. Whereas the FQB is the most significant group of quilters in the 1960s, the Women of Color Quilters Network (WCQN) deserves that distinction for the 1980s and at least the two decades that follow. Ironically, the need for an organization such as the WCQN may be linked to the successes of the civil rights movement. By the mid-1980s residential and occupational integration had resulted in many black women living in predominantly white areas and working in predominantly white workplaces. Successfully walking through the doors opened by their noble predecessors, the black women who joined the WCQN had economic stability and financial flexibility. Unlike their sisters in the FQB, they didn't make quilts out of a necessity to keep their families warm. Quilting satisfied other needs for them. But finding a sister black quilter wasn't as easy for these successful women as it was in Wilcox County, Alabama.

Established in 1986 by quilt artist and historian Carolyn Mazloomi, the WCQN exemplifies many issues that were being grappled with by African Americans at the end of the twentieth century. Like the FQB, the WCQN was organized to empower black quilters. The FQB pursued its objectives within the limitations of a region still mired in Jim Crow segregation. The FQB embraced a value system more acceptable in the 1960s. The FQB took a socialized approach to the designing and selling of the quilts. The quilters work together on behalf of the collective, and profits are shared according to how many hours a quilter has worked, as opposed to the selling price or popularity of the particular quilt. The group identity is prioritized over the individual identity or style of any single quilter. With the exception of just a few women who assumed leadership positions, no member of the FQB is singled out for particular commendation. Anyone familiar with the value systems of the 1960s will recognize this communal model as a popular experiment of those years.

And anyone familiar with the values of the 1980s will recognize the self-determination model embraced by the WCQN. Mazloomi's vision allowed for women to join the network without compromising their individual status

or style. She wanted the network to provide an artistic hearth around which women of color could gather and exchange ideas, patterns, and opportunities. She notes, "African American quilters clearly needed acceptance and affirmation to sustain their creativity. They found it in 'the Network,' which became a home where there was a freedom to work in all styles and techniques, whatever the skill level."[38]

Mazloomi, along with many of the other quilters who affiliated with the network, dislikes the rigidity of the characteristics for black quilts established in the 1960s and 1970s. As WCQN quilts so vividly attest, African Americans make an extraordinarily broad range of quilts.

Nonetheless, WCQN quilters would not deny an African-derived sensibility for some fabric and design choices. Indeed, many of them rely heavily on African textiles and fabrics imprinted with African designs. Marion Coleman notes that the availability of African textiles was one of the primary reasons she pursued a career as a quilt artist. Some quilters, such as Ed Johnetta Fowler Miller, have traveled to Africa and apprenticed with contemporary African textile artists.

Although part of the message here is that it is folly to generalize too broadly about contemporary African American quilters, it can be said that WCQN quilters tend to demonstrate their reverence for African aesthetics in a self-conscious manner. They intentionally select a fabric, motif, or theme that communicates an African inspiration for the quilt. This argument for self-determination and choice differs from the claim that black quilters innately prefer, for example, long bright horizontal fabric strips because of a subconscious, African-derived taste for the look of textiles structured in strips.

WCQN quilters rely upon one another for many of the components of a black quilter's life. They share information on new tools or techniques. They circulate the sources of appealing fabrics. They organize exhibitions that display the quilts made by members. They try to intervene when unscrupulous collectors or dealers exploit unschooled African American quilters. They can work together to promote respect for the scope of contemporary black quilters. As a later chapter will demonstrate, the WCQN has focused much of its attention on the display of art quilts in galleries and museums.

In 1988, two years after the formation of the WCQN, the Fulton County (Georgia) Arts Council sponsored the first biannual National Black Arts Festival (NBAF) in Atlanta. With a black audience in mind, African Americans organized this event to celebrate the breadth of cultural expression from peoples

of the African diaspora. The word "folk" isn't in its title, and its organizers showcase high-quality diasporic art, theatre, and dance. A long-time veteran of the Smithsonian festivals, Roland Freeman recalled in 1996, "The first festival was in 1988, and I have found each of the three since then to be so meaningful and joyous as to set the NBAF apart from all other local, regional, and national festivals I have experienced."[39] Freeman curated an exhibit of his photographs in the 1988 festival and a fuller exhibit of quilts from his personal collection in 1990. Art quilters such as Faith Ringgold have exhibited their work at the festival.

Since the NBAF promotes African American cultural production, black quilt exhibits are considered within a sphere of ethnically similar art, music, and performance. At the NBAF, less attention is paid to rigid authenticity. Black quilters who have learned their craft from books are as welcome as those who have learned from their grandmothers. Although the festival's goals include education, its mission does not prioritize preserving or documenting African American cultural practices for the purpose of future academic study. Its organizers lack the institutional clout of the Smithsonian Institution and must concern themselves with the extraordinary costs of mounting the extravaganza.

CONCLUSION

As a black woman and a quilter, Daisy Anderson Moore has far more options than did Harriet Powers. In the hundred years or so between the exhibition of Powers's Bible quilt at the Cotton States and International Exposition and Moore's display of her Underground Railroad quilt at Southern University, African Americans have successfully improved their standard of living. Dire financial hardship forced Powers to sell her quilt, and it is fortuitous that its buyer preserved it and her version of Powers's story. Daisy Moore enjoys a level of personal financial security that protects her from ever having to sell her quilts. The scholars who have found their way to her door are African American, and, in any case, she decides how much or little to share with us. She's opted to record her own family history so her grandchildren and great-grandchildren will know her perspective on their legacy.

Like many African American quilters she's not particularly concerned with any academic debates over the authenticity of her quilts. As an avid reader, though, she's pleased by the books and articles that have been written about

black quilting traditions. Since she freely acknowledges how influential "how-to" books have been on her personal quilting practices, she's unlikely to be invited to the Smithsonian Festival of American Folklife (now called the Smithsonian Folklife Festival) or be competitive for a National Heritage Fellowship. Nonetheless, her quilts and wisdom about them are in demand. She doesn't mind that they are more coveted for public display in February than during the rest of the year. Her identity as a black woman poses no particular obstacles to the enjoyment she garners from sharing her quilts. For Daisy Moore, such sharing is a source of pride.

Chapter Eleven

BLACK QUILTS/WHITE WALLS

"Hang them," she said. As if that was the only thing you *could* do with quilts.[1]

From black women who go to their Baptist church five times a week to Muslim men who pray five times a day, from NPR addicts to NASCAR fans, people have much to say about the striking quilts they've seen hanging in any number of places. Since the time nearly twenty years ago when I started interviewing African American quilters and studying the history of black quilts, I have fielded many questions and comments that reflect their visibility in literary, popular, and high culture. The quotation above foreshadows the movement of black quilts from beds to walls, and comes from Alice Walker's celebrated 1973 short story, "Everyday Use." Many of Walker's peers—the major black writers of the past fifty years—have incorporated quilts into their fiction. Book lovers immediately ask me if I have read Walker's "Everyday Use," and virtually all questioners profess a great fondness for the story. My colleagues who teach African American literature almost always try to include it in their courses, and, in fact, it's a fixture on the reading lists of many courses in American literature.

I also encounter a lot of questions about the more prominent black art quilters, those creative artists whose quilts were made to hang in galleries and other public venues. I'm asked if I'm studying the artistic and literary work of Faith Ringgold, probably the most well-known and well-documented black art quilter. Frankly, I feel my age a bit when college freshmen remark that they read *Tar Beach* or *Aunt Harriet's Underground Railroad in the Sky*, Ringgold's quilt-based children's books, *years* ago, when they were in preschool or elementary school. With the possible exception of *Little Black Sambo*, I myself didn't read

a work of fiction featuring a black protagonist until I was in high school, and now my college students' first literary experiences include black quilts as plot elements.

More and more, I'm also asked about the heroic stories linking quilts to the Underground Railroad—the secret routes eighteenth- and nineteenth-century slaves took from the South to the North. These questioners have heard that abolitionists hung quilts in specific locations to signal a safe haven for runaway slaves. Or they've heard that maps were camouflaged in quilts. Black men and women have sought me out to look at their old inherited quilts, hoping I'll tell them that their treasured family heirloom contains one of the special blocks that signaled a path from slavery to freedom.

I also hear a lot from art museum patrons about the highly acclaimed exhibits based on the quilts from rural Alabama. To date, The Quilts of Gee's Bend and the sequel, Gee's Bend: The Architecture of the Quilt, have been mounted in upscale exhibition spaces in Texas, New York, Washington, D.C., and California, to name just a few locales. To the extent that quilts and quilters can generate a cult-like following, the quilts and quilters of Gee's Bend have done so. Devotees can wear Gee's Bend quilt–inspired scarves or neckties; they can attach their children's pictures to the refrigerator with Gee's Bend magnets; they can surf the Internet more smoothly with Gee's Bend mouse pads. And there's great interest in whether or not their quilts reflect an African sensibility; folks want to know if their favorite quilt motifs are, in fact, African-derived design elements.

Thus, Alice Walker's story proved to be a harbinger: "hanging" black quilts has become almost commonplace. In 2006, an interested black quilt fan could admire striking black art quilts on the walls of the Brooklyn Museum and the New York Historical Society, as well as utilitarian quilts used as props on stage at the Broadway Theatre in the award-winning musical production *The Color Purple*. Californians could check out an exhibition on four generations of African American quilters at the Museum of Craft and Folk Art in San Francisco or make their way over to the more stately (and pricey) de Young Museum to explore the Bay Area's first Gee's Bend exhibition. The new Museum of the African Diaspora, also in San Francisco, hosted quilt-making demonstrations and historical lectures by black quilt scholars.

Black quilts were on display in middle America as well. Towards the end of 2006, the Figge Art Museum in Davenport, Iowa, hosted a major exhibit of African textiles and African American quilts from the collection of noted

curator Eli Leon. The second Gee's Bend exhibit opened at the Museum of Fine Arts in Houston and went on to the Indianapolis Museum of Art at the end of the year. One of the year's popular DVD releases, *Hustle and Flow*, features a well-worn family string-pieced quilt being used to soak up extraneous noise as the film's brash hero records "It's Hard Out Here for a Pimp," in the back bedroom of his ghetto bungalow. At the end of the year, the U.S. Postal Service released first-class postage stamps imprinted with images of the Gee's Bend quilts.

Clearly, African American quilts have accrued enormous value—and not just the sentimental or symbolic varieties. Black quilts now have worth beyond the interfamily struggles over them in any one household, a situation enacted in "Everyday Use." They have value to writers—not just Alice Walker, but Gloria Naylor, Margaret Walker, Toni Morrison, Walter Mosley, and other prominent authors as well. They have value for artists such as Faith Ringgold, Ed Johnetta Miller, Aminah Brenda Lynn Robinson, and other marquee artists. Collectors, curators, and art dealers have infiltrated the black quilt world, bringing with them previously unknown commercial complications. The elevation of black quilts from functional bedcoverings to art objects has been accompanied by myriad developments—some good, some not so good. And by understanding the popularity of quilts signaled by the response to "Everyday Use," we can better understand the past forty years of black life.

"EVERYDAY USE"

Alice Walker's moving and masterful telling of one black family's poignant struggles over inherited quilts, published in 1973—an early point in post–civil rights movement America—makes "Everyday Use" the perfect point of departure for an examination of contemporary black issues as seen through the prism of quilts. "Everyday Use" is one of the most frequently anthologized short stories in African American literature, and for good reason: in a dozen or so fictional pages, Walker offers a cogent vignette inhabited by three black women grappling with the legacies of Jim Crow rural black life and the promises and pitfalls of the post–civil rights era. In many respects, the emotional dilemmas confronting the Johnson family are ones that many black families of the 1970s were negotiating.

The sensitive story is told from the point of view of a rural African American mother who has promised heirloom family quilts to her younger daughter, Maggie, the timid one who stayed in the South. Mama's older, more formally educated daughter, Wangero (named Dee at birth), has developed a sudden nostalgic attachment to these particular quilts. Wangero (Dee) argues that unsophisticated Maggie won't safeguard Grandma Dee's quilts appropriately, that she might even relegate them to "everyday use." If Mama wisely bequeaths them to Wangero (Dee), the educated daughter won't use them on beds; she'll hang them on walls to symbolize her heritage. But Mama is unpersuaded by this reasoning. Grandma Dee's quilts will remain Maggie's dowry, and Wangero (Dee) can help herself to any of the other quilts still in the household.

Within the framework of the story, Mama and Maggie, both quilters themselves, treasure Grandma Dee's handiwork because it connects them to her and those family members whose well-worn clothes are preserved in the quilts. Wangero's attachment to their rural southern past is much more ambivalent. Determined to escape the dreary environs of her youth, she has long ago abandoned Grandma Dee's name and earlier had rejected a quilt from Mama when she left for college. But now, she wants to mount her grandmother's vintage quilts on her walls where visitors will covet them and associate her with the newly affirmed aesthetic traditions of black America.

In light of the issues raised in previous pages, one of the key moments in the story comes when Wangero (Dee) unpacks the quilts from a trunk in Mama's bedroom. At the time of publication, this aspect of Walker's short story was being enacted throughout black America. Quilts like Grandma Dee's were being ferreted out of dusty trunks in black households in the North as well as the South. Real-life Wangeros who had avoided quilting lessons from their kin were starting to enroll in classes and buy books on the subject. Young men and women who had closeted the quilts their grandmothers had sent with them to their dormitories suddenly were substituting them for the store-bought bedspreads that once seemed so much more stylish. Black family quilts came to augment the decorative accessories on display in family and living rooms. Quilts were emblematic of numerous everyday artifacts, of music, foodways, and gardening, things that previously had been overlooked and even scorned but that now could be seen as cultural resources. Many black Americans had once felt compelled to reject all vestiges of their southern rural past. Using quilts as an example, Walker captures the realization that occurred in the 1960s and 1970s, when many formally educated

blacks shared a genealogical epiphany. In spite of the economic deprivation endured by African Americans, the cultural legacy was a rich one, worthy of celebration and reverence. While the cramped shotgun houses inhabited by the Johnsons and countless other black families were drafty and dark, these simple structures sheltered ancestral lessons and handmade objects worth preserving.

After family quilts were retrieved from trunks, attics, and basements, they remained as particularly revered commodities. Numerous social, cultural, and economic factors coalesced in ways that sustained this abiding fascination with black quilts. Much of the impetus stemmed from the burgeoning academic field of African American studies as well as the blossoming interest in black genealogy. With an unprecedented amount of research being conducted about black history and artistic production, the everyday achievements of slaves and their descendents were receiving long-overdue attention.

Serendipitously, the feminist/womanist movement was elevating the worth of the domestic accomplishments of the very real women upon whom Walker modeled Grandma Dee, Mama, Wangero, and Maggie. A strip quilt stands as tangible evidence that the eyes of black women saw potential in used fabric and discarded feedbags. A new quilt top pieced onto a fraying older quilt stands as tangible evidence of how hard black families had to work to keep their elders and offspring warm. A double wedding ring quilt stands as tangible, visual evidence that the hands of black women (and men) had mastered highly complicated skills. To be a family whose trunks contained quilts was to be a family with a past of which to be proud. So the well-worn quilts came out of the trunks in the attic or out from the back shelves of closets.

Even three-plus decades after the publication of "Everyday Use," we still see in it underlying issues that continue to surface within the black community. In this short story ostensibly about a family quarrel over quilts, Walker systematically tackles black history, gender, education, art, and family matters.

CONCLUSION

The following chapters document the myriad ways in which quilt quarrels have come to echo cultural struggles. These last chapters build upon one another like the rectangular strips that a quilt maker uses to construct a log cabin square. The shortest one at the top is as significant as the widest one at the

bottom. The chapters come together and explore the public presence of black quilts and the proliferation of debates about black quilts as they emerge in the public sphere. The chapters are about the shifting values bestowed upon black quilts and quilters, about dilemmas and developments of importance within the African American community. These chapters are about contemporary American cultural issues.

Chapter Twelve

LIFT AS YOU FLY:
FAITH RINGGOLD

A white wall in the Harlem brownstone of celebrated author Maya Angelou is adorned with a striking story quilt.[1] The quilt was a birthday gift from her friend, the noted entertainment industry giant Oprah Winfrey, who had commissioned artist Faith Ringgold to create one of her signature story quilts in honor of Angelou. That Angelou, Winfrey, and Ringgold came together around a quilt project seems more than fitting. All three of these black women hold comparable levels of esteem in their respective fields. When it comes to influencing the tradition of African American autobiography, Angelou is at the head of the class. Winfrey's stature is unprecedented in the entertainment industry, with her name frequently atop various "wealthiest" and "most influential" lists.

And within the world of folks who know anything at all about narrative quilts, Faith Ringgold enjoys the highest acclaim of all contemporary story quilters. Ringgold's intricate painted fabric story quilts frequently include majestic urban bridges, and the ambitious female figures she appliqués and paints onto them fantasize about sprinting, flying, or floating over the concrete and steel expanses. It is an image relevant to all three of these famous black women. Born in pre–civil rights era and pre–women's movement America, Oprah, Maya, and Faith also had ambitious dreams of an adulthood unencumbered by restrictions imposed on them by their race and gender. While they now serve as exemplars for countless women, as young black girls they lacked African American female role models. That they found their way across their respective bridges stands as testimony to their intellects, their tenacity, their creative abilities, and an abiding fierceness that characterizes the black

women who have beaten the odds and achieved widespread attention and respect.

While the economic status of African American women as a group still lags, a few remarkable black women have attained great success. In addition to possessing enormous creative abilities, quilter-artist Faith Ringgold is noteworthy for her keen business sensibilities. By reviewing the choices she made in the dissemination of her art and the articulation of her abilities, we can better understand how some African American women were able to achieve prosperity.

COMING OF AGE ON SUGAR HILL

Born in New York City in 1930, Faith Jones enjoyed a more secure childhood than most black children during the first half of the twentieth century. Her maternal grandparents had been amongst the tens of thousands of blacks who, seeking better opportunities, migrated from the rural South to the urban North. Her father, Andrew Jones, made his way from rural Florida to New York City, where he "was a truck driver for the Sanitation Department, and his pay of $36.20 per week was a good wage in those days."[2] During Faith's early years, her mother, Willie Posey, was one of the rare black women who could afford to stay home with her children. Consequently, she had the time to craft impeccable outfits for her children, who grew up in a home where sewing was an everyday activity. During World War II, Willie went to work in the defense industry, taking advantage of her sewing acumen. She snared a good job making military uniforms. Andrew and Willie ultimately divorced, and Willie leveraged her seamstress experience into a postwar career as a fashion designer.

By the time Faith was a teenager, Willie had moved her three children from a working-class Harlem community to a posh Sugar Hill neighborhood. Black America's most noteworthy sons and daughters—Thurgood Marshall, W. E. B. Du Bois, Duke Ellington, Willie Mays, Paul Robeson, Marian Anderson, and numerous other African American celebrities—made their homes on these avenues between Edgewood and Amsterdam and the streets between 145th and 155th. While Willie didn't quite belong to the upper tier of the black bourgeoisie, she sustained a relatively comfortable lifestyle for herself and her one son and two daughters. Willie's clientele was firmly rooted in the black upper classes; she specialized in designing one-of-a-kind garments that well-

heeled black women could wear to concerts, cotillions, weddings, and other formal events favored by affluent blacks.[3] Thus, Faith Ringgold came of age in a household headed by an artistic, successful, and confident black woman who encouraged her children to aspire to greatness.

The flamboyant Willie Posey's creative and technical skills were inherited by her talented daughter. But instead of making peplum suits for the black elite of Harlem and Martha's Vineyard, Ringgold initially pursued a career as a painter. She attended New York City's venerable City College, where she majored in art and education. By the 1960s, she was teaching in the public schools and actively seeking to establish a reputation as an artist.

BECOMING A BLACK ARTIST

Like so many urban African Americans of her generation, she eventually adopted the powerful exhortations of the Black Power movement. Her paintings reflected her political principles and social convictions. Her confrontational canvases, with titles such as *Flag for the Moon: Die Nigger* and *Big Black*, were initially rejected, even by other black artists. But Ringgold defiantly persevered, in spite of the initial hostility to her work, and by 1967, she had been featured and favorably reviewed in her first solo art show in New York City. Between the late 1960s and the early 1980s, Ringgold expressed her artistic and political insights through paintings, posters, dolls, performance pieces, masks, soft sculpture, and tankas, a type of fabric wall hanging created by Tibetan Buddhists.

She became well known in some artistic circles and was able to support herself as an artist, but she also began to amass significant evidence that racism, sexism, and artistic elitism had continuously impeded opportunities for black artists. When the Whitney Museum of American Art devoted an exhibit to the paintings and sculpture of the 1930s and neglected to include a single African American artist, Ringgold spearheaded the effort to hold a demonstration outside the museum. She was also on the front lines of the movement to position women's art on the white walls of museums such as the Museum of Modern Art and the Whitney. All the while she was experimenting with familiar and unfamiliar artistic tools.

By 1983, Ringgold had tested working with fabric, paint, words, and other elements, all of which would come together in her first story quilt, titled

"Who's Afraid of Aunt Jemima?" The ninety-by-eighty-inch quilt is comprised of acrylic paint on canvas, as well as dyed, painted, and pieced fabric. In that it contains eighteen blocks of brightly colored, half-square, strip blocks, it resembles a very traditional, common African American quilt. But these conventional blocks are outnumbered by twenty-seven fabric and paint portraits of four generations of a black American family. Using nine blocks for words, Ringgold inscribes the quilt with the story of a family who must grapple with many of the challenges of nineteenth- and twentieth-century life. Grandpa and Grandma Blakely and their descendents buy their way out of slavery, set up family businesses, migrate to Harlem, and serve in the armed forces in Korea, all the while trying to ensure that each generation finds itself in improved circumstances. The Blakelys exemplify the aspirations of numerous upwardly mobile urban black families of the 1960s and 1970s. Although other artists had used quilts to tell stories before, Ringgold made quilts into multidimensional book-like extravaganzas. Even more than in her paintings, posters, and other genres, she could use this form to tell the kinds of epic family stories that appealed to her. And the story quilts delighted her expanding audience.

Although she retired from public school teaching when the income from her art career became steady and reliable, Ringgold's devotion to children never subsided. Well aware of the dearth of African American heroes and heroines in children's literature, she collapsed several of her story quilts into vibrant children's books. Using the story she created for "Tar Beach," the first quilt from her popular "Women on a Bridge" series, Ringgold offered her young and not-so-young readers a captivating tale of eight-year-old Cassie Louise Lightfoot's infatuation with the George Washington Bridge. Unafraid, Cassie makes up her mind to overcome her family's obstacles by flying over them.

The "Women on the Bridge" series in general and "Tar Beach" in particular are far more accessible works than many of Ringgold's earlier, more confrontational pieces of art. "Tar Beach" doesn't feature any distorted American flags or bleeding human figures. Racism does surface in the story: a "grandfather clause" renders Cassie's father ineligible for the union. But the eight-year-old is optimistic about enabling him to overcome the prejudices of the bosses who denigrate him for being "colored or a half-breed Indian."[4] Cassie's plans include giving him the bridge, as well as ensuring that her family has ice cream for dessert every night. Both the quilt and the book struck positive chords, with the latter winning many prizes, including the prestigious Caldecott

Medal, probably the highest honor possible for a children's book. Cyré Cross recalls writing a paper about it when she was in the fifth grade; *Tar Beach* and the other children's books that followed are mainstays in elementary school libraries.

Many of Ringgold's actual story quilts are in the collections of first-tier museums and galleries: the Solomon R. Guggenheim Museum, the Metropolitan Museum of Art, the Museum of Modern Art, the National Museum of American Art, and the Philadelphia Museum of Art are just a few of the high-profile venues that own original Ringgold works. But this prolific artist also makes clear that just because a museum has acquired a black quilt does not mean that they will display it. In her 1995 autobiography, *We Flew over the Bridge: The Memoirs of Faith Ringgold*, Ringgold notes that a private collector gave "Tar Beach" to the Solomon R. Guggenheim Museum. According to Ringgold, legions of young patrons who have read her award-winning children's book derived from the quilt have made pilgrimages to the museum, only to learn that it is not on display. To be sure, most museums can only exhibit a small fraction of their holdings at any given time. Nonetheless, Ringgold persuasively argues that elite museum policies and practices frequently reflect ambivalence about black quilts on white walls. She praises the persistence of her young fans, and concludes that "if Tar Beach ever hangs on the walls of the Guggenheim, it will be due to the children."[5]

Faith Ringgold's generation of black artists was probably the first to have the education and autonomy to maintain control over their creative work. Very early in her career, Ringgold secured the services of competent professionals to exhibit and market her oeuvre. But she always took care to retain appropriate oversight. Her agents and galleries worked for her, not vice versa. Further, she continues to maintain scrupulous control of the images from her work—posters, puzzles, dolls, greeting cards, books—that are the more commercial by-products of her story quilts.

DEFENDING AND PROMOTING BLACK ART

By producing postcards, posters, calendars, children's books, and similar items, Ringgold provides less affluent fans with opportunities to own "a Ringgold," and, of course, the sale of these items generates revenue for her that augments the income she derives from the sale of her story quilts. Circa 1989, I bought

my first Ringgold, a twenty-dollar poster version of her "Church Picnic Story" quilt. I had it framed (for several times the cost of the poster), and it hangs on a white wall over the antique Singer sewing machine that my husband and I inherited from his relatives.

Ringgold is adamant that she should realize the appropriate profits from her work. In 1995, while she was watching an episode of the situation comedy *Roc* on Black Entertainment Television (BET), Ringgold noticed the poster of her "Church Picnic Story" quilt on the walls of a fictional black church. The set designers had selected this particular poster because it evoked the mood they wanted for the scenes of a children's church concert. And in fact, through her art dealer, Ringgold had granted a nonexclusive license to the High Museum of Art in Atlanta to sell the posters. To Ringgold, this arrangement would allow fans like me—folks who could never afford the tens of thousands of dollars that an original Ringgold story quilt retails for—to have an exemplar of her talents in our homes.

She had not envisioned, however, that the nonexclusive license would either allow or enable BET to use her artwork on a television program. Hence, Willie Posey's confident daughter, Faith, nurtured amongst the black intelligentsia on Sugar Hill, sued BET for copyright infringement. Although initially the lower court sided with BET, Ringgold and her attorneys appealed. The appellate court agreed with Ringgold and referred the case back to the lower court. By pursuing her artistic rights so ferociously, Ringgold further positions herself in the pantheon of strong African American women she has so frequently celebrated in her story quilts. Within the art world, she now functions as Ella Baker, Sojourner Truth, Ida B. Wells-Barnett, Rosa Parks, and others have done in the political realm.

In keeping with the "lift as you climb" mandate (Ringgold would probably prefer "lift as you fly"), which is so meaningful to black women's self-help organizations, Ringgold has established a not-for-profit 501(c)(3) corporation appropriately named the Anyone Can Fly Foundation. Its mission reflects the values she has promoted since her girlhood in Harlem, "to expand the art establishment's canon to include artists of the African Diaspora and to introduce the Great Masters of African American Art and their art traditions to kids as well as adult voices." The foundation provides academic and public sector researchers with the funds to conduct and publish research on African American artists born before 1920. It also provides curriculum development resources to enhance the teaching of black art in schools.

From her own mother, Ringgold was bequeathed both artistic sensibilities and unflagging stamina. She has optimized these gifts and, in turn, is sharing them with future generations. Because she has promoted and protected her artistic output, her own daughters and grandchildren will likely be well positioned to fulfill their own aspirations. By channeling some of her resources into her foundation, Ringgold has also ensured that her work will have an impact beyond the scope of her own family. This kind of financial security and flexibility is a relatively new and most welcome development within the African American community.

The story of Faith Ringgold—quilt maker, artist, and businesswoman extraordinaire—reveals much about the obstacles faced and achievements reached by members of the African American middle class. Ringgold was born in the 1930s into a black family more privileged than most at the time. Compared to most working-class blacks, young Faith came into adulthood with both a solid education and previous exposure to African Americans who had achieved high levels of professional success. Her mother's fashion clientele came from the upper echelon of black society as it existed in the mid-twentieth century. But the standard of living enjoyed by even the most successful African Americans was meager in comparison with that of the white upper classes. Faith Ringgold was eager to redress these and other racial and gender-based inequities, and partnered with other black activists to use her creative abilities in the service of social and cultural justice. Her search for her niche within the art world and for a medium suitable to her vision led her to quilts—quilts unlike any ever placed on a bed or a wall—and from them she has achieved a level of widespread recognition and success. The story of Ringgold's artistic career reveals much about the achievements possible for black Americans in the latter half of the twentieth century and the first decade of the twenty-first.

LEGENDARY QUILTS

"Like most Americans, probably, I first heard of the Underground Railroad in the form of legend."[1] So recalls Fergus M. Bordewich in the introduction to his prize-winning, meticulously researched history of the Underground Railroad, *Bound for Canaan: The Epic Story of the Underground Railroad, America's First Civil Rights Movement.* He continues his recounting of oral tradition by sharing the story of an African American neighborhood in his suburban New York hometown where, legend had it, fugitive slaves had escaped from the South, settled, and built their first homes on free soil.

Bordewich's recollections are similar to my own, although I grew up over a hundred miles from his native Westchester County. Speaking about St. David's AME Episcopal Church on Eastville Avenue in Sag Harbor, New York, family members, neighbors, and teachers alike claimed that the only church still standing in the African American section of the small historic village had once been a "station"—a temporary hiding place where fugitive slaves could be sheltered—on the Underground Railroad. The timing of the church's construction—1840, when the Underground Railroad was in its ascendancy—and the relative success of Sag Harbor's nineteenth-century black population lend credence to the local legend. In the early nineteenth century, when the abolitionist movement was gaining momentum elsewhere in the eastern United States, Sag Harbor was coming into its own as a highly prosperous whaling port. It is known that free blacks were among those who worked on the whaling ships, and several African American families settled in the Eastville section of Sag Harbor. In 1840, along with members of the nearby Native American communities, these families built a house of worship for local people of color, one

that stands to this day. But Bordewich, clearly one of today's leading authorities on the Underground Railroad, was unable to unearth any documentation to support his childhood stories about his hometown, and Sag Harborites lack compelling documentation to substantiate St. David's stature as a station.

Bordewich explains the proliferation of unsubstantiated Underground Railroad landmarks by likening this phenomenon to the Lewis and Clark Expedition, the California gold rush, and a handful of other episodes in American history that share deeply romanticized characteristics which have long attracted popular attention and partially informed speculation. Because its efficacy was linked to secrecy, the Underground Railroad did not generate a copious paper trail. The fugitive slaves who were able to access it did so largely through word of mouth, and oral tradition regarding it has always been lively. Without ever really being exposed to the limited historical documentation on the workings of the Underground Railroad, many Americans think they know more information about it than can actually be substantiated. In addition to the local legends like the ones Bordewich and I heard as we were growing up, similar motifs emerge in the many movies, novels, stage shows, and children's books that have contributed to common understandings and misunderstandings about it.

For well over a decade now, "quilt" and "Underground Railroad" have been linked in stories people tell about America's first civil rights movement. Like earlier narratives, these accounts comingle hearsay and historical evidence in ways that defy authentication. Nonetheless, just as the earlier stories about the Underground Railroad reflect the worldview of those who shared them, so do the recent debates about quilts and the Underground Railroad offer a compelling portal through which to examine contemporary understandings about slavery and freedom. Further, in analyzing the often contentious debate over quilts and the Underground Railroad, we can see and probe the ways in which racially charged cultural assumptions are stated, studied, disseminated, embraced, and debunked.

STORIES FOR CHILDREN

Given the numerous ways in which the realities of American slavery contradict the egalitarian ideals of the Founding Fathers, it is not surprising that teachers and parents trying to educate schoolchildren in the nuts and bolts of early American history have returned to the Underground Railroad as a favored

topic. Underground Railroad stories feature identifiable role models within the context of dispiriting history lessons on slavery. The fugitive slaves who bravely seek their freedom can be cast as unsullied heroes and heroines. As we shall see later in this chapter, the subplot in Harriet Beecher Stowe's *Uncle Tom's Cabin* focusing on the harrowing escape of Eliza, Harry, and George Harris has been a staple of children's lore for well over a century. The abolitionists and Quakers who risked censure and arrest to assist fugitives are also noble heroes and heroines. Numerous stories have been written about Harriet Tubman, a quilter best known for her many daring returns to the South to usher blacks from slavery to freedom. The edifices and tools that enabled the Quakers and abolitionists to protect the runaway slaves are sanctified entities. Like Bordewich, children in Sag Harbor still hear that the quaint church on Eastville Avenue was possibly an Underground Railroad station. But here and in countless other American communities, this generation of children has also read or heard Underground Railroad stories in which quilts function as powerful totems signaling a sanctuary for the brave runaways.

Just as she's been at the forefront of so many artistic and political trends, Faith Ringgold figures prominently in the evolution of the stories about quilts and the Underground Railroad. After the success of the children's book *Tar Beach,* which she penned in conjunction with the story quilt of the same name, she published her second book on this theme, *Aunt Harriet's Underground Railroad in the Sky*. It was one of several fictional children's books written in the early 1990s that posited a connection between quilts and the Underground Railroad—the term used to describe the often perilous routes used by fugitive slaves who sought a pathway from the slave states of the South to the free states of the northern United States and the even safer country of Canada. Along the way, abolitionists and other sympathizers offered their homes, barns, and churches as temporary shelters to fugitive slaves. Often these escapes were facilitated by former fugitives referred to as conductors, the best known of these being Harriet Tubman, whose courage and cunning Ringgold celebrates in her book. Within this fanciful story, the young time-traveling heroine Cassie learns that runaways have been assured that a house with a quilt on its roof waits to shelter them.

The plot of *Sweet Clara and the Freedom Train,* published in 1995 by Deborah Hopkinson, also interweaves quilts and the Underground Railroad. The picture book, aimed at the lower elementary grade levels, tells the story of a precocious slave girl who crafts a patchwork quilt containing a disguised map

that reveals a safe route from the slave states to Canada. Twelve-year-old Clara has had rare access to valuable geographic information, and before using it to forge her own escape, she applies both her seamstress skills and her knowledge to construct a coded quilt that other slaves will be able to follow to freedom.

The commercial and critical success of all of these children's books is doubly notable. First, prior to the 1990s, juvenile literature featuring black protagonists constituted a relatively new phenomenon. Certainly, when Willie Posey was bringing up Faith Ringgold in the 1930s and when Ringgold was raising her daughters in the 1950s, there were few, if any, heroic black children featured in mainstream children's literature. Probably the only black face was the asphalt-colored one of Little Black Sambo, a comic and unflattering image unlikely to inspire African American pride. Prior to the civil rights movement, African American children and the children of progressive white parents and schools were usually exposed to Harriet Tubman and similar icons only during Negro History Week celebrations. In the 1990s, *Tar Beach*, *Aunt Harriet's Underground Railroad in the Sky*, and *Sweet Clara and the Freedom Train* were popular both within and beyond the black community, proving that the right kind of story with African American protagonists would appeal to a sizable market. When I referred to these books in a lecture to a class of college freshmen in 2005, several students of Asian, Latino, and European descent shared fond memories of reading about Cassie and Clara when they were in elementary school. My students' familiarity speaks to the cultural significance of these publications—first, in that they represent a long-awaited moment in which narratives of black life are deemed relevant and worthwhile stories for all American children, and second, in their role in perpetuating connections between black quilts and the Underground Railroad. Whereas Bordewich and I can trace our understandings of the bravery of fugitive slaves and those who protected them back to specific geographic landmarks in our hometowns, many folks who were children in the 1990s will have a fabric touchstone with which they associate the Underground Railroad.

QUILT/WOMEN'S/AFRICAN AMERICAN STUDIES

By the 1990s, when these books were published, the core story—that quilts were used as codes on the Underground Railroad—was moderately familiar to those who paid close attention to African American folklore studies or who

followed the study of quilt history. Pioneering quilt scholar Gladys-Marie Fry, who had studied the African American oral tradition, suggested that quilts were sometimes used as markers of the houses on the Underground Railroad.[2] The award-winning quilt documentary *Hearts and Hands* also made a very quick reference to quilts and the Underground Railroad.[3]

In 1993, about the same time that *Aunt Harriet's Underground Railroad in the Sky* was first captivating youngsters, Jacqueline Tobin, an author and college instructor, perused an antique stall in a Charleston, South Carolina, shopping mart. The stall's proprietor, an older black woman named Ozella McDaniel Williams, was selling homemade quilts. According to Tobin, Williams reinforced her sales pitch by offering an elaborate account of a quilt code used by slaves on the Underground Railroad. Williams's meandering tale claimed that familiar quilt blocks such as the "Bear's Paw," "Monkey Wrench," "Log Cabin," and "Dresden Plate" were assembled in ways interpretable to conductors and fugitives needing a map to guide them out of slavery. Tobin consulted with African American art historian and quilter Raymond Dobard, who agreed that Williams's story was plausible; together, Tobin and Dobard decided that they were the right pair to write a book about the code and the Underground Railroad. Acknowledging that their sources were limited, the coauthors of the resultant *Hidden in Plain View: The Secret Story of Quilts and the Underground Railroad* carefully inform their readers that their evidence comes from oral testimony handed down from one generation to the next in one family: "Ozella received [the story of the code] from her mother, who received it from Ozella's grandmother."[4]

Hidden in Plain View was published in 1999, and, in the finite corpus of books on African American quilting, it is probably at the top of the best-seller list. For all of the reasons that young readers embraced the stories contained in *Sweet Clara* and *Aunt Harriet*, older readers also were enthralled by Ozella McDaniel Williams's account, in which flying geese motifs signaled the need to persist towards the North and "Monkey Wrench" blocks meant that the fugitives should assemble their tools to get ready for their escape. In an author's note, Dobard concedes, "Our interpretation of the code is based in part on informed conjecture. While we believe that our research and the piecing together of our findings present a strong viable case, we do not claim that our 'deciphering' of the code is infallible. Nor do we insist that our perspective is the only one for viewing the code. We have written the book in a way that encourages questions."[5] Initially, the book received a great deal of favorable

attention and publicity. Dobard was interviewed on *The Oprah Winfrey Show*, always coveted exposure for an author.

But not all readers were favorably impressed by the book and the research that undergirds it. Historians, folklorists, and other scholars who work with oral testimony were disappointed that the authors relied on only one informant and didn't take any steps to corroborate her story with other extant sources. Dobard and Tobin didn't seek out other black men and women of Williams's generation, whose ancestors might have passed on stories about the Underground Railroad, nor did they probe written documentation that might have validated or disputed the Williams family recollections. Quilt scholars were dismayed by the lack of rigor the authors employed in matters related to textile history and scholarship. One concerned textile scholar summarizes the outcry against the book: "[P]rofessional historians and an increasingly vocal group of laymen and women students of quilt history and the history of African-Americans have decried the 'Quilt Code' as without factual basis, accusing its proponents of sloppy scholarship at best and sheer hucksterism at worst."[6] Dobard and Tobin didn't offer any valid explanations as to how quilt motifs and fabrics unknown in any other antebellum quilts were used in the quilt code, particularly since there were no concrete examples of any real quilts actually containing such a code. Some of the sources that Dobard and Tobin did cite were unorthodox at best; they even footnote *Sweet Clara and the Freedom Train*, undoubtedly one of the first instances in which a children's picture book is used for the purposes of scholarly verification.

One of the most telling clues to the precariousness of the theory as delineated in *Hidden in Plain View* is discernible in Jacqueline Tobin's more recent book, *From Dawn to Midnight: The Last Tracks of the Underground Railroad*. Tobin's reputation as a coauthor of the most prominent book on the quilt code along with the title of this 2007 publication would suggest that it expands on the use of quilts as tools for the escape of fugitive slaves. But Tobin doesn't even include *Hidden in Plain View* in the bibliography of *From Dawn to Midnight*. Although she does refer to some of the more interesting ways in which escapes were facilitated—for example, she tells the story of an abolitionist/ornithologist who used his bird watching as a cover when meeting with potential runaways—she never mentions the quilt code. The only reference to quilting in the entire book comes in a quotation from early women's rights activist Susan B. Anthony, who merely refers to her diminishing interest in her own quilting. *From Dawn to Midnight* boasts an extensive bibliography, one much richer in

Underground Railroad sources than is present in *Hidden in Plain View*. By publishing a book on the Underground Railroad that lacks any references to quilt codes, Tobin seems to be conceding that her earlier work is flawed.

In most circumstances a new book by an author sells better during the first few months after its release than an earlier book by the same author. As of this writing in early 2008, the sales figures on Amazon.com suggest that more readers are still buying *Hidden in Plain View*, now nine years old, than *From Midnight to Dawn*, Tobin's current book. In fact, the appeal of *Hidden in Plain View* seems to have suffered very little as a result of the failure to cite it in *From Midnight to Dawn*, or of the Web pages, conference papers, and articles that question its veracity and are critical of the research skills of the coauthors. Any bookstore with a sizable inventory of books on African American culture or quilt studies is likely to have copies of *Hidden in Plain View*. Upon hearing of my research into African American quilters, people often assume I can explain how the Underground quilt code worked. Belief in the Underground Railroad quilt code continues to proliferate. I note in the profile of Daisy Anderson Moore that this retired high school science teacher resumed quilting after a self-imposed hiatus because of her desire to make her own version of an Underground Railroad quilt. Numerous other individual quilters have paid tribute to the courage of those who traveled by the Underground Railroad by making quilts that contain the motifs associated with the code. Ironically, as more and more research fails to unearth any concrete connections between quilts and the Underground Railroad, the more resilient and accepted the original accounts of a connection have become.

MULTIPLE IDENTITIES AND AFFILIATIONS

A lot of people take the quilt code controversy very seriously. The cast of professional academics invested in the debate is an uncharacteristically lengthy one. The controversy has been of interest to credentialed textiles and quilt scholars, American historians, women's and ethnic studies authorities, and specialists in American literature. But both quilt studies and African American studies are fields that have inspired many individuals without the standard academic credentials, such as master's degrees or doctorates of philosophy, to immerse themselves in the subject matter as labors of love, and many of the more dedicated individuals are as highly respected in the field as their counterparts

with the more traditional academic credentials. Many such dedicated individuals are vocal regarding the code. More than with other academic controversies, the Underground Railroad quilt debate has also attracted numerous lay stakeholders—owners of real or imagined heirloom quilts, quilt collectors and dealers, members of quilt guilds, elementary school teachers, journalists, and members of Ozella McDaniel Williams's family—who play a significant role in shaping the debate.

All of these stakeholders enter and engage in the debate with the perspective of their training (or lack thereof) as well as attitudes and assumptions linked to their individual identities. In an article summing up several presentations she's delivered on the weakness of the quilt code as outlined in *Hidden in Plain View*, folklorist and quilt scholar Laurel Horton acknowledges that her conclusions that the Dobard/Tobin theory of the code is completely "indefensible" were apt to be greeted with some skepticism because her professional credentials might, in the minds of some, be outweighed by her personal identity "as a white Southerner." And Horton is correct: both the personal and professional identities of individuals engaged in the debate have shaped the discourse. So it makes sense to review some of the professional and personal identities of those who have staked out a position on this topic.

We can begin with the *Hidden in Plain View* authors themselves. Tobin is a writer with particular expertise in women's studies, while Dobard is an art historian with a faculty appointment at Howard University, a historically black institution. Tobin invited Dobard to collaborate on this project, and it is likely that she sought a coauthor whose ethnic and intellectual identity would enhance the overall credibility of the book. Tobin is white, and Dobard is African American. Although Dobard is himself a highly respected quilter, neither Tobin nor Dobard had prior expertise in either the history of the Underground Railroad or of quilts. Enchanted by Williams's story, they did not take enough time to adequately review the literature that would have shed light on her narrative. Their bibliography is passable on Underground Railroad sources, but quite thin in the area of quilt history. They did enlist several other authorities to write introductions and prefaces to *Hidden in Plain View*. In fact, the book is buttressed by more introductory material than is typical, as if the authors had anticipated the skepticism their argument would attract and believed that the more authorities who praised it, the better.

None of the book's introductions was written by credentialed textiles scholars, and it is this latter cohort of authorities who have tended to be the most

vociferous critics of the work. Textiles scholarship remains a field that has not attracted many African Americans. For textiles scholars, the material, the literal material, comes first. Using archives, state-of-the-art scientific techniques and equipment, they can date and scrutinize threads and fabric. Their historical research has produced timelines for the introduction of kinds of fabrics and styles of blocks. Those scholars who specialize in quilts know that album quilts originated in Baltimore, and that the appearance of crazy quilts coincided with the Philadelphia-based Centennial Exhibition of 1876. So they approach anecdotes regarding the quilt code as good textile pathologists, determined to follow the threads to the truth. Since their equipment and timelines offer no substantiation for the claims recorded from Ozella McDaniel Williams or those reported by Gladys-Marie Fry, they steadfastly question the legitimacy of any quilt code and seem enormously frustrated by the widespread and increasing acceptance of the code's authenticity. One extensive Web site, entitled The Underground Railroad "Quilt Code," is so thorough in its repudiation of connections between quilts and the Underground Railroad that its overall word count exceeds that of *Hidden in Plain View*.[7]

Ironically, textiles scholars share with authorities on women's and African American studies their status as academic underdogs: many more mainstream scholars perceive the research from these new disciplines as frivolous and of marginal significance. Thus, at the very time that textiles scholars are trying to establish legitimacy for the entire enterprise of quilt history, the charming story of a quilt code surfaces—a story that can be refuted by the scientific tools that they themselves have developed and for which they seek to gain visibility. Their impatience with the tenacity of the code/railroad stories is quite understandable, although some of the critiques unduly belittle believers. At the end of 2006 the owner of The Underground Railroad "Quilt Code" Web site added a section entitled "Quilt Code Hall of Shame," in which she castigates those who commercialize the code.

Not all academics nor all white specialists have approached the code quite so cavalierly. The research conducted by Marsha MacDowell and Laurel Horton is noteworthy. Noted Civil War quilt scholar Barbara Brackman has taken a particularly engaging approach to the code. In her book *Facts & Fabrications: Unraveling the History of Quilts & Slavery*, she contextualizes the stories within the realm of oral tradition, myth, tales, and legends. Describing how she answers questions regarding the code she states: "We have no historical evidence of quilts being used as signals, codes, or maps. The tale of quilts and the

Underground Railroad makes a good story, but not good quilt history."[8] The bulk of the book, published by a press that specializes in well-regarded "how to" quilt books, then offers its readers instructions on historically authentic quilts that individuals can create to honor the courage shown by blacks during the antebellum and Civil War era. Anyone assuming that African American authorities will reject the research of white scholars need only look at the enthusiastic blurbs on the back cover of *Facts & Fabrications* contributed by Kyra Hicks and Carolyn Mazloomi, both highly respected black authors of books on black quilting traditions.

As the Hicks and Mazloomi endorsements of Brackman's book suggest, not all African Americans who have read or heard of the code assume its veracity and disregard the evidence of its flaws. As is always the case with "retractions," far more people have heard the original narrative—that a code existed and worked—than have been exposed to the debates surrounding its authenticity.

It's easy to understand why nonspecialists, upon reading *Hidden in Plain View* or hearing a synopsis of the argument, would find the story appealing and credible. Many African American families fortunate enough to have what they believe to be very old quilts can be quite enamored of the alleged connections between the Underground Railroad and a quilt code. Slave households were allowed precious few commodities; contemporary African American households, therefore, are more apt to have a passed-down quilt than a two-hundred-year-old dining room table or a jeweled broach that can be traced back to an eighteenth-century ancestor. In addition, although some black families have succeeded in sustaining family stories that can be traced back to the antebellum era, most are unable to give their children specific family narratives related to the deeds of their enslaved ancestors. The story of a quilt code weaves together a special object, a homemade quilt, *and* a great narrative, a tale that depicts the ancestors as heroes.

Not surprisingly, the strongest supporters of a connection are those individuals whose financial well-being is well served by belief in a quilt code. Recall that the late Ozella McDaniel Williams was trying to sell quilts when she shared her version of the quilt code story with a possible buyer. Some of her female relatives and other entrepreneurial black women quilters have cunningly capitalized on belief in the code. With *Hidden in Plain View* as substantiation, they make, market, and sell quilts commemorating the alleged code. Quilters, folk art dealers, and others whose livelihoods can be enhanced by the discovery, display, or sale of quilts connected to the Underground Railroad are as

unlikely to draw attention to the weaknesses in the accounts as they would be to point out weak threads in an antique quilt. Ozella McDaniel Williams is not the first antique vendor to try to close a sale by relating a feel-good story. For better or for worse, buyers often shop for more than just a particular object; they want to own a piece of history about which they can tell a compelling story. By providing purchasers with charming anecdotes regarding their newly acquired wares, vendors like Williams and her relatives are resorting to tried-and-true sales tactics.

Students of African American quilting include more than textiles scholars; they also include academics trained in folklore, American history, and cultural studies, as well as professional curators and quilters who are keenly interested in the history and culture of their craft. There are diverse ethnic identities within these added groups, among which are a significant number of African Americans. Very few, if any, of these specialists deny the weaknesses apparent in *Hidden in Plain View*.

I belong in this category myself and can easily concede the overall flimsiness of the arguments maintaining that the quilts themselves were maps. I don't think my ancestors, or anyone else's for that matter, could have looked at a block with a flying geese motif and understood from it how far and in what direction to run. On the other hand, I don't find it completely implausible that at one time or another during the antebellum era, abolitionists may have used an innocuous domestic object like a quilt to convey the presence of a safe house. After all, antislavery activists couldn't boldly post signs saying "Hide from Slave Catchers Here." But Underground Railroad history doesn't offer many clues that quilts were useful tools. A rather obvious problem stems from the fact that the fugitives would need sunlight in order to see a quilt. Since the sight of any African American traveling was unusual, conductors and fugitives tried to limit their traveling to nighttime, when they would be more likely to avoid encounters with other travelers. On the other hand, history does suggest that conductors and fugitives developed aids that were as clever as the quilt code is alleged to have been. Bordewich offers conductor Addison Coffin's description of the way in which nails and stones were placed in rural North Carolina so that fugitives could find their way:

> At each fork, the fugitive was shown how to find a nail driven into a tree three and a half feet from the ground, halfway around the tree. If the right-hand road was to be taken the nail was driven on the right-hand side; if the left the nail

was to the left. Where there were fences but no trees, the nail was driven in the middle of the second rail from the top, in the inside of the fence, and pointing either to the left or right. When nothing else was available, the nail was driven into a stake or else a stone was so set so as to be unnoticeable by day, but easily found at night.[9]

Nails in trees don't tickle the imagination as much as quilts on clotheslines, but Coffin's firsthand account does demonstrate how ingenious conductors and fugitives were.

In spite of my reservations about the Underground Railroad and quilt code connections, I feel no strong obligation to aggressively discredit the stories or disabuse the many believers I've met. When asked, I certainly share my conclusions and refer to the weakness of the evidence that has been uncovered to date. I know of several other quilt scholars who are similarly disinclined to invest a lot of energy into unraveling the code. I can't speak for the others, but I can share my own perspective—one clearly informed by my orientation as an African American folklorist—as well as information gathered during some presentations by and conversations with other quilt code minimalists. "Was there really a quilt code?" is an interesting question, but it is not the one I find most compelling. Instead, I'm interested in grasping better what this whole saga reveals about different understandings of African American history and culture. Why do so many parents and teachers, black and nonblack, find the children's books about the quilts and the code so noteworthy? Given the grow-ing number of books on African American quilts and quilters, why is *Hidden in Plain View* such a big seller? Why have so many quilters paid tribute to the alleged code by making contemporary code-inspired quilts? Why are some textiles scholars so sufficiently dismayed by belief in the code that they invest what must be hundreds of hours in debunking it? Why has this simple little tale proven to be so potent?

LEGENDARY QUILTS

To probe these issues, we must get beyond the core content—the actual truth claim—embedded in the story. It is important to assign the stories to a suit-able narrative classification. It is important to understand what role is played by the reputations of the people who choose to share the stories as well as the

media they select for dissemination. And finally, it is important to consider how the accounts fit or don't fit with other available information about the Underground Railroad, the institution of slavery, and the status of African Americans in the United States.

A good place to start on these points is with a discussion of nomenclature. What exactly are these accounts? The more stubborn advocates of the quilt code/Underground Railroad connections prefer that these stories be considered as historical "facts." Those equally stubborn researchers entrenched in the camp of the quilt code debunkers often refer to them as "myths" or "fairy tales." None of these labels is satisfactory. On the one hand, we obviously lack the evidence to consider them facts. On the other, the stories also lack the characteristics literary scholars would ascribe to "myths" and "fairy tales." These latter labels seem to be used in order to denigrate anyone who finds the stories genuinely credible.

I think Fergus Bordewich was on the mark with the earlier stated observation that most Americans first hear of the Underground Railroad in the form of a legend. From my perspective, the stories are legendary and best fit the category of contemporary legends (sometimes referred to as urban legends), and the analytical tools folklorists use to document and analyze legendary narratives are extremely useful in understanding the persistence of the Underground Railroad/quilt code cycles. Perhaps these related genres appeal to me because I've written extensively on racially potent contemporary legends. I think some quilt code skeptics would consider my classification of the quilt code/Underground Railroad texts as contemporary legends tantamount to refuting them. But as I explain my rationale, I believe it will become apparent that an important cultural truth undergirds the stories linking the Underground Railroad to a quilt code.

Before analyzing the quilt code as a contemporary legend, I'll review some of the characteristics of other texts that fall into this category. Sometimes contemporary legends feature seemingly mundane commodities. One cycle alleges that Snapple Iced Tea is owned by the Ku Klux Klan; another, that fashion designer Liz Claiborne donates part of her profits to white supremacist organizations; yet another, that Church's Fried Chicken is owned by the Ku Klux Klan.[10] Other cycles feature more weighty concerns: the belief that AIDS was designed as a genocidal weapon; that illegal drugs were intentionally placed in inner-city communities to inhibit black male achievement; that the levees protecting the African American neighborhoods of New Orleans were intentionally

dynamited following Hurricane Katrina in order to limit the growth of the black population. Although these texts have circulated within the African American community, contemporary legends thrive within all kinds of groups. Female college students often assure me that the nutritionists in charge of their campus dining halls stave off eating disorders in the undergraduate student population by surreptitiously dousing the salad bar fodder with tasteless, odorless spray-on carbohydrates. Many middle-class parents of young children persist in believing that Satanists or sadists hide razor blades in apples or otherwise sabotage Halloween treats. Just as there has been much research devoted to demonstrating the lack of evidence for connections between quilts and the Underground Railroad, so, too, have these texts been scrutinized and found to lack substantiation. Nonetheless, it is easy to find folks who believe that divers dynamited select levees in New Orleans, and, each October, thousands of perfectly good apples get discarded as parents worry about stranger danger.

Several common denominators are evident in these texts and the ways in which they are communicated. These contemporary legends are all narratives that are told as if they are true, but all lack reliable standards of evidence. Multiple versions of each legend exist and circulate orally, in print, and on the Internet. Once scrutinized, the evidence of the truth claim embedded in them is often, but not always, found to be weak. Nonetheless, these legends continue to circulate, drawing in new believers, while those investigators who think they have debunked a cycle of texts fret about the susceptibility of believers. In fact, often when individuals hear evidence undermining the truth claim in a legend, they accept that as evidence of the story's veracity.

The actual account that Ozella McDaniel Williams shared with Jacqueline Tobin meets the criteria for a contemporary legend. In a verbal exchange, the quilter told a listener a story that she'd heard from family members and that she conveyed as though she believed it to be true. But she didn't substantiate it with irrefutable documentation. In this version, the quilts are disguised maps. Other early versions differ, claiming that it's the presence of a quilt proximate to a safe haven that establishes the link between quilts and the Underground Railroad. Gladys-Marie Fry, herself an authority on African American contemporary legends, may well have first heard the "quilt on a clothesline" account she refers to in *Stitched from the Soul* from one or more of the many dozens of people she had previously interviewed about slave and Reconstruction-era narratives.[11] Similarly, a comment made in *Hearts and Hands* is offered in the telltale style of a rumor or contemporary legend: "*They say* quilts were

hung on the clotheslines to signal a house was safe for runaway slaves" (emphasis added).[12]

"*They say.* . . ." Clearly, the audience for *Hearts and Hands* is expected to share the narrator's confidence in "they." We most often hear contemporary legends from individuals or sources we trust to be knowledgeable about particular subjects. Through our more informal familial and social networks, we hear "news" about the elements of everyday life that is simultaneously mundane and dense with symbolism. Fried chicken, quilts, salad bars, Halloween treats, and even AIDS are just the kinds of subjects conducive to lively informal exchanges around the dining room table or on the way to work. If your grandmother, who has been a sound source of information about the benefits of wearing a hat in cold weather, tells you that the church near the old graveyard was once an Underground Railroad station or that quilts were used as signals in some communities, you are likely to believe her. If a colleague who gave you good advice about how to get a salary raise tells you not to let your children eat any apples collected on Halloween, you are likely to discard the fruit.

More elaborate renditions of the narratives will often include comments on why other sources may be unreliable on this subject. Many of the people who share the Underground Railroad/quilt code story include references to the many years in which African American ingenuity was intentionally omitted from the history books. Just as the numerous children's books I voraciously read in elementary school all featured white heroes and heroines, so, too, did the history books I was assigned in junior high and high school. In recent decades, African American history has been incorporated more fully into the historical canon, but blacks who came of age before or during the civil rights movement certainly recall when our stories, if covered at all, were handled in a superficial and often stereotypical fashion. As an earlier chapter indicates, for much of the twentieth century, African American religious, cultural, and political organizations used Negro History Week and Black History Month to compensate for the dearth of attention to African American culture in schools.

Does this mean that we are more likely to hear and believe contemporary legends from members of our own ethnic groups? This is often, but not always, the case. When I first started to research contemporary legends, many circulated exclusively within the African American community. Blacks didn't tell whites that Church's chicken contained a sterilizing additive; they told other African Americans. But, and this could be construed as a sign of racial progress, I now find more crossover texts. There are whites who have heard

that drugs are intentionally distributed in inner-city areas. There are certainly whites who have heard about the Underground Railroad/quilt code. But people don't necessarily believe a text because they share the same racial identity as the person telling them a legend. I've certainly interviewed numerous African Americans who never accepted the allegations about Church's chicken, never believed that a conspiracy was responsible for the proliferation of illegal drugs, and never believed that a quilt could have disguised a map to the free states of the North. Yet ethnicity and understandings of ethnicity play a role in quilt code stories, just as they play a role in other aspects of modern life.

As I noted earlier, belief in contemporary legends can actually be enhanced by the accumulation and dissemination of contrary evidence. It is usually not the evidence itself that triggers acceptance, but the caustic attitude of those pushing the evidence. As the now notorious O. J. Simpson trial unfolded, more and more evidence mounted linking the former athlete to the murder of his ex-wife and her friend. Simpson's trial dominated the news, and many white media pundits editorialized about his guilt in advance of the verdict. The more the media was inclined to convict him, the more that many (but not all) African Americans found tenable the conspiracy theories depicting Simpson as a victim of a racist police agenda. Blacks, and some whites familiar with the complicated history of African Americans and law enforcement, were distressed by the intractability of the "convict O. J." crowd. The same phenomenon occurs in discussions about the quilt code. Often those scholars who have compiled the anti–quilt code evidence demonstrate little understanding of how important it is to many black Americans to finally be able to share stories that cast their enslaved ancestors in heroic ways. The textiles scholar who maintains The Underground Railroad "Quilt Code" Web site has clearly become somewhat knowledgeable about the sources and facts of the Underground Railroad chapter in African American history. What is missing from her lengthy assault on the quilt code and those who subscribe to it is any real understanding of the context in which many contemporary African Americans hear stories of their past.

Discussions about those who believe or disbelieve contemporary legends risk an all-too-easy slip into absolutes. Ethnic identity is not an absolute predictor of belief. Just as many African Americans heard the evidence unfold regarding O. J. Simpson and did not believe he was a victim of a conspiracy theory, many African Americans might find their way to The Underground Railroad "Quilt Code" Web site and accept the evidence it contains as refuting

the quilt code. However, its callous tone and relentless probing could easily remind some black readers of the days in which their history was routinely denigrated.

Of course, the initial contemporary legends that posited a quilt code are encased within genres held to a high standard of veracity. To the quilt code debunkers, the uncritical articulations of the contemporary legends within the bodies of purportedly documentary works—*Hidden in Plain View, Stitched from the Soul, Hearts and Hands*—reflect amateurish research skills. They would argue that the coauthors should have scrupulously checked the claims of Williams's ancestor. And, given that *Hidden in Plain View* is pitched as a nonfiction book about the quilt code, the critics raise a very valid point.

Contemporary legends also thrive when they are a good fit with the rest of our knowledge and attitudes about a given subject. Stories about sadists at Halloween make sense to the many parents who keep track of the real news reported about pedophiles and other adults who believe themselves to be entitled to hurt children. We process and evaluate the Underground Railroad/quilt code legends in terms of our other understandings about American slavery. For most people, the mental file folder we access for a subject such as antebellum slavery contains entries from a number of disparate sources. The lessons we received from history teachers and professors aren't always at the front of the folder. And even if historical resources dominate, historians have consistently revised and reshaped the slavery canon. Cyré Cross's history lessons emphasize different aspects of nineteenth-century American life than were stressed in my day. For those whose families can trace their lineage back to the middle of the nineteenth century, ancestral stories will be prominent in their minds. But no doubt to the chagrin of many professional historians, the representation of slavery in literature and film has had a profound influence on our understandings of it. The dramatic potential for familial, racial, social, and regional conflict inherent in American chattel slavery has long inspired the literary imagination. *Birth of a Nation, Gone With the Wind*, and similar twentieth-century narratives successfully captured the rapt attention of the masses. But the sweeping stories about benevolent plantation owners, buxom white southern belles, debonair young men, and their loyal but sometimes obstreperous slaves diminished slightly in popularity in the aftermath of the civil rights era. Alex Haley's novel *Roots* assumed an important position in the pantheon of creative tomes regarding slavery, and gave rise to a miniseries based on it. *Roots* and other books penned by African American authors in the last decades

of the twentieth century offered story lines in which the slaves, not the slave owners, were the lead characters.

Although runaway slaves and the slave catchers who pursued them were depicted in several of the major fictive works about slavery, for the most part, the dramatic focus was on stationary, not runaway, slaves. But from the 1850s until the mid-twentieth century there was one prominent fictional story of a fugitive slave that was reenacted time and again. Published in 1852, Harriet Beecher Stowe's *Uncle Tom's Cabin* stands as the most influential book ever to confront the institution of slavery. In the nineteenth century, only the Holy Bible outsold *Uncle Tom's Cabin*, sometimes referred to as the world's first best seller. In the serialized magazine installments that predated its publication as a book and in the novel itself, in the hundreds of stage shows also known as "Tom shows," and in the numerous films based on the novel, parallel subplots trace the paths of George, a talented slave artisan, his wife, Eliza, and their five-year-old son, Harry. In order to endow it with credibility, Stowe based many plot elements on genuine accounts from slavery, and the subplot involving Eliza and George was based on the escape of a real family. Distressed over the occupational exploitation that he must endure, the mechanically gifted George decides to run away, vowing that once he's in a free state, he'll send for Eliza and Harry. She reluctantly agrees to wait, but this plan goes awry when Shelby, Eliza's master, sells her and Harry. Knowing that George might never be able to find them if they are sold "down river," Eliza runs away with Harry. In the novel, Stowe created memorable depictions of Eliza, with Harry in her arms, sprinting across the partially frozen Ohio River to escape the vicious slave traders pursuing her. With the help of benevolent Quaker abolitionists, George, Eliza, and Harry are reunited and find their way along the Underground Railroad to Canada, ultimately migrating to Liberia.

In Stowe's novel as well as in the versions of the story adapted from it, the victimization of Eliza, George, and Harry is in the foreground. Stage shows, films, and even Classic Comics renditions of the escape have added ferocious dogs and portrayed the slave catchers as powerful and ominous, while depicting the fugitives as terrified victims. In the novel Eliza's bravest moment comes when she reluctantly chooses to navigate the treacherous river by jumping from one patch of ice to another in her effort to reach the free state of Ohio. In stage shows and films, this sequence is often the dramatic climax. But Eliza is not rendered as an athletic daredevil. Dramatists and filmmakers have followed Stowe's lead, emphasizing that Eliza's actions in the face of the harsh elements

of nature and the brutish slave traders stem from her faith in God. From the 1850s until the 1950s, the fictional story of Eliza and Harry was the best-known account about the Underground Railroad. Bordewich observes, "Virtually every literate American (and many who weren't literate) knew Eliza's story, if not from reading the novel itself, then from the numerous dramatic versions that remained staples of the popular stage well into the twentieth century."[13]

By the 1960s, 1970s, and 1980s, historians and literary critics eager to analyze African American primary sources rediscovered the slave narratives and autobiographies of Frederick Douglass, William and Ellen Craft, Henry "Box" Brown, and others. Their slave narratives and autobiographies were reissued, in some cases for the first time in close to a hundred years. The real accounts of fugitive slaves, like *Uncle Tom's Cabin*, could be read as stories of individual African American triumph. Escaping from the watchful gaze of slave owners, overseers, and "paterollers" required both physical and mental agility. Henry "Box" Brown figured out how to ship himself to a free state. William and Ellen Craft disguised themselves and traveled as an invalid white slave owner (light-complected Ellen) and her attentive manservant (William). Frederick Douglass, who was probably the most widely known runaway of the antebellum era, was mysterious about the details of his escape in the early versions of his narrative. He wanted to protect the chances of subsequent enslaved men and women who might be able to take the same route. These stories of the strength, ingenuity, and bravery demonstrated by real nineteenth-century blacks, however, never gained the prominence enjoyed by Stowe's fictional characters.

For approximately one century, the harrowing escape constructed by Harriet Beecher Stowe worked—worked better, in fact, than any of the true stories. It personalized both the predicament faced by the thousands of black men and women who risked their lives in pursuit of freedom and the unfailing determination of those who pursued them. One of the most compelling arguments used by abolitionists against slavery always had been the peculiar institution's devastating impact on families. Even before they ran away, George, Eliza, and Harry were unable to live together. But they had done all the right things, all the things good Christians are supposed to do. George had bettered himself to the point of being essential to his owner's success. Eliza was unflinchingly loyal to her mistress. Both were light complected, thereby leading to the unfortunate implication that humans with "white" blood were subject to slavery but at the same time morally superior to those who were more darkly complected. Their ignoble pursuers symbolized the capitalistic excesses endemic to the southern

economy. Stowe created fugitives who would appeal to antebellum readers, whom she hoped to win over to the antislavery cause, and the less politically oriented dramatists who later adapted her story to stage and screen diluted the moral fiber of the characters in order to suit their audiences' taste for a melodramatic action story.

But by the late twentieth century, a different kind of Underground Railroad story was needed to satisfy more comprehensive understandings of the circumstances of slaves and slave owners. The heroes and heroines did not undergo a complete makeover; in the quilt code stories, we do see some traits reminiscent of the Stowe characters. The African Americans who pursue freedom are still hard-working, courageous, and Christian. Many of them are female, many even young girls. This development makes sense when we consider that the modern women's movement followed on the heels of the modern civil rights movement. Both movements sought to undermine the image of slaves/women as powerless victims and to reinforce stories that stress the intelligence required of nineteenth-century blacks and women. In the quilt code stories, leaving their shackles behind requires the slaves to outsmart, not outrun, the more powerful slave catchers. Their "weapon" is an unorthodox one, a product of women's work, an innocuous quilt, which provided a path to freedom. Illiteracy isn't an impediment to a successful escape, because the cunning fugitives know how to read the codes embedded in the quilts. The evil slave catchers play a much less dominant role, and instead of coming across as ruthless ogres, they are depicted as hapless fools, too ignorant to even realize that mere quilts are signaling the way from their plantations to the free enclaves of the North. Whereas brute physical strength and stamina were essential characteristics for the fugitives in *Uncle Tom's Cabin*, mental prowess is celebrated in the quilt code/Underground Railroad legends. All in all, these postmodern stories about plucky and confident fugitives, "smart" quilts, inept slave catchers, and astute abolitionists are eminently likeable. They affirm a view of slavery in which the slaves have agency and control—important attributes to post–civil rights movement African Americans. These are stories of liberation, not escape.

CONCLUSION

When teaching a college class that addresses nineteenth-century slavery, I cover all this terrain and more. I assign at least one slave narrative as well as

sound secondary materials that include coverage of the Underground Railroad. Now that Bordewich's book is available in paperback, it's a likely choice the next time around. Together, the class and I review the archival sources that document just how limited the slaves' access to commodities like fabric and thread were. We review and analyze the folk materials the slaves were able to create, the awe-inspiring spirituals, plaintive work songs, clever proverbs, and captivating folktales that were recorded by early ethnographers.

I'm well aware that, after the final exam, most of my students will forget the details of the route to freedom taken by William and Ellen Craft or Frederick Douglass. If I've done my job well, though, they'll have a command of the basic research tools useful for studying the African American experience in the eighteenth and nineteenth centuries. I expect that they will always remember that American chattel slavery was an egregiously dehumanizing institution. They will recall that, with the aid of courageous and resourceful antislavery activists, thousands of slaves, mostly men and mostly from border states, were able to find their way to freedom. This was a remarkable feat for all involved. The Underground Railroad can be an enormous source of pride to anyone who wants to find noteworthy achievements embedded within the "peculiar institution."

This is the truth that undergirds the legend that quilts facilitated the escape of slaves. The sources I train my students to use don't authenticate a quilt code. They do, however, affirm that nineteenth-century African Americans were enormously creative and courageous.

Chapter Fourteen

ONE MORE RIVER TO CROSS

"Any good woman my age from Alabama definitely knows how to quilt."[1]
ROSA PARKS

On March 11, 1997, forty-two years after Rosa Parks's civil disobedience prompted the thirteen-month-long boycott of the Montgomery city bus lines, Alabama state legislators headquartered in Montgomery designated the "Pine Burr" quilt as the state's official quilt. After identifying and celebrating the accomplishments of two African American quilters from the Freedom Quilting Bee (FQB), the official resolution concludes by saying,

> WHEREAS, quilts and artifacts of the Civil Rights era, which will be presented and stored in the Freedom Quilting Bee, will provide an accurate documentation of the events taking place in American history; and
>
> WHEREAS, a love and understanding of the history of our state are enhanced by traditions that have become a part of our way of life and the customs of the American people, and the official recognition of the Pine Burr Quilt will enhance the cultural stature of Alabama both nationally and internationally. . . .[2]

In 1955, Rosa Parks never could have predicted that the Alabama power structure would deem quilts made by black Alabama women worthy as status symbols for the entire state. The scribe who penned the resolution above for the two houses of the Alabama state legislature was absolutely right when he wrote that an appreciation for quilts would "enhance the cultural stature of Alabama both nationally and internationally." As noted earlier, black Alabama quilters from the FQB were important participants in the first Smithsonian

Festival of American Folklife in the 1960s, which took place in the nation's capital. But the range of influence of Alabama black quilters has reached far beyond the capital mall, and extends long after the turbulent 1960s. In the latter half of the twentieth century, the cultural stature of Alabama has been enormously enhanced by widespread attention to and celebration of quilts made by African American Alabamians.

The list of accolades is impressive. The International Quilt Study Collection (IQSC), which is housed at the University of Nebraska at Lincoln and is the most significant academic quilt collection in the world, includes the Robert and Helen Cargo Collection, a collection dominated by quilts made by African American Alabamians. The National Endowment for the Arts (NEA) has named two African American Alabama quilters—Nora Ezell and Mozell Benson—as recipients of its prestigious National Heritage Fellowships. Big books featuring black Alabama quilts adorn coffee tables throughout the United States. Major exhibits featuring Alabama quilts have inspired even culturally jaded New Yorkers to stand in long lines. Textile scholars have drawn upon Alabama quilts in their debates over whether an African aesthetic significantly influences the appearance of African American arts. Legal scholars use Alabama quilts to test their conclusions about intellectual and artistic property laws. Employing Alabama quilts as case studies, African American and white academics struggle to advance their often competing theories regarding what makes for a beautiful black quilt. In short, virtually all of the issues that surface regarding black quilts on white walls can be illuminated by focusing on African American quilters who pieced their first quilt under the stars that fall on Alabama. And once again, by reviewing the circumstances of African American quilters, we can access issues relevant to black America writ large.

IN ALABAMA QUARTERS

It is perhaps a good thing that most quilters and quilt scholars are unintimidated by scraps. When it comes to assembling a coherent picture of nineteenth-century quilt traditions—particularly as they existed in the slave quarters—we have little more than documentary fragments with which to piece together a story. In trying to connect twentieth- and twenty-first-century African American Alabamian quilting with its historical roots, we can see the challenge quite

clearly. Whatever quilts might have been made by the slaves in Alabama were made for use, and, consequently, we lack any tangible example of an Alabama-made slave quilt. In putting together theories about what Alabama slave quilts were like, it's as though we have to construct a quilt by using fabrics that are no longer available to us.

So secondary print materials have to be used. The best sources for information about the lives of slaves are problematic. Quilt scholars have used the interviews of ex-slaves conducted between 1936 and 1938 by employees of the Works Progress Administration (WPA) to substantiate African American slave quilting practices. But the interviewers, available for hire by the WPA because of the Depression, were unevenly trained, and their biases about blacks and the era of slavery often seep through the interviews. Suspicious of the uncharacteristically friendly whites who showed up at their doors with tape recorders, cameras, and lists of questions about "slavery times" and "the War between the States," the elderly African Americans had no reason to be fully candid and forthcoming in the interviews.

Twenty-three hundred interviews were conducted, with two hundred and twenty-one of those taking place in Alabama. Within these there are only six references to "quilt." Three of these six are brief comments about the presence of quilts or quilting at the time of the interview itself. The other three refer to slave quilting. One is a very brief reference to quilts on a clothesline. The other two are a bit more substantive. Martha Bradley notes: "In cotton pickin' time us'd stay in the field till way atter dark and us'd pick by candle-light and den carry hit and put hit on de scaffold. In de winter time us'd quilt, jes go from one house to anudder in de quarter. Us'd weave all our ever' day clothes but Master Lucas'd go to Mobile ever' July and Christmas and git our Sunday clothes."[3]

In the one other substantive recollection about slave quilting in Alabama, Dellie Lewis recalled integrated quilting sessions: "Durin de Christmas celebration, us all had gif's. Us had quilting bee's wid de white folks, and effen a white gent'man throwed a quilt ober a white lady he was titled to a kiss and hug from her."[4]

From these narratives we can clearly assume that some Alabama slaves knew how to quilt. But it seems imprudent, based on the corpus of WPA Alabama narratives, to conclude that quilting was widespread in the slave quarters. After all, over two hundred Alabama ex-slaves didn't mention quilts or quilting. Although the accounts of these and several other narrators depict benevolent and generous masters, we cannot assume that the bucolic descriptions weren't

triggered by the need to adhere to the preconceptions of the interviewers. Paul Escott, an astute specialist regarding the WPA narratives, describes the milieu of the times: "Perhaps poverty coerced people into saying what they thought the 'government man' wanted to hear. Moreover, the South of that day was a tightly segregated society. Institutionalized racial discrimination dominated social life as pervasively or almost as harshly as slavery ever had."[5]

In addition to the WPA narratives, a few other data fragments offer clues as to the likelihood of pervasive slave quilting. As the Martha Bradley quote above indicates, artificial lighting was limited, and slave cabins often had no more than light from fireplaces after dark. Working until after sundown didn't leave a lot of time for quilting. Inventories and the observations of travelers also remind us that cloth was a very precious commodity throughout the antebellum world, and most field slaves would have had very limited access even to discarded material. Commenting on Alabama slaves, traveler Harriett Martineau complained about "[b]lack women ploughing in the field with their ugly, scanty, dingy dresses."[6] Given the tenuousness of the available sources, it seems safest to conclude that, while some African Americans were comfortable with quilting at the end of the Civil War, many others may not have been. Similarly, there are no specific documents that we can use to affirm what Alabama slave quilts looked like.

Little more is known about the quilts in the late 1930s, at the time of the WPA interviews themselves. We know that, in at least three of the more than two hundred households visited by the interviewers, quilts were present. As we shall see in the section on the quilts from Wilcox County, there was at least some documentation of black quilts in one part of the state. To best understand the emergence of widespread interest in African American quilts, we must start in the 1950s and 1960s.

The twentieth-century civil rights movement rendered the utilitarian quilts of black Alabamians visible beyond the communities that crafted them. Understanding how many Americans moved from watching boycotts on television to admiring black quilts on museum walls requires a look at the movement itself. American historians may disagree regarding the precise episodes that stand as its bookends, but all would concur that the Montgomery bus boycott in 1955 certainly comprised one of the earliest victories, and that the assassination of Martin Luther King, Jr., in 1968 signaled the demise of the avowedly nonviolent phase of the movement. Clearly, this entire era offers a convenient historical marker from which to measure African American progress. The civil rights

movement's generals and foot soldiers succeeded in dismantling many onerous policies and practices that had restricted African Americans, but their heroic efforts did not eliminate all racial discrimination or establish a level playing field for blacks in the United States. So while the movement demonstrably improved black access to the American dream, the legacy of three centuries' worth of economic, educational, and legal deprivation combined with lingering racism continued to curtail African American upward mobility.

Mobility metaphors have always permeated African American expressive culture. The enslaved Africans were moored to the property of their New World captors; thus, the language of their aspirations foregrounded freedom to move. The earliest sacred music traceable to the slaves focuses on spiritual mobility with titles such as "One More River to Cross," "The Heavenly Road," "Steal Away to Jesus." Historians have made a convincing case that the slaves composed these lyrics because the afterlife references allowed them to disguise political aspirations under the cloak of religious ones. The masters could take comfort from the naive notion that their slaves were singing about getting to heaven, while the enslaved blacks could multitask—singing about how much they wanted to steal away to heaven and at the same time contemplating stealing away on the Underground Railroad.

Mobility metaphors remained salient after the Emancipation Proclamation; references are evident in sacred and secular music, literature, artwork, and folklore throughout the twentieth century. Jim Crow segregation, economic instability, and educational disadvantages kept generation after generation of black Americans stagnant, unable to move forward. In Alabama and throughout the South, they were often tethered to the land of white property owners who made sure that at the end of each growing season, the black sharecroppers owed them money that could only be worked off through tilling their land for another year. The *movement* part of the term *civil rights movement* speaks to the political, economic, educational, and cultural places black Americans wanted to reach in order to liberate themselves and their children from the control of white land owners and the governmental officials who answered to them. By the middle of the twentieth century, the desired movement was boldly announced in literal and pragmatic terms. African Americans didn't ponder how to secretly steal away to freedom; rather, they publicly demonstrated their aspirations by marching en masse in full view of their oppressors. In a speech delivered at the end of the treacherous voting rights march from Selma to Montgomery, Alabama, in March of 1965, Dr. Martin Luther King, Jr., proclaimed,

"It is normalcy all over our country which leaves the Negro perishing on a lonely island of poverty in the midst of a vast ocean of material prosperity. . . . No, we will not allow Alabama to return to normalcy."[7] King was advocating that black Alabamians engage in political activity that he believed would position them for prosperity.

One cluster of communities of black sharecroppers, within which there were also many quilt makers, knew exactly what King meant by life on an island of poverty. Gee's Bend, Alabama, often described as "a bulb of land surrounded by the Alabama River," is an impoverished agricultural community between Selma and Montgomery. In the early 1960s, its residents, called Benders, confronted the local county leaders in an effort to register to vote. But in a typical Jim Crow strategy to keep the franchise away from blacks, the county would only allow a black to vote if a white citizen "vouched" for him or her, and no white Alabamans would vouch for a Bender. Benders and their neighbors did not give up agitating the county leadership, however. Impressed by their convictions, Martin Luther King, Jr., accepted their invitation to preach at Gee's Bend's largest black church. Following his impassioned speech, Benders and their neighbors in Alberta, Rehobeth, and the other tiny black enclaves in the area were more determined than ever to protest the segregation practices that were endemic to their corner of Alabama.

Their bold activism stimulated both positive and negative long-term consequences. Lucy Mingo recalls, "When the people around here started getting active in the freedom movement, a lot of us got put off the land we'd been sharecropping on. All of us were just pushing. A lot of us Mingo people had worked for [one man] and we had to leave his land. . . . He told us, 'If you go down to Camden and agitate, I'm going to put you off of my land.'"[8] To deter their black neighbors from conducting themselves as individuals entitled to full citizenship, the leaders of the white power structure in nearby Camden, the Wilcox county seat, mothballed the ferry boat that had allowed Benders to cross the Alabama River in just a few minutes. Some local historians attribute the ferry's sudden demise to financial problems, but others, including local leaders willing to acknowledge their own once-racist actions, maintain that the ferry was docked to keep Benders in their place. "We didn't close the ferry because they were black," Sheriff Lummie Jenkins said. "We closed it because they forgot they were black."[9]

During his Selma speech, King warned that because of white hostility to civil rights activity, "We are still in for a season of suffering in many of the

Black Belt counties of Alabama, many areas of Mississippi, many areas of Louisiana."[10] For Benders, it was an arduous four-decade-long season. Symbolically, the season of suffering ended for the Benders on September 18, 2006, when eighty-nine-year-old resident and quilter Allie Pettway smashed a bottle of champagne on a brand-new vessel, christening the first ferry that would cross this part of the Alabama River since 1965.

Although the Voting Rights Act guaranteeing access to the voting booth was passed by Congress in 1965, for the next forty-plus years Benders had to drive on a rough country road to Camden in order to exercise that right. During those last several decades of the twentieth century, getting out of Gee's Bend required a one-hour car trip—and getting out of Gee's Bend was necessary not only for voting, but also for attending middle and high school, visiting a doctor or keeping any other kind of professional appointment, shopping, and attending to other routine matters that most of us take for granted. Benders could vote, but they were still stranded on an island of poverty. The economic well-being of the seven hundred or so residents of Gee's Bend was as precarious at the end of the twentieth century as it had been prior to the movement's Alabama activities. In other words, King's objective to propel these Black Belt Alabamians out of the stubborn grip of poverty was thwarted.

SEWING/SOWING FREEDOM

Even if the Benders continued to experience a kind of economic bondage, however, there were positive consequences to the civil rights activity in which they participated. And it started with quilts. You don't have to leave Gee's Bend to piece a quilt. And it's likely that widespread attention to the quilts crafted in Gee's Bend, Alberta, Rehobeth, and the other small communities that hug the Alabama River created the incentives for the eventual restoration of the ferry service, empowered the women who had once marched for civil rights, and stimulated discussions about the definition of art and art quilts in settings far removed from the Black Belt of Alabama. From at least the 1920s and throughout the rest of the twentieth century, the women of Gee's Bend created aesthetically striking quilts out of old feedsacks, worn-out clothing, and used bedding. A 1937 New Deal program that was geared towards enabling farm families to survive the Depression supplied each Gee's Bend household with a sewing machine, thus recognizing and furthering these women's efforts.

Gee's Bend quilts, many of which continued to be hand-stitched even in households that boasted sewing machines, epitomized the utilitarian quilts that were common to black households in Alabama and throughout the Jim Crow South. Until the 1930s, black residents dwelt in cold, drafty structures constructed from wooden poles and planks and marginally insulated with clay and newspapers. The dirt ground was visible between the planks of the floors; the sky was visible through cracks in the roof. In this environment, quilts were essential sources of warmth. In conjunction with the same efforts that brought the sewing machines to Gee's Bend, the Federal Emergency Resettlement Administration sponsored the building of structurally sounder homes, popularly known as "Roosevelt cottages," on their land. The new homes did not diminish the importance of quilts, however, which were still staples in these subsistence-level households. Describing life in a Roosevelt house, Helen McCloud recalls the assembly-line process she devised to keep up with the demands on her quilting skills: "We didn't have no blankets then, so I had to keep making them things. I had to run six beds, children sleep two to a bed back then, sometime need four and five quilts on a bed, according to the weather."[11] McCloud and the other women of Gee's Bend thought they were making quilts, but many of the outsiders who found their way to Gee's Bend looked at their clotheslines and saw art.

As noted earlier, in 1965 civil rights activist and Episcopal priest Francis X. Walter was probably the first to propose that these quilts were so unique that they could be successfully marketed beyond the Alabama borders.[12] He had seen them on the clotheslines of Wilcox County homes as he returned to Selma from Montgomery, and forthwith speculated that the women's quilt-making skills could relieve at least some of the economic burdens they faced. Labeled as folk artists for the first time, some of the women of Gee's Bend began to enjoy a few years of modest fame and were able to supplement their incomes by making quilts, pillows, and similar textile products at a quilting house built for the FQB collective in nearby Rehobeth.

Work at the quilt house provided welcome security to some of the women. Alvira Wardlaw notes that the Bee was at one point the largest employer in the area.[13] In her oral history interview for the Voices of the Civil Rights Movement project, Nettie Young praises the Bee as well: "The Quilting Bee, that was my first job out of the cotton patch. . . . I get Social Security now because I worked at the Quilting Bee for thirty years. I wouldn't be getting that if I stayed farming. I thank God for the Quilting Bee, yes. It was a blessing God gave me."[14]

But not all the women were this enthusiastic. Annie Mae Young, now one of the most celebrated Gee's Bend quilters, has more ambivalent recollections about the Bee: "They had to do things too particular, too careful, too many blocks so I never did have nothing to do with them."[15] In order to successfully market their work to a larger public, the FQB quilters had to create quilts that both remained visually distinct from white-made quilts and also conformed to at least some of the consumers' assumptions about how a quilt should look and how it should be made.

FROM AFRICA TO ALABAMA?

The laudatory attention received by the FQB placed the quilters of Wilcox County on the folk artists map, and positioned made-in-Alabama black quilts on the white walls of the Yale School of Art and Architecture Gallery. Chapter ten offers a brief overview of scholars' varying analyses of the quilts in the first stages of this journey, as they made their way from beds to festivals and fairs. But soon, as these quilts that had been made for everyday use began to be sought for museum walls, they stimulated more academic debate and became new commodities in ongoing controversies about the cultural roots and artistic caliber of African American artistic production.

Appearance was at the core of this debate. In conjunction with putting the quilts on walls, academics felt obliged to explain why they didn't look very much like the quilts made by accomplished white quilters. With their large, bold design elements and unorthodox colors and patterns, African American utilitarian quilts seemed different to many viewers. Yale graduate student Maude Wahlman was one of the first scholars, but certainly not the last, to trek to Gee's Bend in order to probe African American aesthetic practices. By assigning artistic and monetary worth to the quilts of Wilcox County, Wahlman joined her predecessor Reverend Walter in undercutting long-held white prejudices about the talents of African Americans. Within social science academic circles, scholars had long espoused theories denigrating African American creative abilities. Gunnar Myrdal, who eventually received the Nobel Prize for Economics, claimed, "*In practically all of its divergences, American Negro culture is not something independent of general American culture. It is a distorted development, or a pathological condition of the general American culture*" (italics in original).[16] Although they were studying an urban and not a rural commu-

nity of African Americans, Nathan Glazer and Daniel Moynihan came to a reductionist conclusion regarding black culture that was similarly applied widely to all African Americans: "[T]he Negro is only an American and nothing else. He has no values to guard and protect."[17]

These arguments are representative of a much larger body of opinion that claimed that the middle passage—the horrific time Africans spent on slave ships between the west coast of Africa and the ports of the Americas—had been so traumatic that it had eliminated any vestiges of African expressive sensibilities, rendering its victims into cultural blank slates by the time they were herded onto American shores. African captives and their descendents were *only* capable of producing substandard creative products that had been derived solely from their exposure to European models. While proponents of these theories did not themselves scrutinize quilts made by African Americans, it seems reasonable to assume that they would have dismissed any suggestions that these reflected African influences.

The preceding well-respected notions of inferior black cultural productivity did not go completely unchallenged, however. In the course of their research, some anthropologists, folklorists, and ethnomusicologists had already identified conspicuous commonalities between the music, dance movements, folktale motifs, religious practices, and other verbal idioms of some West African communities and the music, dance movements, folktale motifs, and religious practices of black Americans, thereby showing that innate West African tastes and talents had indeed survived the middle passage. Influenced by these scholars, Wahlman used quilts by Wilcox County women as evidence of her thesis that African American quilts reflect more of an African than a substandard European aesthetic. The "retentions" versus "blank slate" debate, which had emerged in conjunction with the theories regarding verbal arts, migrated to quilt studies in the late 1970s when Wahlman, along with her mentor, Robert Farris Thompson, and folklorist John Vlach, offered arguments linking the appearance of black quilts to the look of West African artifacts.

Clearly, this link is not absolute nor exclusive, for even black-made quilts in Wilcox County reflect some mainstream, non-African aesthetics. In general, Wahlman and like-minded scholars have suggested that rural southern black quilts, like so many artifacts created by African Americans, syncretize or comingle characteristics from both sides of the term—the African and the American. For the most part, however, they make the case that the African influences are the dominant ones.

Gee's Bend, Alabama, appears to be a particularly good region for case studies of the debate over whether African Americans reproduced art that retained an African sensibility or merely created weakly executed imitations of European artistic forms. According to several contemporary African American members of the Pettway family of Gee's Bend, one of their mid-nineteenth-century ancestors, Dinah, came to the Pettway plantation from Africa on one of the last slave ships to dock in the New World. Thirteen years old at the time she arrived in Alabama, she had been sold separately from other family members on the slave ship. Scholars who have followed up on this provocative slice of family folklore have determined that a slave ship named *Clotilde* did indeed illegally dock in Mobile, Alabama, in 1859. Several years later, a black girl named Dinah was bequeathed by the slave owner Pettway to his married daughter. Other Africans were also transported to this region of Alabama from the same slave ship. Whereas most contemporary African Americans cannot name any particular African ancestor, the relatively late date of this transaction—although slavery itself was still legal in 1859, it had been illegal to import from Africa for over fifty years—allows twenty-first-century Pettways at least to share some vague stories about Dinah.

Wahlman deduced that Dinah and other *Clotilde* captives may have influenced more than just family stories. Referring to several southern quilters, including Gee's Bend's Leola Pettway, Wahlman notes, "Contemporary African American quilters such as Jewell Allen, Mozell Benson, Alean Pearson, Nora Ezell, and Leola Pettway use bold colors and large designs as part of their textile aesthetic, perhaps due to memories their ancestors would have had of the communicative function of African fabrics."[18] She also concludes, "I think that the ancestors of some African American quilters like Martha Jane Pettway and her daughters, Joanna and Plummer T., adopted Nine Patch and other checked and triangular patterns like Wild Goose Chase, because they resembled the nine square patterns of West African weaving."[19] As noted in chapter one, Wahlman distinguishes utilitarian southern African American quilts from mainstream white ones by noting the following characteristics as key features in the handiwork of black quilters: (1) an emphasis on vertical strips, (2) bright colors, (3) large designs, (4) asymmetry, (5) improvisation, (6) multiple-patterning, and (7) symbolic forms.

But there isn't any tangible evidence that these seven criteria reflect Dinah's aesthetic sensibilities; academics and collectors don't know what her handiwork looked like, if indeed she ever had the opportunity to create anything

tangible. Thus, the theories that contemporary Gee's Bend quilts are inspired by an African aesthetic are just that, theories. The resemblance between the surface designs of many of the quilts and some West African textiles is quite striking. But the resemblance to scrap utilitarian quilts made by quilters from other ethnic groups is also evident.

African retention theories are sometimes articulated as though the particular practice is taught from one generation to another. Viewed from this perspective, Dinah and other African captives would have taught their daughters to rely upon large colorful strips of fabric in their quilts, and each generation of daughters would have taught their daughters sequentially all the way down to the quilt makers documented in the 1960s and 1970s. While this is a possible explanation, it is not a probable one. For this theory to work, large numbers of enslaved black women would have had to work in a domestic sphere that we know to have been largely unavailable to them. The vast majority of female slaves were field servants working out of doors throughout the daylight hours. Historian Jacqueline Jones concludes, "The drive for cotton profits induced slave owners to squeeze every bit of strength from black women as a group. According to some estimates, in the 1850s, at least 90 percent of all female slaves over sixteen years of age labored more than 261 days per year, eleven to thirteen hours each day."[20]

Their opportunities to interact with the few women who were domestically employed were limited to Sundays. Further, as noted earlier, slave clothing allotments were miserly; indeed, as a commodity, all fabric was quite precious, and even prosperous white households lacked spare fabric from which to select quilting materials. Certainly access to quantities of brightly colored fabric with which to construct strips would have been extraordinarily unusual. While some slave women did learn to sew and to quilt in conjunction with their duties, they would have come from the relatively small percentage of women who were assigned domestic responsibilities rather than from the majority, who were purchased to perform field labor.

Even fifty years after the Emancipation Proclamation, conditions for many Alabama African Americans had not changed very much. At the turn of the twentieth century, the very poorest black Alabamians were forced to live in squalor. Describing the living conditions he found as an early extension agent for Tuskegee Institute, Thomas Monroe Campbell recalls, "Not only near the school, but throughout the Black Belt in Alabama and other Southern States could be seen hundreds of squalid, ramshackled cabins, tenanted by forlorn,

emaciated poverty stricken Negroes who year after year struggled in cotton fields and disease laden swamps, trying to eke out a miserable existence."[21] In order to repay the white land owners with whom they "shared," all able members of the family, regardless of age or gender, were needed to work in the cotton fields. In fact, "fields" is a bit of a misnomer, because Campbell and others report that maximizing what little land they had was so important that many sharecroppers planted cotton right up to the doors of their cabins, unable to assign any square footage to an indulgence like a yard.

By taking a stocked wagon and trained extension agents with him to the Black Belt enclaves, Campbell was implementing the goals of Booker T. Washington and George Washington Carver to share scientific farming and housekeeping methods with African American farm families who lacked access to any source of information about improving their standards of livings. Never one to be reticent about his prescriptions regarding how blacks could better themselves, Booker T. Washington offered sharecropping women a list of resolutions to embrace, which included the statement that, in black cabins, "[t]here is a lack of cleanliness, pure air, proper clothing and proper food. We urge that every woman keep her home clean, well-aired, and her children well-fed and clothed."[22] In Black Belt communities, Campbell set up demonstrations to acquaint sharecroppers with useful techniques for running better households and better farms. Describing the demonstration areas for the women, he notes, "The cabin was cleaned and otherwise set in order as a demonstration of what a cabin could and should be like. White curtains were made and hung at the windows; the floors were scrubbed; and pretty rugs, made by the women, were placed on the floors."[23] While the written record does not mention quilts per se as items that women were taught to make, it is clear that Tuskegee Institute prioritized the teaching of sewing, both on the campus in the home economics department and at the extension sites. Thus, while some turn-of-the-twentieth-century African American Alabama women may have learned to quilt from their mothers, there were many black mothers born in slavery or in the first generations after slavery who had never been allowed to develop domestic skills. That Washington, Carver, and Campbell felt compelled to teach seemingly basic housekeeping skills reminds us that the domestic paradigm of the autonomous nuclear family—with the adult male's primary role as breadwinner, the adult female's as homekeeper, and the offspring's as student—was as foreign as indoor plumbing to turn-of-the-century Black Belt families. Even fifty years after slavery, black survival required that each family member's first

role be an economic one. Over time, the domestic model slowly infiltrated such communities. Nonetheless, for most of the twentieth century, the financial imperatives had to be prioritized; women and children worked in the fields as their first responsibility, and cared for the house and attended school only if and after the needs for a healthy cotton crop were met.

As a result, it is easy to see why many of the technical features of the Wilcox County and other rural black quilts could be used to support the hypothesis that blacks were limited to making slipshod knockoffs of white American masterpieces. Even the most ardent admirers of these functional quilts acknowledge that the workmanship on many of them would have been deemed unacceptable by many mainstream quilters. Stitches are large and uneven. Often all four sides of the quilts are different lengths. There is little internal alignment of strips of cloth. Compared to the quilts that many middle-class white women were making for their families, these black quilts were poorly executed.

Of course, it is important to note that rural blacks were systematically denied access to the basic resources that would have allowed their technical quilting skills to flourish. The low-level subsistence economy that characterized the sharecropping life overall meant that little or no investment could be made in quilting. Unlike their more urban counterparts, these black women did not labor in white women's homes; they labored in the fields. They did not have a portal to someone else's discarded commodities. In an agricultural economy, their access to fabric, even scraps, was extremely limited, and scissors, thimbles, and eyeglasses were luxury items virtually unknown in their households. Since they wanted to keep their families as warm as possible, they cobbled together the best possible quilts that their limited skills, time, and resources permitted. Impoverished white women in similar constrained circumstances, for example in the Appalachians, made quilts technically akin to many of those made by mid-twentieth-century African American Alabamians. In quilt making, extreme poverty breeds gritty pragmatism, not perfectionism.

Arguments that rural southern black quilts are African inspired are also framed in terms of innate preferences. In other words, while Dinah may not have steered her daughter and her daughter's daughters toward asymmetrical surface designs and other African preferences, each generation was artistically predisposed to generate African design elements. In addition to sharing Dinah's skin tone and hair texture, her Alabama descendents also shared her tastes.

Much to the chagrin of some academics and collectors, some white quilters make quilts that reflect what seems to be an African aesthetic, while some

African American quilters produce quilts that bear little if any resemblance to African textiles. Because of Wahlman's focus on quilts that can be used to theorize African survivals, very little work has been done on other African American quilts from Alabama. One stunning example did hang on the white walls of Michigan State University. Crafted by Rosa Parks in Montgomery in the late 1940s, it is an impeccably constructed appliqué floral medallion quilt. The mother of the civil rights movement was clearly proud of the range of styles that could be seen in the black quilts extant within her family. At the African American Quilt Discovery Days at the Detroit Historical Museum, she brought a shiny nine patch quilt made by her mother, Leona McCauley, as well as her own meticulously constructed floral appliqué quilt. Whereas an argument could be made that Mrs. McCauley's satin stunner subscribes to some of the criteria outlined by Wahlman, Parks's own floral appliqué quilt reflects no standards associated with the African aesthetic. Because it boasts no defining African attributes, it is the kind of quilt that many collectors and curators tend to ignore.

Quilt collectors and curators also find American quilts—made by white quilters who lack proximity to black quilters—that possess traits reminiscent of African textiles. Influenced by late twentieth-century studies of African influences on ancient cultures, quilt scholar Denise Campbell reasons that African design elements were embraced by the Greeks long before white Europeans colonized the Americas.[24] Hence she makes the case that African practices were appropriated by the ancients and disseminated over time throughout Europe and parts of Asia. Thus, even mainstream American quilts that contain design motifs common to African textiles do so because these elements were long ago borrowed from Africa.

Taken together, the multitude of perspectives about whether African influences are discernible in Alabama black quilts reflects the range of vantage points about the "Africanness" of black Americans. Beginning in the middle of the twentieth century, we have Myrdal, Moynihan, Glazer, and the majority of their contemporaries uncritically asserting that "Americanness" prevails and that Negroes had yet to achieve at the same level as idealized (white) American men and women. As the civil rights movement waned, earnest young scholars such as Wahlman and Vlach, eager to dismantle notions of western cultural superiority, boldly proclaimed the Africanness, the beautiful Africanness, of Alabama quilts. Using selective quilts from rural communities like Gee's Bend, they wrote articles and books and mounted exhibits touting the genius inherent in strip quilts.

But to black women experts such as Cuesta Benberry and Carolyn Maz-loomi, these young voices were louder than they should have been and were drowning out those of black authorities like themselves, who had to compete for opportunities to critique their own culture. Although Benberry, Mazloomi, and others often studied African textiles, they weren't making quilts that adhered to the most publicized paradigm. The first generation of black quilt authorities wanted the walls of museums and galleries to have room for quilts that did not conform to the narrowly drawn Africanist aesthetic. Benberry reasons,

> How could this small sample of late twentieth century African American quilts represent in its entirety the contribution of thousands of black quiltmakers work-ing at the craft over two centuries? Would the history of blacks in America affirm that they had been a monolithic group without different experiences, environ-ments, customs, beliefs which would affect their creative efforts? What should one think of African American quilts, made over such a long period of time that did *not* conform to the aesthetics-based identification? The casual answer that African American quilts not in compliance with the criteria were simply copies of white-made, traditional Euro-American quilts was unacceptable.[25]

A decade later, the debate continued, and continued to reflect the contempo-rary political trends. In the mid-1980s, several years after Maude Wahlmann's initial research was conducted, Eli Leon began to collect and scrutinize quilts made by African American women. Leon's interest quickly escalated into a passion, and studying, writing about, curating, and dealing African American quilts became a full-time pursuit for the self-trained quilt scholar. To Leon, the thousands of quilts he saw, first in northern California and then during field studies in Texas, California, and Louisiana, pointed towards Africa. He coined the term "Afro-traditional" to refer to "a superficially heterogeneous cluster of qualities that depart from mainstream American standards (as represented by the quilts which have survived, disproportionately the quilts that middle and upper class quilt makers made for show rather than use) while abiding by conventions that cross-cut a broad spectrum of West and Central African cultures."[26] In *Accidentally on Purpose: The Aesthetic Management of Irregulari-ties in African Textiles and African-American Quilts*, an exhibition and catalogue curated and published by Leon in late 2006/early 2007, he juxtaposes African American quilts with African textiles and points to numerous visual similari-ties. Expanding on Wahlmann's six criteria, he offers at least fifteen categories

in which commonalities between African and African American textiles can be seen.

For example, Mattie Pickett, one of the quilters with Alabama roots that Leon documents, explains her approach to quilt patterns by saying, "You can change the pattern. If you don't want it that-a-way, then you turn round and change it around."[27] Leon uses Pickett's unorthodox "Texas Star" quilt as well as other unconventional black-made quilts inspired by conventional main-stream quilt designs to validate his conclusion that African American quilters, like their African ancestors, are inclined to practice "flexible patterning."

When the quilts collected by Leon are placed adjacent to African textiles, the similarities are obvious. Nonetheless, the evidence for widespread aesthetic continuity is not without weaknesses. Even though he may have amassed one of the largest collections of African American quilts in the world as well as a size-able number of African textiles, he relies heavily on twentieth-century examples to draw conclusions about the artistic sensibilities of Africans who lived in the seventeenth and eighteenth centuries. Further, because the peoples of Africa and African Americans are internally diverse peoples, sweeping assessments about culture may not apply to subgroups. Like so many of us who study black quilt history, Leon looks to the WPA narratives for evidence regarding slave quilting, but he doesn't really acknowledge the limitations inherent in these sources. As the quotation above suggests, he does indicate that there are many unanswered questions and that much more documentation needs to be done on the appearance of everyday quilts made by women from other traditions.

Based on his twenty-five-plus years of research, Leon concludes:

I believe that West and Central African men and women in the new world carried mental images of their old world design structures, coupled with skills and attitudes about accidentals, that served as alternatives to printed patterns and exact measurement. Unlike some Europeans, whom they may have ob-served measuring quilt pieces, they were adept at working from "models in the mind"—immanently portable templates that would have had particular signifi-cance considering the dearth of personal possessions accompanying Africans to this country.[28]

The "models in the mind" concept may constitute what Richard Dawkins has referred to as memes. With the discovery of genes, life scientists have provided a device for understanding biological commonalities between gen-

erations. In recent years, some evolutionary biologists have argued that cultural and social formulae reappear because they are stored in memes. Richard Dawkins defined memes, in 1976, as "the basic unit of cultural transmission or imitation."[29] As examples of notions that reside in memes, he listed "tunes, ideas, catch-phrases, clothes fashions, ways of making pots or building arches."[30] Clearly, ways of making quilts could be added to this list. From this perspective, African American women incorporate African motifs into their textiles because the appeal of these patterns is stored within them in the same way that a trait giving them dark hair repeats itself in their family.

These debates over quilt aesthetics—which sometimes became extremely heated—reflect similar controversies that erupted in the endeavors to situate African American culture appropriately within the realm of American culture. Roland Freeman traces some of the tension to the ethnic identity of individuals within the debate, noting, "Both white and black America were continuing to struggle with appropriate inclusion and valuing of African and African-American history and culture, and what was occurring in the predominantly white museum field reflected the overall situation. It did not seem to value the few black scholars involved with African-American folk culture, and for the most part white scholars were defining how the field should be interpreted, exhibited, and positioned."[31]

The racial identity of the scholars involved in this debate generated one of its major ironies. Although there are exceptions to this statement, for the most part, those scholars and collectors most invested in tracing black aesthetics to an African source are white, and those individuals most eager to resist these generalizations are African American. Prior to the civil rights movement, most whites condemned blacks because of the inferiority they perceived in all things African. Many black Americans absorbed this disdain for African artifacts. But in the heyday of the 1960s, many black Americans who had been raised to shun Africa discredited the derogatory stereotypes that had been passed on to them and loudly proclaimed their kinship with their African ancestors. These reversals demonstrate just how topsy-turvy the racial dialogue in the post–civil rights movement era became. Since it was largely white collectors who subscribed to and endorsed the African retentions theories, the quilts that fit into that paradigm garnered more critical attention and could be sold for higher prices and displayed at higher-end venues.

These debates about African aesthetics have decidedly western capitalistic implications. Financial rewards accrue to those quilts, quilters, and dealers

associated with quilts that conform to Wahlman's criteria. The online auction Web site eBay frequently lists quilts that sellers refer to as "Gee's Bend," using this as a code for fitting these criteria. What happens on eBay doesn't stay on eBay. At auction houses and galleries the quilts that make the most money conform to the Africanist retentions standards as first delineated in the 1970s. Few if any African American scholars and quilters deny the existence of a cohort of African American quilts that fit the criteria outlined by Wahlman and Leon. But the prominent codification of their opinions can inhibit scholars who have demonstrated that a much broader range of quilt types should be associated with African Americans. Campbell notes that Wahlman's "inattention [to other styles of black quilts] kindled a spark of rejection and depreciation of other authentic characteristics associated with African American quilt aesthetics by art critics, curators, collectors, and historians."[32] These quilt scholars dislike having to accept an artistic market in which white scholars proclaim that the most compelling African American quilts are those derived from an African aesthetic. By privileging quilts that adhere to that aesthetic, some white collectors, dealers, and curators are profiting from the display and sale of quilts made by financially disadvantaged black women.

BACK TO GEE'S BEND

These issues and others are painfully apparent when we scrutinize the second and much more visible wave of popularity enjoyed by the quilters of Wilcox County. When William "Bill" Arnett, a noted and notorious art patron, dealer, and curator, saw a photograph of a Gee's Bend quilt in Freeman's *A Communion of the Spirits* in 1997, he, too, went to Gee's Bend. Five years later in 2002, an exhibit curated by Bill Arnett and his son Paul, entitled The Quilts of Gee's Bend, opened in Houston, Texas, and then traveled to several other cities. A second exhibit entitled Gee's Bend: The Architecture of the Quilt opened in the summer of 2006 and is scheduled for several other venues through the end of 2008. Hanging on the most coveted of white walls—the Whitney in New York, the Corcoran in Washington, D.C., the de Young in San Francisco—the quilts of Gee's Bend have had a wider and more appreciative audience than any other African American quilts. Whereas in the 1970s the quilters of Wilcox County were being celebrated for their African aesthetics, in the late 1990s and early 2000s the fulsome praise comes for constructing quilts that look like

modern art. And the potential profits of modern art associations far exceed those of African ones.

Critiquing the original Gee's Bend exhibit when it was installed at the Whitney, *New York Times* art critic Michael Kimmelman described the quilts as "some of the most miraculous works of modern art America had produced."[33] Astonished references to modern art and artists choke reviews of the exhibits and the catalogues that were published in conjunction with them. Kimmelman elaborates on the first exhibit by saying, "Imagine Matisse and Klee (if you think I'm wildly exaggerating, see the show) arising not from rarefied Europe, but from the caramel soil of the rural South in the form of women, descendents of slaves when Gee's Bend was a plantation."[34] Peter Marzio, director of the Museum of Fine Arts in Houston, the first stop on the Gee's Bend exhibit train, notes that "the women know one another's styles as confidently as Jackson Pollock knew his as compared to Willem de Kooning."[35] A review in *Textile* explains that an Annie Mae Young quilt "features a bold study in corduroy stripes—red orange and bright gold over red orange and browns—that could pass for an early Albers or a late Klee, floating over the sea of indigo pieced from old denim."[36] In my many visits to the original exhibit—I've seen it at the Whitney, the Corcoran, and the de Young—I hear reverent attendees whispering entranced comparisons to the paintings of celebrated fine artists. To these and other patrons of the arts, the quilts of Gee's Bend deserve top-notch art museum real estate because their surface features compare so favorably to abstract expressionist art. The underlying assumption is that these modern artists—Pollock, Klee, Matisse, Albers, de Kooning—are geniuses, and since these African American quilts are structured, colored, and composed like their paintings, then these quilters are artists of the highest caliber.

The quilters of Gee's Bend were sanguine about their sewing and quilting skills and completely flabbergasted by the initial references to their work as "art." Loretta Pettway assesses her training and abilities by saying, "I didn't think I was too good at cutting out. If I could have got with friends to get me on the right track, maybe. But I just didn't have friends so I had to piece things up the way I could see to do."[37] Mary Lee Bendolph recalls the early conversations about her "old raggly" quilts as art: "When we were in Gee's Bend and the Arnetts were calling the quilts art, I said, I don't see where no art was."[38]

While the Gee's Bend women did not promote themselves as first-tier quilters or artists, other more confident and privileged quilters had long been arguing that quilts were art and deserved their share of space on museum walls. By

the late 1950s and early 1960s white women such as Jean Ray Laury and Radka Donnell, with graduate degrees in fields related to the fine arts, were making quilts as artworks, not as bedcoverings. Curated in 1971 by Jonathan Holstein and Gail van der Hoof, the first major museum exhibit devoted to quilts was entitled Abstract Design in American Quilts and was held at New York's Whitney Museum of American Art. The exhibit triggered a revival of interest in quilt making as well as sustained discussions regarding whether quilts constitute works of art. Naysayers reject the association of quilts with art on the grounds that quilt making is a craft. Gender and race issues erupt in these discussions as well. In an interview for the Alliance for American Quilts, Jean Ray Laury surmises that quilt making is "not seen as artistic in the sense of it being personally creative in the way that many other areas like sculpture and painting are. I think part of it is identification with women. It's seen as women's work and I think it's really entrenched."[39] Yet Laury, Donnell, and the first generation of art quilters didn't set out to make something to sleep under; rather, they took up fabric, scissors, and thread in order to make aesthetic statements. To art quilters, frequently referred to as fiber artists, the walls where paintings hang are the most appropriate spaces for their work.

When the Holstein and van der Hoof show was installed at the Whitney in 1971, art quilts clearly were seen as white women's work; no African American quilts were included in the exhibition. Thirty-plus years later, the Whitney's power brokers were still not entirely hospitable to those who contracted to hang the Gee's Bend quilts on their walls. Maxwell Anderson, the former director of the Whitney who partnered with Peter Marzio of the Museum of Fine Arts in Houston to mount the original exhibit, is no longer employed by the tony New York museum. In spite of the record crowds and enormous acclaim received by the original installation, Anderson believes that "Gee's Bend didn't map to any notions the board felt were important. It didn't map to the commercial paradigm. . . . About six months before the Gee's Bend show launched at the Whitney, I was asked by the trustees if it was too late to cancel."[40]

Since 2002, reviewers of quilt displays invariably invoke the Gee's Bend exhibition in any assessment of an African American quilt collection. A *New York Times* review of Threads of Faith, which was mounted in the gallery of the American Bible Society in New York City, uses the Gee's Bend exhibit as a point of contrast, noting that "the sophistication . . . in [Threads of Faith] is a far cry from the humble circumstances of [Harriet] Powers and other African-American quiltmakers, including the famous geometricists of Gee's Bend, Ala.,

the subject of a traveling show soon to open at the Corcoran Gallery of Art in Washington."[41] Art quilts crafted by black women engineers, marketing executives, professors, and similar highly respected professionals anchor Threads of Faith. These are black women who have successfully secured many of the opportunities articulated by King and other leaders of the civil rights movement. As the title and venue suggest, all fifty-three of the artists created works that reflected some aspect of their spiritual identity. While some of the quilts, such as Michele David's "The Creation: And God Created the Earth" or Cynthia H. Caitlin's "Peace at Christ's Birth," beautifully embody the predictable Christian images signaled by their titles, others, such as Denise M. Campbell's "Will the Real Aunt Jemima Please Stand Up and Collect Her Inheritance" and Gwendolyn Magee's "Bitter the Chastening Rod," are indicative of an African American tendency to weave together spiritual and political beliefs. Campbell's quilt boldly resurrects the biblical Jemima and clothes her in African fabric and jewelry, while Magee offers a nude black pregnant woman being chained and whipped. Such quilts are meant to disturb and disrupt notions that African Americans are no longer affected by the indignities of slavery and the Jim Crow era.

The quilters of Gee's Bend owe their acclaim to an authority on African American vernacular art who made his way to Gee's Bend well ahead of Bill Arnett. As already noted, it was a photograph of an Annie Mae Young quilt in photojournalist Roland Freeman's book *A Communion of the Spirits* that prompted Arnett's first visit to Gee's Bend. Prior to The Quilts of Gee's Bend exhibit, A Communion of the Spirits stood as the most ambitious and exhaustive exhibit featuring black quilters. A Communion of the Spirits, which toured thirteen museums throughout the United States, featured thirty quilts as well as one hundred seventy-five photographs of varying sizes, thirty-five of which have quilted frames for the exhibit. Female and male quilters of all ages and all socioeconomic groups from forty states are documented by Freeman. The quilts of well-known artists are included alongside those of women whose quilts were always made for family members. The gallery spaces that contracted for the exhibit tended to be those that serve African American constituencies—locales such as the Martin Luther King Arts Complex in Columbus, Ohio, and the Gibbes Museum of Art in Charleston, South Carolina.

Freeman's exhibit and the handsome companion book share the subtitle *African-American Quilters, Preservers, and Their Stories,* and both the book and the exhibit are more about the quilters themselves than they are about the

quilts. Freeman's passion is clearly for the women and men who focus their aesthetic, spiritual, and creative energies on their quilts. He loves the quilts for what they reveal about the makers. Most of the photographs in the exhibit and the book include a quilt or quilts as well as the quilt maker and perhaps even a family member or two or three. Husbands and wives stand together in front of family quilts. Children look at a quilting mother or grandmother with rapt attention. Members of quilting bees are shown surrounded by their quilts. Freeman prioritizes capturing the social milieu in which a quilt is crafted.

In many of the photographs, quilts overlap or are stacked like a pile of books, preventing the viewer from seeing the design of the entire quilt. Even someone fairly knowledgeable about quilt motifs might not see enough of the quilt to determine if it's a nine patch or a four patch. Yet the quilt makers are always captured with all of the dignity befitting a sit-down portrait setting. Freeman's priorities can be seen in his remarks about the experience of documenting the Freedom Quilting Bee (FQB) quilters. Feeling dissatisfied with the results of his initial photo session with them, he relates, "That night I lay awake, still thinking about the FQB photograph I had recently taken. The next morning I called Carrie Williams, the FQB manager, and asked if she thought the women would have felt better about my photographing them if they'd had advance notice and been able to dress and do their hair."[42] Williams assured Freeman that the women would have been more enthusiastic about being photographed with such advance warning, and so, "The next morning, in a joyful mood, thirteen FQB members gathered for a group photograph at the sewing center."[43] Freeman's recollections of his field work in Gee's Bend focus on the thirteen quilters, not the striking look of the Annie Mae Young quilt that had seduced Arnett. He didn't purchase the now famous Young quilt because his own collection already contained numerous examples of scrap quilts made by African Americans.

By the standards generally applicable within African American literary culture, *A Communion of the Spirits* succeeded. Until the 2002 publication of *The Quilts of Gee's Bend*, it was by far the thickest book ever published on African American quilts. None of its 396 high-quality paper pages are wasted; in nine chapters it methodically spells out the breadth and range of African American quilt-making traditions and practices. The well-received exhibit traveled widely to places that were comfortable to African American attendees. Nonblack patrons certainly had access to the exhibit as well. After taking it in, men and women who hadn't quilted in years ferreted out their threads and scissors,

and novice quilters marched themselves to the fabric stores. Even determined nonquilters found inspiration in the celebration of kinship networks that undergirded the exhibit.

But neither A Communion of the Spirits nor any other African American quilt exhibit has received the acclaim and name recognition bestowed upon The Quilts of Gee's Bend. According to Arnett, over a million people have seen the original Gee's Bend exhibit, and after its U.S. commitments are complete, it will move to international locales. A play based on the life of one of the quilters has been penned, and there's a reference to the quilts in the physics book entitled *Categories on the Beauty of Physics: Essential Physics Concepts and Their Companions in Art and Literature.*[44]

Why has this particular exhibit generated so much attention? Arnett traces the ascendancy of The Quilts of Gee's Bend exhibit to the review by *New York Times* art critic Michael Kimmelman referred to above. Before that review was published, attendance was not out of the ordinary and only the Museum of Fine Arts in Houston and the Whitney in New York had booked the exhibit. No doubt the Kimmelman review had a positive impact, but other attributes of the exhibit also figure in its success.

First, Arnett's track record as a curator of African American vernacular art enabled him to make the appropriate initial contacts with museum directors. Bill Arnett has been an important player in the art world for his entire adult life. In his early years he scoured Europe, Asia, and Africa for works that could be sold for profit in the United States. In his first few years he worked out of galleries with business partners, but eventually he abandoned the gallery route and began to work from his family home, renting warehouses that are now packed with his acquisitions. More recently, Arnett had been the creative force behind Souls Grown Deep, a well-reviewed exhibition of African American self-taught art developed in conjunction with the 1996 Olympics in Atlanta. To accompany the mammoth exhibit and make the research that fueled it accessible to those unable to attend it, Arnett published a pair of monumental companion volumes entitled *Souls Grown Deep: African American Vernacular Art of the South, Volume 1: The Tree Gave the Dove a Leaf,* and *Volume 2: Once That River Starts to Flow.* Even by coffee table book standards, these are really big books. Each weighs about ten pounds and has six hundred or so very large pages.

Arnett is an insider, but he is certainly not a beloved darling of the art museum world. He has alienated many colleagues in the field (and is rumored to

keep an enemies list), but most professionals who have an appreciation for self-taught art recognize his eye for the genre and respect his stature in the field. When Arnett pitched the concept for the Gee's Bend exhibit, the museum representatives knew that they were negotiating with someone able to deliver a high-quality experience. The Gee's Bend exhibit was well researched, and, again, two enormously showy big books were prepared to credential the exhibit and the artists. In the language of marketing, the Arnetts know how to brand an exhibition, and the enormous success of this one is a testimonial to their commercial acumen. They know how to get museum curators to put vernacular art on their walls, and they know how to help them attract patrons to the exhibit.

ARE THEY QUILTS? ARE THEY ART?

After seeing The Quilts of Gee's Bend at the Whitney, a white female friend of mine sheepishly confessed disappointment in the highly touted exhibit. What was the big deal, she wondered. The quilts were irregularly sized, several were soiled, and their stitch work was crudely executed. To her, they didn't look like good quilts, much less fine art. Artist Jean Ray Laury had a very different experience at an exhibition of her own art quilts. She overheard two utilitarian quilters say, "These aren't really quilts, they are *just* art."[45] To hang a quilt, any quilt, on the walls of an art museum is to ask viewers to process the piece as a work of art. These conversations remind us that patrons may bring definitions and standards with them that may be counter to the ones intended by the curators. Nonetheless, in the minds of the cultural elite, fine art sits at the top of the hierarchy of individual visual expression. Quilts from Gee's Bend have gone from Alabama to the nation's capital twice; they were featured on the mall of the Smithsonian Institution in the 1960s as examples of folk art, and in the 2000s, they were inside the Corcoran Gallery of Art. Many artists would maintain that it's better to have your work indoors at the Corcoran than outside at the Smithsonian.

Although some visitors like my friend above are unimpressed by the Gee's Bend quilts, they are by far outnumbered by patrons who are enchanted by the exhibit. On the day the exhibit opened in San Francisco, I observed a white female patron crying in front of the quilts. I overheard her tell her companion that she had been thrilled to hear that the exhibit was coming to San Francisco;

when she'd seen images of the quilts and the quilters in a publication, she was so moved that she determined to save her money in order to travel to the exhibition's next location, wherever it was, so that she could see the quilts with her own eyes. The exhibit was even better than she had expected, so she planned to return again and again to the de Young. These two very different responses to the quilts lead to the question: do the quilts of Gee's Bend deserve the artistic accolades they have received?

I'm convinced that if the Gee's Bend quilts were merely attached to the gallery walls with typical impersonal wall labels next to them, there would have been no hoopla about this exhibit. Reviewers, collectors, academics, and other patrons are enticed by the fact that unlettered rural black women had created quilts similar to the artwork created by marquee professional artists. If a new generation of professional artists had created these designs, would they have been cited in a physics book? Gary Alan Fine, author of *Everyday Genius: Self-Taught Art and the Culture of Authenticity,* maintains, "The purity—the unmediated quality—of the vision gives a work by an elderly black sharecropper a greater value than the 'same' work by a wealthy white stockbroker."[46]

The exhibits and the three books consistently remind us of the humble and difficult circumstances from which the impoverished quilters came. In addition to the quilts, the walls of the de Young feature stark black-and-white photographs of desolate, historic Gee's Bend, many of which were taken in the 1930s by Arthur Rothstein for the Farm Security Administration. Rothstein's photos are supplemented by sepia-toned ones of the contemporary quilters represented in the exhibit. No doubt taken with a high-tech digital camera, the more recent photographs are meant to be indistinguishable from ones taken sixty years earlier. Virtually all of the countenances are serious and convey a message that life for Gee's Bend quilters in the late 1990s was as difficult as it was for their grandmothers in the late 1930s. Even the name selected for the exhibit lends itself to the mood. Roland Freeman complains that more of the quilters come from Alberta, Alabama, than Gee's Bend. But The Quilts of Alberta or The Quilts of the Black Belt of Wilcox County doesn't carry the same bluesy panache that The Quilts of Gee's Bend does. Sweet female voices that match the tone of the poignant photographs come from hidden speakers as patrons traverse the gallery. A twenty-minute documentary on Gee's Bend plays continuously throughout the exhibit. In my many visits in several cities, the room showing the video is always packed, sometimes with more patrons watching the video than looking at the quilts.

The exhibit evokes nostalgia for the more inspiring moments of the civil rights movement. The most political quilt is one of the last that most patrons will see before exiting the exhibit. It features a housetop motif and contains red, white, and blue fabric stamped with the word "vote." The videos and books that accompany the exhibit stress the political bravery shown by the quilters in the 1960s, when, risking their well-being and livelihood, they marched with King.

Openings of the exhibit and special events held in conjunction with it often feature sacred music; the quilters are excellent singers. Andrew Dietz, author of a biography on Bill Arnett, notes, "In Milwaukee, the women took to the stage at a black tie gala while museum staff compared the quilters' work to modern art masters Barnett Newman and Josef Albers. The all-white audience listened, hushed. Accolades complete, the women stepped to center stage and wowed the packed room with sweet spiritual sounds. 'Somebody Knockin' at Your Door' rang out against the stark contemporary hall, shaking it like an earthquake at a revival meeting."[47]

Word of mouth and reviews such as Kimmelman's bring in the crowds. It's a popular exhibit for field trips; I've often seen groups of students being marched through the gallery. In all of my visits to the exhibit, white patrons have by far outnumbered black ones. In one of my visits to the de Young in San Francisco, I counted approximately eighty adults in the gallery, and other than the security guard, me, and my son, there were no African American patrons present. On the other hand, many African Americans don't avail themselves of the offerings of elite museums. Still, many of those black patrons who have seen it have been inspired and moved. The African American Quilt Guild of Oakland, along with the Museum of the African Diaspora (MOAD) in San Francisco, enjoyed a satisfying partnership with the de Young during its 2006 San Francisco sojourn.

QUILT PRODUCTS AND PROFITS AND PROBLEMS

The success of the exhibits and the popularity of the Gee's Bend quilts can be construed as a godsend to quilters from Wilcox County. Born into poverty in Jim Crow Alabama, the quilters of Gee's Bend have now seen their quilts hanging on the most coveted of all white walls and being fussed over by the likes of Oprah Winfrey, Martha Stewart, and first lady Laura Bush. Prior to the

exhibit, warm expressions of respect, recognition, and adoration were few and far between for these women. In a Pulitzer Prize–winning story on the ferry between Gee's Bend and Camden, Mary Lee Bendolph, a victim of childhood and spousal abuse, said, "Some people have a good life . . . But I had a rough life. But I thank God that he helped me come through, and I ain't dead."[48] Now her fans queue up to ask Mrs. Bendolph to autograph the pictures of her quilts contained in the exhibit catalogues published in 2002. In 2006, the Arnetts' publishing company issued a handsome art book, *Mary Lee Bendolph, Gee's Bend Quilts, and Beyond,* devoted exclusively to her and her quilts. Bendolph and her sister quilters have gone from being outlaws to heroines in their native Alabama, where women once harassed for their 1960s civil rights activity were now being asked to attend civic events such as the ribbon cutting at the 2005 opening of the new west wing of the Alabama Department of Archives and History in Montgomery.

The acclaim they received also afforded them opportunities to travel far beyond Montgomery, which had once been a fairly exotic destination. For most of the quilters, the trips to the urban museums exhibiting their quilts were their first excursions across Alabama state lines. Loretta Pettway recalls staying awake for the entire 2002 trip from Gee's Bend to Houston because she didn't want to miss a single sight. In 2006, when I met her briefly in conjunction with the de Young exhibit in San Francisco, she happily signed multiple copies of the coffee table books and agreed to have her picture taken with anyone who asked. With each shot, she looked right into the lens and said proudly, "Gee's Bend, Alabama." Over and over again, the Wilcox County quilters I met in 2006 described all aspects of their new lives by saying, "It's a blessing."

Although high praise for their quilts and the opportunity to see their work documented in magnificent art books and on the walls of classy museums are certainly laudable rewards for the ladies, it seems reasonable to expect that more concrete financial rewards would also accompany their success. The reports about the financial transactions as they occurred in the first few years after the Arnetts first came to Gee's Bend certainly sounded promising. Wilcox County quilters were being paid some of the highest sums they had ever garnered for their quilts. When he went to Gee's Bend, Bill Arnett went on an unprecedented shopping spree, buying hundreds of quilts. "There's an awful lot of quilt money coming into the bank," a Camden banker commented to a friend.[49] Arnett acknowledges that, once he saw Annie Mae Young's quilt in Freeman's *A Communion of the Spirits,* he headed for Gee's Bend, ferry or no

ferry. According to published reports, he paid Young four thousand dollars for six quilts. At the other end of the scale, he paid forty dollars for the least appealing quilts.[50] He spent six months making repeat visits to the twenty-eight houses of Gee's Bend, purchasing the best examples of quilts that conformed to his view that spectacular quilts resemble abstract art. He and his adult sons, who have become partners in his vernacular art ventures, devoted themselves to selling the idea of an exhibit proving that the quilters of Gee's Bend hold their own with the painters and sculptors typically associated with the Corcoran and the Whitney. The extraordinary reviews and the positive word of mouth regarding the exhibitions fueled high prices for authentic Gee's Bend quilts. A decade after Arnett's first buying trip to Gee's Bend, "new" Gee's Bend quilts range in price from a low of twenty-two hundred dollars to a high of twenty-four thousand dollars.

Of course, many fans of the exhibit will be unable to buy an actual quilt. But museum gift stores have made an art form out of adapting the quilts in their galleries into more affordable and portable commodities for patrons who want a permanent reminder of the exhibits. Predictably, an abundance of Gee's Bend paraphernalia is on sale at any of the gift shops associated with the exhibit and in many other commercial venues that sell art-related products. In 2007, the Gee's Bend Quilter's Collective Web site only listed museums that hosted the exhibit through 2006, but they had 2008 calendars for purchase, somehow having the resources to update the most commercial aspect of the Web site. Scarves, ties, refrigerator magnets, tote bags, holiday cards, and similar items can be purchased by those wanting to own their own Gee's Bend quilt, albeit in miniature and mass-produced form.

But the Gee's Bend bandwagon gained momentum, so much so, that, in 2005, a licensing deal between Kathy Ireland, the fashion model turned retail executive, and Tinwood Ventures, the company representing the Gee's Bend quilters, was signed. As a result, you can buy trays, rugs, or vases with Gee's Bend motifs from any store or Web site that carries products associated with the former *Sports Illustrated* swimsuit model. The products are fairly affordable; in late 2007 a savvy Web shopper could find a machine-made, made-in-the-USA, 100 percent olefin rug for approximately five hundred dollars. Consumers preferring a higher-quality rug could purchase one from the Classic Rug Collection. The owner of the company, Barbara Barran, who eventually entered into a partnership with ABC Carpet to merchandise Gee's Bend rugs, offers hand-knotted, wool rugs created by experienced Turkish rug makers. Hence, a Bar-

ran rug roughly the same size as an Ireland one costs in the neighborhood of five thousand dollars. Probably the least expensive Gee's Bend tie-in could be had for a mere thirty-nine cents. Under the auspices of its American Treasures series, the U.S. Postal Service issued ten Gee's Bend stamps in August of 2006.

From the beginning some observers familiar with the African American folk art world were concerned that the national and international acclaim being bestowed upon the quilters was not garnering for them an appropriate level of financial compensation. Since the first unscrupulous white music collector offered a rural black farmer/bluesman pocket change in payment for a recording of a Delta blues song, the relationship between unlettered black folk artists and white collectors has been a troubled one. Deprived of any kind of useful business or legal education, many artistically talented southern African Americans have been ill equipped to negotiate on their own behalf. The history of abuse is rampant in the music industry, and comparable exploitation has occurred in the sphere of material folk art as well.

Accusations that he unduly profits from the black folk artists in his stable have long haunted Bill Arnett, the primary collector/curator of the Gee's Bend quilts. In 1993, *60 Minutes* ran a story entitled "Tin Man," which explored Arnett's financial relationship with Thornton Dial, a profoundly gifted African American vernacular artist. Interviewer Morley Safer made the "money shot" for the program when, as Dial spoke proudly of his new home, Safer showed viewers tax records indicating that Bill Arnett in fact held the title to the black artist's beloved house. Undeterred, Dial remains loyal to Arnett, and Arnett passionately defends the integrity of his business dealings with the artists he represents.

Perhaps because of the *60 Minutes* debacle, Arnett initially cooperated with the media by responding to questions about his financial dealings with the Gee's Bend quilters. In early 2004, Arnett told *Washington Post* reporter Linda Hales that $1 million had already gone back to Gee's Bend and that, between 2003 and 2008, he expected another million to go for the construction of a community center there.[51]

Nonetheless, in the first few years after the exhibit opened in Houston, many critics were dissatisfied with Arnett's level of disclosure and distrusted the alchemy of his more complicated financial arrangements with the quilters. At that juncture, the criticism didn't come from the quilters themselves, who seemed always to be profuse in their support for Arnett. Asked if she had

regretted selling a quilt to Arnett, Arlonzia Pettway replied, "If I hadn't sold it to Bill Arnett it would have ended up getting torn up and thrown away, and now it's up on a wall in a museum and we're all proud to be able to come see it."[52] Louisiana Bendolph's first print in the Paulson Press series of fine art prints that were inspired by the quilts and sell for two thousand dollars is a tribute entitled *American Housetop (For the Arnetts)*. When an African American New York–based curator publicly questioned the arrangements, a member of the Gee's Bend community issued a pointed response: "Earlier this year [2004] the women quilters of Gee's Bend—every able-bodied quilter in the exhibition—founded the Gee's Bend Quilters Collective, which establishes prices, creates inventories, and handles sales, marketing, and accounting. Individual quilters receive half the proceeds from the sale of their quilts, and above that, we pay dividends to all our members."[53]

The Gee's Bend Quilters Collective is one of several organizations that assume responsibility for protecting the financial interests of the quilters and the investments of the Arnetts. The others are the Gee's Bend Foundation, the Tinwood Alliance, Tinwood Media, Tinwood Ventures, and the Tinwood Foundation. The missions of the six organizations seem to overlap more than the colors on a Gee's Bend quilt. The attractive but dated Gee's Bend Quilters Collective Web site is hosted by Tinwood Ventures, and states its purpose thus:

> Tinwood Ventures has worked closely with the Gee's Bend quiltmakers to help set up The Gee's Bend Quilters Collective. In addition to assisting in the marketing of the Collective quilts, Tinwood Ventures is working with the Gee's Bend community to establish the Gee's Bend Foundation. Tinwood Ventures seeks to preserve the creative integrity of the sources from which culturally meaningful art forms originate. Tinwood Ventures endeavors to give the artists it works with the attention, respect, and economic security they deserve, without altering the methods, styles, or themes of their artistic processes. Tinwood Ventures seeks to develop alternative means of bringing vernacular art to current and emerging audiences in order to offer the art the opportunities it deserves to thrive and to influence future generations. As a socially responsible business, Tinwood Ventures donates (a) substantial portion of its revenues to the communities from which the art originates.[54]

The exhibits, the exhibit catalogues, and many of the related products identify the Tinwood Alliance as sponsor. A credit line on the page opposite

the table of contents in *The Quilts of Gee's Bend* states, "The quilts reproduced in this book are from the William Arnett Collection of the Tinwood Alliance. Tinwood Alliance is a 501(c)(3) nonprofit corporation dedicated to advancing the understanding of vernacular art and artists."[55] While the state of Georgia has no record of the Tinwood Alliance incorporating as a not-for-profit corporation, it does have a file for the Tinwood Foundation, which established itself as a nonprofit in 1999. However, the state of Georgia administratively dissolved the corporation in 2005. According to an employee in the office of the Georgia secretary of state, the dissolution was the result of Tinwood Alliance's failure to submit required annual reports (November 15, 2006).[56] My research suggests that no company containing the name *Tinwood* has ever filed an IRS 990, the tax form required of 501(c)(3) corporations. Late in 2006, a representative of Tinwood clarified that "We (Tinwood), along with community leaders from Gee's Bend, recently set up the Gee's Bend Foundation, a 501(c)(3) nonprofit."[57] In early 2008 a representative of Tinwood indicated that the Gee's Bend Foundation was granted nonprofit status in February of 2006 and that the status of Tinwood Alliance, to be registered in Delaware, is "pending."

The same credit page in *The Quilts of Gee's Bend* that claims 501(c)(3) status also says, "Publication of this book has been made possible through the support of Jane Fonda." Actress and philanthropist Jane Fonda lives in Atlanta, where her offices and apartment are decorated with artwork by Thornton Dial and other vernacular artists represented by Arnett. In 2002, she agreed to become Arnett's business partner in the publishing arm of the Tinwood Alliance. Through Arnett and his sons, Fonda and her daughter Vanessa Vadim were able to preview the Gee's Bend quilts and early on became smitten with the quilters. Vadim went on to work for Tinwood Media and coproduced the documentary on Gee's Bend that accompanies the exhibits. Fonda herself is no stranger to controversy. Her anti–Vietnam War activity still galls many Americans. According to Dietz, Fonda wanted to amass evidence that would validate the integrity of Arnett's business dealings, and enlisted journalist Nancy Raabe to compile a report.[58] But Raabe, herself a supporter of Arnett, did not actively look into Arnett's transactions with the quilters.

Given the paucity of public records and Tinwood's propensity to speak about financial matters in only the most general terms, interested parties are unlikely to get a handle on the level of compensation received by the Gee's Bend quilters. Part of the problem stems from the many business ventures that

entitle the quilters to profit. First of all, there are the actual quilts. The reports indicate that the individual quilters receive approximately 50 percent of the sale price. If that's the case, then they are in conformance with the industry standard. In both vernacular and fine arts worlds, dealers routinely retain in the neighborhood of 50 percent of the price of a piece of art that they sell. Other dealers and collectors had been buying Wilcox County quilts at lower prices prior to the arrival of the Arnetts, who purchased hundreds of quilts *before* the exhibits and books enhanced their value. Thus, if the Arnetts or prior dealers purchased a quilt for one hundred dollars and then sold it for two hundred dollars to a collector, who, capitalizing on the fervor generated by exhibit, then sells it for two thousand dollars, the quilter's take is still the original one hundred dollars. Since the Arnetts did such a comprehensive sweep of existing quilts during their preexhibit buying trips, the quilters, many of them on fixed meager incomes, have to make new quilts in order to receive higher sale prices.

But Gee's Bend has come to mean more than just quilts. The quilters ought to be entitled to a large share of the monies associated with the multitude of objects derived from their art—from VISA gift cards to vases with the motif of a Gee's Bend quilt. Kathy Ireland's statements regarding the licensing agreements tout the future construction of a community center in Gee's Bend as a positive outcome of their joint venture. Bill Arnett notes that "[i]n 2005 several leaders of the community came together with concerned outsiders to start the Gee's Bend Foundation, in an effort to improve economic opportunities and the quality of life for the residents."[59] As Linda Hales of the *Washington Post* notes, "That makes the prospect of Gee's Bend mania easier to love."[60]

If the community center represents the goals of the quilters themselves, and if that's where they would like to see money made from sale of their quilts invested, then Hales is right. Asked about the plans for the center, a Tinwood representative acknowledged, "The royalty revenues from consumer products will, as you no doubt are aware, provide at best a tiny fraction of the funds needed to create such a facility and thus we were probably a bit overenthusiastic about our timelines."[61] But given that the population of Gee's Bend is still approximately seven hundred individuals, most of them elderly, it seems plausible that they might prefer larger individual shares of the monies their quilts are bringing in, or might wish to make other communal investments. While the Arnetts vehemently profess fairness, they keep the paper trail private, preventing others from scrutinizing the financial underpinnings of the relationships.

"Mind your business," "I don't take my business into the street," "None of your damned business," and similar expressions attesting to the value of personal privacy are familiar retorts within the black community. It is easy to believe that they might well be leveled at those individuals and organizations who probe for details about the business side of the relationship between the Gee's Bend Quilters Collective and the owners of the Tinwood companies. On the other hand, there's also a long and respected tradition of African Americans who have succeeded in looking out for others in less fortunate situations and, in the words initiated by the black women's clubs of the 1890s, to "lift as we climb." Quilters themselves tend to be interventionists. In the antebellum era Harriet Tubman made thirteen journeys from the free states to the slave states in order to shepherd enslaved blacks from captivity to freedom. Rosa Parks and numerous other quilters including the Gee's Bend women themselves took significant risks in order to effect changes for black America. Within African American quilter networks, the term of endearment "sistah quilter" is an increasingly common one. As black women quilters, a kinship bond connects those who are both African American and quilters, a bond almost as close as the one that connects familial sisters. Thus, it is not all surprising that, given the very real history of exploitation experienced by African American artists, Bill Arnett's already tarnished reputation, and the hard-to-decipher Tinwood/Gee's Bend management structure, African American art quilters and cultural critics have questioned the nuances of Gee's Bend finances from the very beginning.

In the early years, many of these discussions occurred in online news groups in response to a feature story about the Wilcox County quilters or to the opening in a new city of one of the Gee's Bend exhibits. More public exchanges took place when the quilters and the members of the Arnett family appeared together at an exhibit opening. In both venues, online and public, the exchanges were quite similar. During a question-and-answer session, an audience member would ask a question about the financial aspects of the exhibit. When exploitation is either subtly or conspicuously articulated, the quilters are quick to defend and praise Tinwood and the Arnetts, and usually explain that the Gee's Bend Quilters Collective serves to protect their individual and collective financial well-being. Members of the Arnett family have tended to respond by reviewing the time, energy, and know-how that they have invested in the quilters. They have often reminded the audience that earlier dealers and collectors, including African American ones, paid the quilters far less than the

Arnetts did. The Gee's Bend quilters themselves don't weigh in during online discussions. In cyber settings, members of the Arnett family have noted that, since few Gee's Bend quilters belong to these virtual worlds, they have offered to represent the quilters' perspectives; they then go on to explain the structure and purpose of the Gee's Bend Quilters Collective.

Deborah Grayson, Ph.D., a Georgia-based art quilter who has expressed her concerns about the business side of the exhibit both in on-line discussions and at question-and-answer sessions held in conjunction with the exhibit, offers the following perspective:

> These debates are not about the quilts per se, they are about a whole host of subtextual issues. Among them is the question of who can speak for others (Others). I don't know any of the women of Gee's Bend personally. I do love their quilts, I own the book and I have attended the shows (in D.C. at the Corcoran and in Atlanta at Modern Primitive). I admit to being concerned (disturbed) when I walked into the gift shop and saw all of the materials for sale (including hooked rugs!) that duplicate the work of the quilters. I wondered whether the women were going to see any of the financial benefits from their work. For me this concern is not an unfounded one. I have seen some of these circumstances before. Also, the problem underlying the Gee's Bend debate is not just about race, it is about class and gender. These women exist at the intersection of these categories, making this debate even more volatile. I am a post baby (post civil rights, post second wave women's movement, etc.). I was fortunate enough to reap the benefits of those who have gone before me. In listening to my elders, in studying the history of these movements and in teaching about these issues what I have learned is that it is very hard for people to move out of their roles/positions when it comes to discussions of race, class, gender, and culture. BUT there IS gray area between the binaries.[62]

The Arnetts respond to inquiries about their income from Gee's Bend by stressing not their profits but rather how much they have invested. Bill Arnett would point out that, absent his vision, there would have been no licensing agreements for sniveling black art quilters and scholars and pesky journalists to question. He and his sons invested their own money buying Gee's Bend quilts. They invested their time documenting the quilts and quilters and researching the history of the community. They cajoled their many contacts in the art and entertainment worlds to garner big-ticket support for the exhibit and the

catalogues. From the beginning, the Arnetts have insisted that the Gee's Bend quilts deserve the best—the best aesthetics for the catalogues, the best venues for the quilts. Yet even those who believe that Bill Arnett's love affair with the quilts of Gee's Bend was one of the best things to happen to this corner of the Black Belt of Alabama can still find his practices troubling.

After nearly a decade during which the Gee's Bend quilters seemed always to defend the Arnetts against the subtle and not-so-subtle accusations of impropriety, in May and June of 2007, three of the quilters broke ranks, legally challenging the Arnetts in three separate lawsuits. Two of the three suits, those with Annie Mae Young and Loretta Pettway Franklin as plaintiffs, claim that the Arnetts underrepresented the monies being earned by the quilts and, without the quilters' informed consent, entered into various licensing arrangements that generated too little or no rewards for the quilters. The third suit charges that Matt Arnett refused to return borrowed quilts that the quilter believed to have been made by slave ancestors.

The filing of the lawsuits was covered in both the local and national press and was the subject of much speculation in the folk art– and quilt-related blogsphere. Not surprisingly, the local Alabama press outlets paid more attention to the story than the national press. These local stories tend to be longer and, for the most part, reflect the efforts of the reporters to include the perspectives of the quilters and their attorneys. They note, for example, that after the first suits were filed, Matt Arnett made the rounds in Wilcox County asking the quilters to sign documents yielding copyrights. These reports indicate that several of the quilters, including the plaintiff Loretta Pettway Franklin, are illiterate. Major national media outlets such as the *New York Times*, the Associated Press, and Reuters also ran stories. In many of the media and in court documents, the Arnetts, who have a prominent public relations firm at their disposal, cast themselves as victims and the three quilters as ungrateful opportunists. The Reuters story quotes an e-mail from Bill Arnett in which he maintains, "I risked nearly everything I have to advance the artistic cause of an impoverished black community . . . against the tide of history and public opinion and in the face of ridicule . . . I was directly responsible for bringing their previously unheralded work to the attention . . . of the wider world, both the art world and the general public, and I was committed to helping them in whatever ways I could."[63] Overall, journalists tended to privilege Tinwood's position. Black Threads, probably the most comprehensive of blogs on African American quilts, notes that the December issue of *Quilter's Newsletter* used only materials from the

Arnetts' side of the case, offering a story on the lawsuits with no perspective from any of the Gee's Bend quilters or their attorneys.

As of this writing, the lawsuits are working their way through the court system. The quilters' actions require the Tinwood companies to account for the monies that have changed hands among the Arnetts, their companies, the museums, licensees, and quilters. Tinwood's harshest critics believe that the company blatantly exploited the quilters for its own financial gain. It's possible that the court system will affirm this view. If Andrew Dietz and others who have profiled Bill Arnett are right, the financial records are likely to be incomplete and inconclusive. The last folk hero, as Dietz refers to Arnett, is a terrible record keeper. It is plausible that even after the courts render a judgment or the parties in the suit settle out of court, serious questions will linger. To be sure, the great Gee's Bend moment will always be sullied by Tinwood's opaqueness in discussing its financial arrangments.

Some of the criticism might have been quieted and perhaps the lawsuits averted if, instead of assuming a defensive posture, Arnett made his dealings with the quilters more transparent. Describing Bill Arnett's response to the questions raised about his "take" in the Gee's Bend extravaganza, Dietz notes, "With feigned patience, he explained to whoever would listen that his efforts have *brought* wealth to the town, *not* taken wealth away [emphasis in text]."[64] According to Dietz, Arnett ended an interview on this subject by saying, "Gee's Bend has been a welfare state forever until we got there, and it made it more or less self-sufficient."[65] In spite of their professions of honesty, Arnett and others affiliated with Tinwood make statements or take steps that trigger doubts. For example, for most of the 2006 and into the 2007 calendar years, the stylish Tinwood Web site offered a link to its annual report.[66] But the link was broken, and e-mails requesting the report went unanswered. It may well turn out that Arnett's most serious offense is not any abuse of the trust the quilters have put into him, but rather his disdain for those who would like Tinwood to share statements about its earnings. With these matters now in the hands of the courts, at least some of the records will be available for scrutiny.

Prior to the filing of the lawsuits, there were African American quilt authorities who did not assume the worst about Tinwood. Documentarian Roland Freeman, whose photograph generated the Gee's Bend phenomenon, does not begrudge Arnett's success and celebrates the good fortune that has accrued to the quilters as a result of Arnett's promotion of their quilts and community. He states, "He [Arnett] has revitalized these women. He is help-

ing to economically empower those women. I don't know the details of their financial arrangements. But nobody ever thinks they are getting paid enough for what they do. Everybody gets ripped off. He's giving them a sense of self-worth in a way that they haven't felt, maybe ever in their lives. Nothing is black and white anymore."[67]

ALABAMA AND THE DREAMS OF AFRICAN AMERICANS

In the summer of 2008, the white walls of the Rosa Parks Museum at Troy University in Montgomery, Alabama, featured a panegyric quilt featuring the two-dimensional faces of John F. Kennedy, Robert Kennedy, and Martin Luther King, Jr. The quilt was made by Riché Richardson, Ph.D., herself a native African American daughter of Montgomery. The time and care she spent making it and the museum's decision to include it in this exhibit testify to the tenacity of the icons it celebrates, still influential many decades after their deaths. From Alabama to Alaska, from Maine to California, countless black homes contain various kinds of makeshift altars adorned by magazine clippings, photographs, or paintings of this trio of heroes so important to the generation of blacks who can recall African American life before the advances of the 1960s. Martin Luther King, Jr., in particular, remains a presence.

Equally common to black households, church services, and sessions in barber and beauty shops are "What would he think of us now?" conversations in which folks speculate about what the opinions of Martin Luther King, Jr., would be if he had lived. How would he have measured the progress made by Alabamians since the 1960s? I suspect he would have been proud of Birmingham-born Condoleezza Rice, whose politics were much more conservative than his, but whose hard work and determination led this daughter of a preacher to be named national security advisor and secretary of state.[68] While he would have applauded the fact that Gee's Bend is now represented in Congress by a black man, one who was born in Montgomery and educated at Harvard, he would have been dissatisfied by the low college attendance rates amongst black Alabamians, particularly males. Having slept under black-made quilts as a child, he would have been pleased by all of the accolades they have received in recent years. Although he'd see it as fitting that the major university program committed to quilt study has a large collection comprised of Alabama-made quilts, he might be chagrined to realize that the meticulous style

STUDIES OF AFRICAN AMERICAN QUILTERS

of quilts made by Rosa Parks could be defined by some criteria as "not African American." He would have enjoyed affixing Gee's Bend postage stamps to his correspondence.

It seems very likely also that he would have been disappointed that there are doubts as to whether or not his friends and comrades from Gee's Bend are reaping the appropriate rewards for their labor. One of the planks of the Poor People's Campaign that he launched as the second phase of the civil rights movement held that poor people should have "[a]ccess to capital as a means of full participation in the economic life of America." The kinds of monies being generated by the quilts and the spin-off products could certainly provide some of the well-deserved capital with which Gee's Bend could be transformed from a lonely island of poverty into a vital, economically viable community, a community in which the quilters can take for granted nice homes, resources for health care, and funds to support their children's and grandchildren's educational aspirations. These are the kinds of investments that could get Pettways, Bendolphs, and other Gee's Bend families permanently off the poverty track.

The loftiest goals of the Poor People's Campaign involved more than merely raising the income levels of African Americans. King and the architects of phase two of the civil rights movement recognized that true financial autonomy required that more African Americans make their way into positions of real power over intellectual, artistic, and financial institutions; they needed more control over the means of production. Some developments trigger pessimism. Although the popularity of the Gee's Bend quilters might be construed by some as a complete success, the murkiness surrounding how much control they and their families are accumulating reveals the extent to which some African Americans remain more dependent than independent. The ongoing promotion of theories that privilege one mode of African American quilting over others undermines artistic agency. But other developments trigger optimism. As was seen in an earlier chapter, there are quilters such as Faith Ringgold who have been able to sustain full authority over the dissemination of their art. Similarly, Roland Freeman and Carolyn Mazloomi have long been working to increase the range of possibilities for and the profits that can be accrued by Alabama quilters. As an academic and an artist, Riché Richardson has launched an impressive career. Alabama African Americans, like the rest of us, have certainly made strides since the 1960s. But, as the women from Gee's Bend are inclined to sing, we all still have at least "one more river to cross."

AFTERWORD

When I would tell people I was writing a book about African American quilters, they would often assume that this project focused on the past. Sometimes I wish I had embarked on a more historical journey. Bringing closure would be much easier. But I really don't regret making the case that the circumstances of black quilters tell us about both African American history and the present status of black Americans. The downside is trying to keep up with the many changes that occur in the black quilt world. The quilters profiled in the nine patch section evolve and tackle increasingly complex quilts and challenges. Given the ages of some, by the time this is published they may have, as we say in African American vernacular about death, passed. Museum and fair exhibits of African American quilts continue to develop, and I worry that the ones I wrote about will be overshadowed by new ones. The circumstances related to the quilters of Gee's Bend are particularly worrisome. As of this writing, lawsuits are working their way through the judicial system. Like many of my sistah quilters, I hope that all of the women whose works undergird those efforts will realize all of the appropriate spiritual and financial rewards.

In December of 2007 when the final contract for this book was being negotiated, I went to Paris, France, to be interviewed by scholars documenting the quilts of Riché Richardson and to try to find the landmarks that had so inspired Faith Ringgold. Two days after I returned, I attended the annual Christmas party of the African American Quilt Guild of Oakland at the home of our president. I told the newsletter editor about the Paris trip, and we reminisced about the many quilt-related activities in which our members had participated during the year. We'd started out in Black History Month with a packed workshop

devoted to teaching any and all how to make miniature nine patch quilts. We'd set a goal of increasing the number of quilts we make for "worthy causes," usually quilts we take to the Oakland area hospitals that care for premature babies. We supported Ora's work on behalf of the murder victims of Oakland; as a guild we made a contribution to offset the costs of school supplies for children of the victims. Some of our more proficient members (not me!) went on a retreat during which they quilted together for several days. It was a good year, but we were eager for the next one to be better. Since I still haven't given a quilt of my own making to worthy causes, I vowed to put that on my resolutions list. We pledged to improve the Web site, look for more opportunities to promote our members' quilts, and try to attract more young members to the guild.

About thirty of us were in attendance at the Christmas party. Although we don't routinely go around confessing our ages, I suspect the youngest of our members are in their twenties and the oldest in their eighties. A couple of us have advanced degrees, while others may not have graduated from high school. We span income levels, some of us quite comfortably set while others clearly face persistent financial challenges. When we do our show-and-tells, our quilts are dissimilar; some of us use machines, others sew by hand; some of us use African fabrics, others calicos and pastels. Some of our members are white, many are black. We have one male member. The food at the potluck reflected our diversity. Sushi, fried chicken, pecan pie, sweet potato muffins, and brie could all be found on our buffet table.

The highlight of our party is one of those raucous ornament exchanges familiar to many who belong to groups that have annual holiday parties. Although every ornament revealed is the subject of praise and enthusiasm, we joyously fight to claim our favorites. As I embarked on my long drive home from the party, sated with the good food and a clear winner in the ornament exchange, I reflected on how fortunate I am to be a part of this remarkable group. If this book captures the beauty, diversity, and generosity inherent in this guild's activities and goals, then I have done what I set out to do back at the Smithsonian Festival of American Folklife in 1986.

NOTES

Chapter 10.

OF FEBRUARY, FAIRS, AND FOLKLORISTS: BLACK QUILTS COME OUT

1. Cuesta Benberry, *Always There: The African-American Presence in American Quilts* (Louisville: Kentucky Quilt Project, 1992), 36.

2. Booker T. Washington, *Up from Slavery* (Oxford: Oxford University Press, 1995), 129.

3. Ibid., 130.

4. Quoted in Gladys-Marie Fry, *Stitched from the Soul: Slave Quilts from the Ante-Bellum South* (New York: Dutton Studio Books, 1990), 86.

5. Sharon F. Patton, *African-American Art* (New York: Oxford University Press, 1998), 99.

6. Ibid.

7. Washington, *Up from Slavery*, 164.

8. Ibid., 165.

9. Fry, *Stitched from the Soul*, 90.

10. Allen W. Jones, "The Role of Tuskegee Institute in the Education of Black Farmers," *The Journal of Negro History*, 60 (2) (1975): 259.

11. John B. Cade, "Out of the Mouths of Ex-Slaves," 20 (3) (1935): 294–337.

12. Carter G. Woodson, "Ten Years of Collecting and Publishing the Records of the Negro," *The Journal of Negro History*, 10 (4) (1925): 598–606.

13. William Wells Newell, "On the Field and Work of a Journal of American Folklore," *Journal of American Folklore* 1 (1888): 3–7.

14. Monroe Work, "The Passing Tradition and the African Civilization," *The Journal of Negro History*, 1 (1) (1916): 34–41.

15. Robert E. Park, "The Conflict and Fusion of Cultures with Special Reference to the Negro," *The Journal of Negro History*, 4 (2) (1919): 116.

16. Melville J. Herskovits, *The Myth of the Negro Past* (Boston: Beacon Press, 1958).

17. Eli Leon, "Arbie Williams Transforms the Britches Quilt" (Santa Cruz: The Regents of the University of California and the Mary Porter Sesnon Art Gallery, 1994), n.p.

18. Emmett J. Scott, "Letters from Negro Migrants 1916–1918," *The Journal of Negro History* 4 (3) (1919): 317–318.

19. *Born in Slavery: Slave Narratives from the Federal Writers' Project, 1936–1938. Arkansas Narratives*, vol. 2, pt. 3: 358.

20. *Born in Slavery: Slave Narratives from the Federal Writers' Project, 1936–1938. Florida Narratives*, vol. 3: 255.

21. *Born in Slavery: Slave Narratives from the Federal Writers' Project, 1936–1938. Arkansas Narratives*, vol. 2, pt. 6: 215.

22. *Born in Slavery: Slave Narratives from the Federal Writers' Project, 1936–1938 Arkansas Narratives*, vol. 2, pt. 2: 48.

23. *Born in Slavery: Slave Narratives from the Federal Writers' Project, 1936–1938. Alabama Narratives*, vol. 1: 317.

24. Roland L. Freeman, *A Communion of the Spirits: African-American Quilters, Preservers, and Their Stories* (Nashville: Rutledge Hill Press, 1996), 143–146.

25. Ibid., 68.

26. Deborah Smith Barney, "An Interview With Rosa Parks, The Quilter," in Marsha L. MacDowell, ed., *African-American Quiltmaking in Michigan* (East Lansing: University of Michigan Press, 1997), 133.

27. Ibid., 134.

28. JoAnn Gibson Robinson, *The Montgomery Bus Boycott and the Women Who Started It* (Knoxville: University of Tennessee Press, 1987).

29. Richard S. Kurin, *Smithsonian Folklife Festival: Culture of, by, and for the People* (Washington D.C.: Smithsonian Institution, 1998), 8.

30. Ibid., 9.

31. John Michael Vlach, *The Afro-American Tradition in Decorative Arts* (Cleveland: Cleveland Museum of Art, 1978), 2.

32. Ibid., 75.

33. Maude Southwell Wahlman, *Signs and Symbols: African Images in African-American Quilts* (New York: Studio Books, 1993), vii.

34. Freeman, *A Communion of the Spirits*, 131–132.

35. Benberry, *Always There-*; Barbara Brackman and Jennie Chinn, *Kansas Quilts and Quilters* (Lawrence: University Press of Kansas, 1993).

36. Steve Siporin, *American Folk Masters: The National Heritage Fellows* (New York: Harry N. Abrams, Inc, 1992), 23.

37. Wahlman, *Signs and Symbols*, 17.

38. Carolyn Mazloomi, *Spirits of the Cloth: Contemporary African-American Quilts* (New York: Clarkson Potter, 1998), 13–14.

39. Freeman, *A Communion of the Spirits*, 99.

Chapter 11.
BLACK QUILTS/WHITE WALLS

1. Alice Walker, *Everyday Use* (New Brunswick: Rutgers University Press, 1994), 33.

Chapter 12.
LIFT AS YOU FLY: FAITH RINGGOLD

1. Roland L. Freeman, *A Communion of the Spirits: African-American Quilters, Preservers, and Their Stories* (Nashville, Tenn.: Rutledge Hill Press, 1996), 141.

Notes

2. Faith Ringgold, *We Flew over the Bridge: The Memoirs of Faith Ringgold* (Boston: Little, Brown, 1995), 13.
3. For a background on the social mores of the black upper class, see Lawrence Graham, *Our Kind of People: Inside America's Black Upper Class* (New York: HarperPerennial, 2000).
4. Faith Ringgold, *Tar Beach* (New York: Crown, 1991), n.p.
5. Ringgold, *We Flew over the Bridge*, 269.

Chapter 13.
LEGENDARY QUILTS

1. Fergus M. Bordewich, *Bound for Canaan: The Epic Story of the Underground Railroad, America's First Civil Rights Movement* (New York: Amistad, 2006), 6.
2. Gladys-Marie Fry and Museum of American Folk Art, *Stitched from the Soul: Slave Quilts from the Ante-Bellum South* (New York: Dutton Studio Books: in association with the Museum of American Folk Art, 1990), 65.
3. Pat Ferrero, *Hearts and Hands: A Social History of Nineteenth-Century Women and Quilts* (New Day Films, 1988).
4. Jacqueline Tobin and Raymond G. Dobard, *Hidden in Plain View: The Secret Story of Quilts and the Underground Railroad* (New York: Doubleday, 1999), 21.
5. Ibid., 33.
6. Leigh Fellner, The Underground Railroad "Quilt Code," 2006. Available: http://www.ugrrquilt.hartcottagequilts.com/
7. Ibid.
8. Barbara Brackman, *Facts & Fabrications: Unraveling the History of Quilts & Slavery* (Lafayette, CA: C & T Publishing, 2006), 7.
9. Bordewich, *Bound for Canaan*, 308–309.
10. See, for example, Gary Alan Fine and Patricia A. Turner, *Whispers on the Color Line: Rumor and Race in America* (Berkeley: University of California Press, 2001); Patricia A. Turner and eScholarship (online service), *I Heard It through the Grapevine: Rumor in African-American Culture* (Berkeley: University of California Press, 1993).
11. Gladys-Marie Fry, *Night Riders in Black Folk History* (Chapel Hill: University of North Carolina Press, 2001).
12. Ferrero, *Hearts and Hands.*
13. Bordewich, *Bound for Canaan*, 387.

Chapter 14.
ONE MORE RIVER TO CROSS

1. Roland L. Freeman, *A Communion of the Spirits: African-American Quilters, Preservers, and Their Stories* (Nashville, Tenn.: Rutledge Hill Press, 1996), 442–443.
2. Alabama Department of Archives and History, Official Quilt of Alabama, 2006. Available: http://www.archives.state.al.us/emblems/st_quilt.html.
3. Library of Congress, Manuscript Division; Library of Congress, Prints and Photographs Division; Library of Congress, National Digital Library Program and Federal Writers' Project, *Born in Slavery: Slave Narratives from the Federal Writers' Project, 1936–1938* (Washington, D.C.: Library of Congress), Alabama Narratives, Martha Bradley, 47.

4. Ibid., Dellie Lewis, 256.

5. Charles T. Davis and Henry Louis Gates, eds., *The Slave's Narrative* (Oxford and New York: Oxford University Press, 1985), 42.

6. Quoted in Barbara Brackman, *Facts & Fabrications: Unraveling the History of Quilts & Slavery* (Lafayette, CA: C and T Publishing, 2006), 41.

7. Martin Luther King, Jr., "Our God Is Marching On!," 1965, MLK Papers Project Speeches. Available: http://www.stanford.edu/group/King/publications/speeches/Our_God_is_marching_on.html, December 6, 2006.

8. "Now They Call It Art," 2004, Oral History, American Association of Retired Persons, the Leadership Conference on Civil Rights, and the Library of Congress. Available: http://www.voicesofcivilrights. org/civil5_gees_bend.html, October 2, 2006.

9. John Beardsley et al. and Museum of Fine Arts, Houston, *The Quilts of Gee's Bend* (Atlanta, GA: Tinwood Books in association with the Museum of Fine Arts Houston, 2002), 31.

10. King, "Our God Is Marching On!"

11. Beardsley et al. and Museum of Fine Arts, Houston, *The Quilts of Gee's Bend*, 90.

12. Nancy Callahan, *The Freedom Quilting Bee* (Tuscaloosa: University of Alabama Press, 1987), 10.

13. Beardsley et al. and Museum of Fine Arts, Houston, *The Quilts of Gee's Bend*, 12.

14. "Now They Call It Art."

15. Beardsley et al. and Museum of Fine Arts, Houston, *The Quilts of Gee's Bend*, 100.

16. Quoted in Lawrence W. Levine and Phi Beta Kappa, *Black Culture and Black Consciousness: Afro-American Folk Thought from Slavery to Freedom* (New York: Oxford University Press, 1977), 442-443.

17. Ibid., 443.

18. Maude Wahlman, *Signs and Symbols: African Images in African American Quilts* (Atlanta, GA: Tinwood, 2001), 5.

19. Ibid., 98.

20. Jacqueline Jones, *Labor of Love, Labor of Sorrow: Black Women, Work, and the Family from Slavery to the Present* (New York: Vintage Books, 1986), 18.

21. Thomas Monroe Cambell, *The Movable School Goes to the Negro Farmer* (Tuskegee: Tuskegee University Archives, 1936), 80–81.

22. Ibid., 85.

23. Ibid., 128.

24. Denise M. Campbell, "Quilting a Culture: Theories of Aesthetics, Representation, and Resistance in African-American Quiltmaking," Ph.D. dissertation, Claremont Graduate University, 2006, 69.

25. Cuesta Benberry, Museum of History and Science (Louisville, KY) and Kentucky Quilt Project, *Always There: The African-American Presence in American Quilts* (Louisville, KY: Kentucky Quilt Project, 1992), 15.

26. Eli Leon, *Accidentally on Purpose: The Aesthetic Management of Irregularities in African Textiles and African-American Quilts* (Davenport: Figge Art Museum, 2006), 37.

27. Ibid., 79.

28. Ibid., 149.

29. Richard Dawkins, *The Selfish Gene* (Oxford and New York: Oxford University Press, 2006), 192.

30. Ibid.

31. Freeman, *A Communion of the Spirits*, 121.

32. Campbell, "Quilting a Culture," 69.

33. Michael Kimmelman, "Art Review; Jazzy Geometry, Cool Quilters," *New York Times*, November 29, 2002.

34. Ibid.

35. Beardsley et al. and Museum of Fine Arts, Houston, *The Quilts of Gee's Bend*, 7.

36. Christine Tate, "Exhibition Review: The Quilts of Gee's Bend," *Textile* (August 1, 2003), 396.

37. Beardsley et al. and Museum of Fine Arts, Houston, *The Quilts of Gee's Bend*, 396.

38. Andrew Dietz, *The Last Folk Hero: A True Story of Race and Art, Power and Profit* (Atlanta, GA: Ellis Lane Press, 2006), 258.

39. Jean Ray Laury, interview with Jean Ray Laury, Oral History, Quilters: Save Our Stories The Alliance for American Quilts http://www.centerforthequilt.org/qsos/

40. Dietz, *The Last Folk Hero*, 32.

41. Grace Glueck, "Design Review; Expressions of Hope and Faith, Inspired by the Work of a Freed Slave," *New York Times*, January 30, 2004.

42. Freeman, *A Communion of the Spirits*, 336.

43. Ibid., 337.

44. H. T. Hamann, John Morse, and Emiliano Sefusatti, *Categories—on the Beauty of Physics: Essential Physics Concepts and Their Companions in Art and Literature*, Categories, Bk. 1 (New York: Vernacular Press, 2005).

45. Jean Ray Laury, "My Life and Good Times as an Art Quilter," *Rooted in Tradition: The Art Quilt Symposium* (Foothills Art Center, Golden, CO: 2005).

46. Gary Alan Fine, *Everyday Genius: Self-Taught Art and the Culture of Authenticity* (Chicago: University of Chicago Press, 2004), 6.

47. Dietz, *The Last Folk Hero*, 260.

48. J. R. Moehringer, "Crossing Over: Mary Lee's Vision," *Los Angeles Times*, August 22, 1999.

49. Dietz, *The Last Folk Hero*, 252.

50. Linda Hales, "From Museum to Housewares: Marketing Gee's Bend Quilts," *Washington Post*, February 28, 2004.

51. Ibid.

52. Dietz, *The Last Folk Hero*, 264.

53. Ibid., 261.

54. Tinwood Ventures, 2006. Available: http://www.tinwooodventures.com/home.html, December 7, 2006.

55. Beardsley et al. and Museum of Fine Arts, Houston, *The Quilts of Gee's Bend*.

56. Phone conversation with the office of the Georgia secretary of state, November 15, 2006.

57. E-mail exchange with Tom Arnett on behalf of Tinwood Ventures and Turner, November 16, 2006.

58. Dietz, *The Last Folk Hero*, 313.

59. William Arnett, Paul Arnett, Joanne Cubbs, E. W. Metcalf, Tinwood Alliance, and Museum of Fine Arts, Houston, *Gee's Bend: The Architecture of the Quilt* (Atlanta, GA: Tinwood Books, 2006).

60. Hales, "From Museum to Housewares."

61. E-mail exchange with Tom Arnett on behalf of Tinwood Ventures and Turner, November 16, 2006.

62. In an e-mail exchange in December of 2006, Dr. Grayson repeated for me comments she had made during an exchange she participated in on an online newsgroup discussion.

63. Matthew Bigg, "Quilt makers fight back," Reuters, September 19, 2007, http://features.us.euters.com/cover/news/N03332078p.html.

64. Dietz, *The Last Folk Hero*, 262.

65. Ibid.

66. *Tinwood Ventures*.

67. Roland Freeman, phone interview with author, October 24, 2006.

68. Jonathan Tilove, "King's Dream Fulfilled in Condoleezza Rice?," *Seattle Times*, January 17, 2005.

INDEX